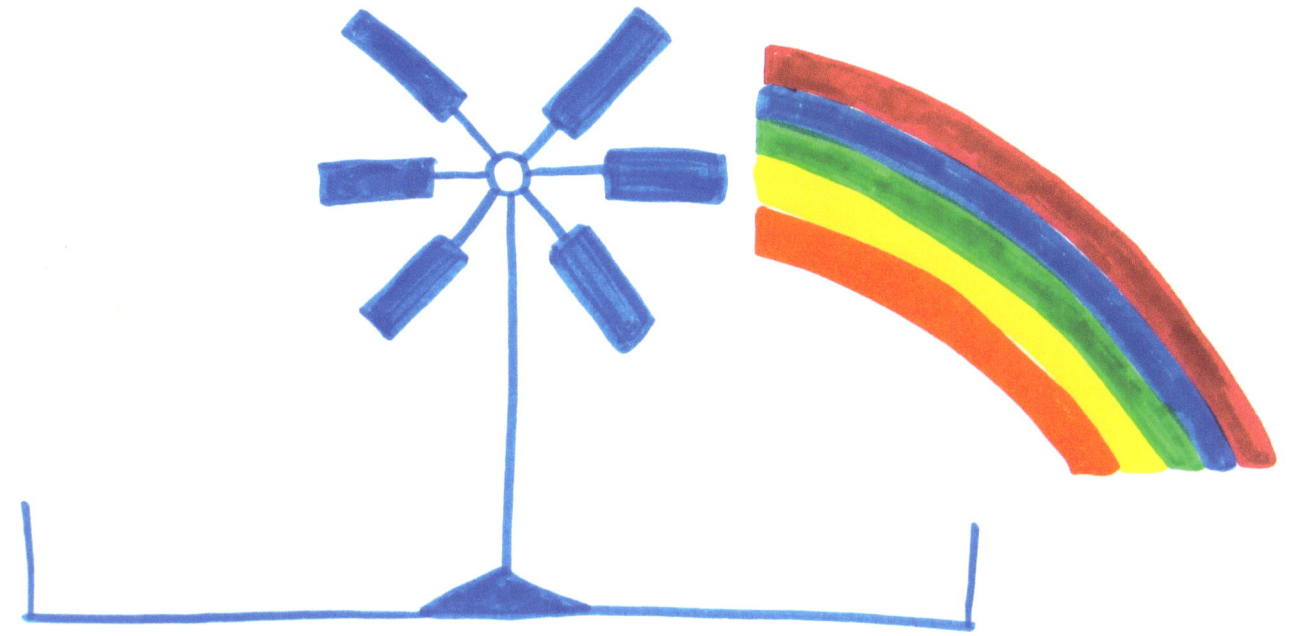

# THE CAN-MAN SHOW

**RAINBOW
THURSDAYS
ARTISTS**

*A PROGRAM OF WINDMILL ALLIANCE, INC. & VICTORY HALL INC.*

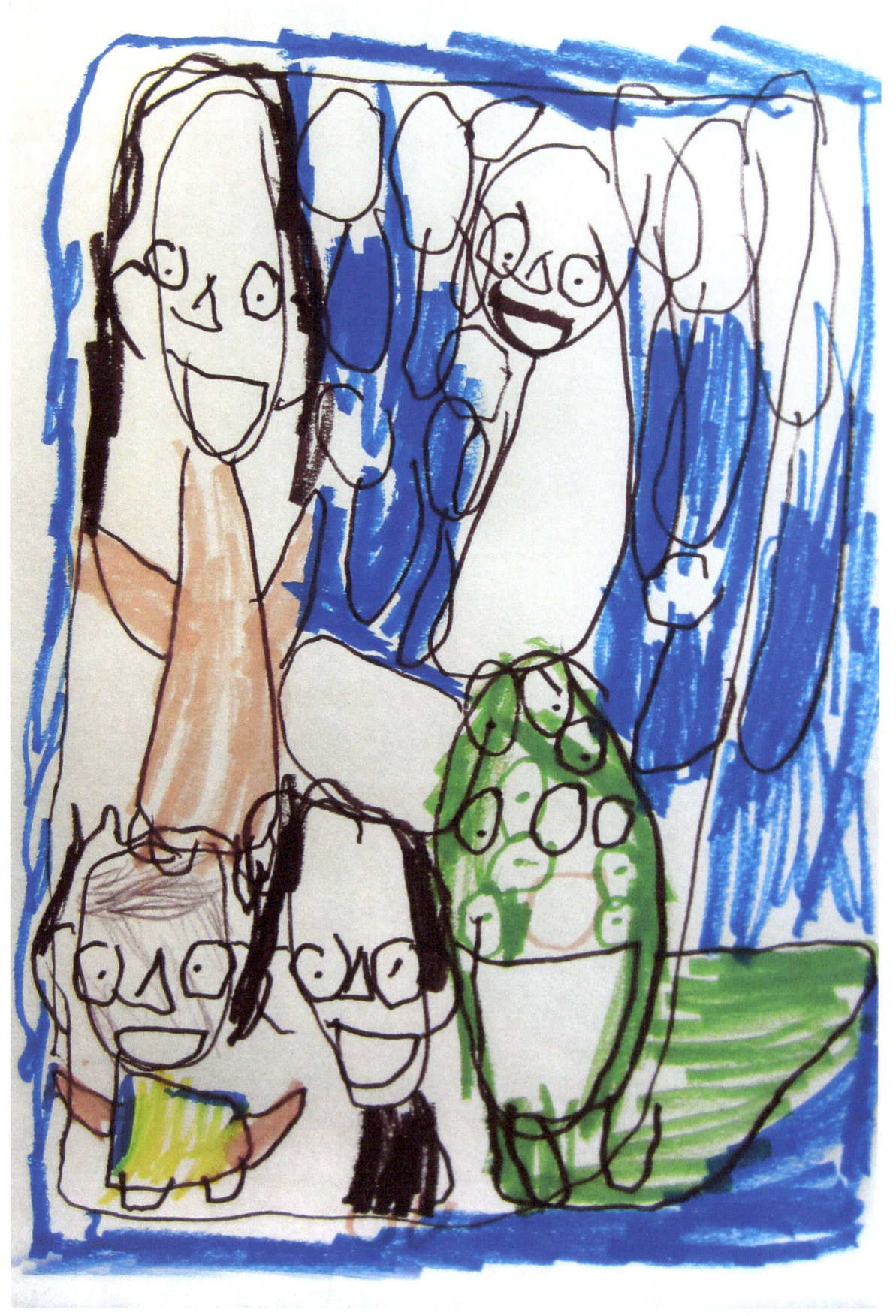

*M is for Monster by Charles*

# TABLE OF CONTENTS

Introduction . . . . . . . . . . . . . . . . . . . . . . . . . . . . . . . . . . . . . . . . . . . . . . . . . . . . . . . . . . . . 4
Aida . . . . . . . . . . . . . . . . . . . . . . . . . . . . . . . . . . . . . . . . . . . . . . . . . . . . . . . . . . . . . . . . . 6
Alan . . . . . . . . . . . . . . . . . . . . . . . . . . . . . . . . . . . . . . . . . . . . . . . . . . . . . . . . . . . . . . . . 8
Charles . . . . . . . . . . . . . . . . . . . . . . . . . . . . . . . . . . . . . . . . . . . . . . . . . . . . . . . . . . . . 10
Cheryl . . . . . . . . . . . . . . . . . . . . . . . . . . . . . . . . . . . . . . . . . . . . . . . . . . . . . . . . . . . . 12
Christopher . . . . . . . . . . . . . . . . . . . . . . . . . . . . . . . . . . . . . . . . . . . . . . . . . . . . . . . 14
Debbie . . . . . . . . . . . . . . . . . . . . . . . . . . . . . . . . . . . . . . . . . . . . . . . . . . . . . . . . . . . 16
Dennis . . . . . . . . . . . . . . . . . . . . . . . . . . . . . . . . . . . . . . . . . . . . . . . . . . . . . . . . . . . 18
Dina . . . . . . . . . . . . . . . . . . . . . . . . . . . . . . . . . . . . . . . . . . . . . . . . . . . . . . . . . . . . . 20
Ed . . . . . . . . . . . . . . . . . . . . . . . . . . . . . . . . . . . . . . . . . . . . . . . . . . . . . . . . . . . . . . 22
Eric . . . . . . . . . . . . . . . . . . . . . . . . . . . . . . . . . . . . . . . . . . . . . . . . . . . . . . . . . . . . . 24
Eugene . . . . . . . . . . . . . . . . . . . . . . . . . . . . . . . . . . . . . . . . . . . . . . . . . . . . . . . . . . 26
Hirra . . . . . . . . . . . . . . . . . . . . . . . . . . . . . . . . . . . . . . . . . . . . . . . . . . . . . . . . . . . . . 28
Jimmy . . . . . . . . . . . . . . . . . . . . . . . . . . . . . . . . . . . . . . . . . . . . . . . . . . . . . . . . . . . 30
Jude . . . . . . . . . . . . . . . . . . . . . . . . . . . . . . . . . . . . . . . . . . . . . . . . . . . . . . . . . . . . 32
Judy . . . . . . . . . . . . . . . . . . . . . . . . . . . . . . . . . . . . . . . . . . . . . . . . . . . . . . . . . . . . 34
Kaitlyn . . . . . . . . . . . . . . . . . . . . . . . . . . . . . . . . . . . . . . . . . . . . . . . . . . . . . . . . . . . 36
Linda . . . . . . . . . . . . . . . . . . . . . . . . . . . . . . . . . . . . . . . . . . . . . . . . . . . . . . . . . . . . 38
Louis B . . . . . . . . . . . . . . . . . . . . . . . . . . . . . . . . . . . . . . . . . . . . . . . . . . . . . . . . . . 40
Luis F . . . . . . . . . . . . . . . . . . . . . . . . . . . . . . . . . . . . . . . . . . . . . . . . . . . . . . . . . . . 42
Marcello . . . . . . . . . . . . . . . . . . . . . . . . . . . . . . . . . . . . . . . . . . . . . . . . . . . . . . . . . 44
Mary Beth . . . . . . . . . . . . . . . . . . . . . . . . . . . . . . . . . . . . . . . . . . . . . . . . . . . . . . . 46
Michael . . . . . . . . . . . . . . . . . . . . . . . . . . . . . . . . . . . . . . . . . . . . . . . . . . . . . . . . . . 48
Mina . . . . . . . . . . . . . . . . . . . . . . . . . . . . . . . . . . . . . . . . . . . . . . . . . . . . . . . . . . . . 50
Nicky . . . . . . . . . . . . . . . . . . . . . . . . . . . . . . . . . . . . . . . . . . . . . . . . . . . . . . . . . . . 52
Nicole . . . . . . . . . . . . . . . . . . . . . . . . . . . . . . . . . . . . . . . . . . . . . . . . . . . . . . . . . . . 54
Noreen . . . . . . . . . . . . . . . . . . . . . . . . . . . . . . . . . . . . . . . . . . . . . . . . . . . . . . . . . . 56
Paulette . . . . . . . . . . . . . . . . . . . . . . . . . . . . . . . . . . . . . . . . . . . . . . . . . . . . . . . . . 58
Sal . . . . . . . . . . . . . . . . . . . . . . . . . . . . . . . . . . . . . . . . . . . . . . . . . . . . . . . . . . . . . . 60
Timothy . . . . . . . . . . . . . . . . . . . . . . . . . . . . . . . . . . . . . . . . . . . . . . . . . . . . . . . . . 62
Wayne . . . . . . . . . . . . . . . . . . . . . . . . . . . . . . . . . . . . . . . . . . . . . . . . . . . . . . . . . . 64
Wendy . . . . . . . . . . . . . . . . . . . . . . . . . . . . . . . . . . . . . . . . . . . . . . . . . . . . . . . . . . 66
Yahaira . . . . . . . . . . . . . . . . . . . . . . . . . . . . . . . . . . . . . . . . . . . . . . . . . . . . . . . . . . 68

Victory Hall Press & Drawing Rooms are programs of Victory Hall Inc. a 501c3 non-profit organization producing exhibitions, programs and public art projects in the NJ/NY area since 2001. *More information: drawingrooms.org*

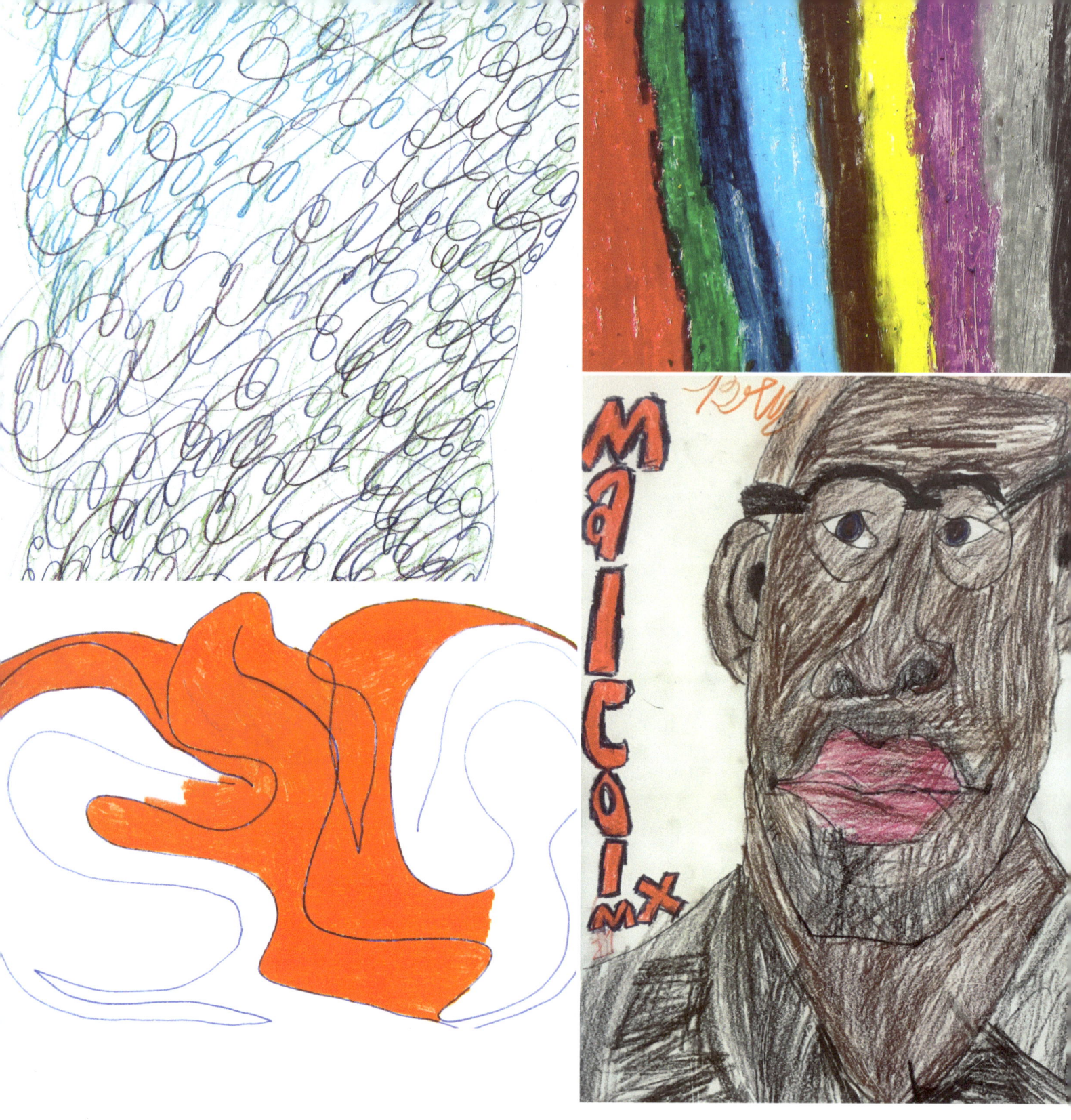

# DRAWINGROOMS
180 Grand St, Jersey City NJ

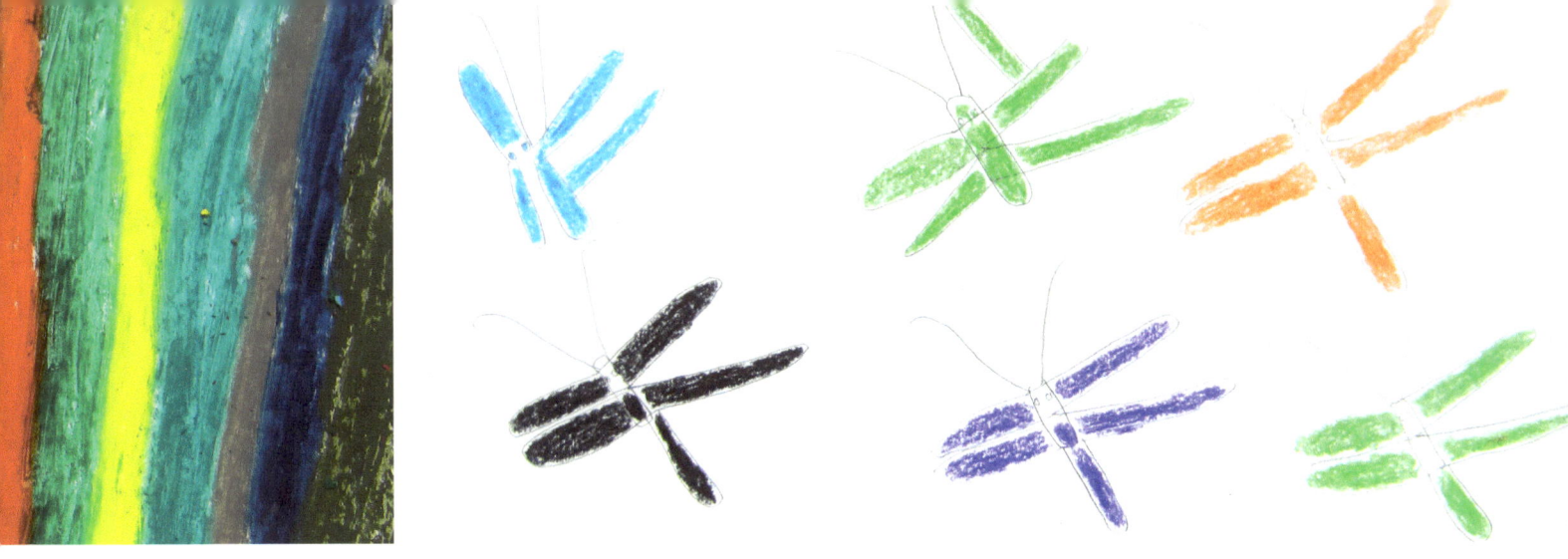

## Rainbow Thursdays Artists: The Can-Man Show, 06/22/17 - 07/22/17

Welcome to The Can-Man Show, an exhibition of works by Rainbow Thursdays Artists at Drawing Rooms. The exhibition is a culmination of almost five years of progress for the group.

Why is it called The Can-Man Show? Rainbow Thursdays Artists came up with the name because collecting cans for recycling is one of the ways they contribute to their hosting program, Windmill Alliance. Wayne even made a painting of the mythic Can-Man for our cover. The name not only acts as an example of their fun sense of humor, but also refers to their abilities (what they can-do) as well-- so they are all Can-Men and Can-Women. They also named themselves Rainbow Thursdays Artists almost five years ago. In keeping with their name, you will find that they create imaginative, thoughtful works that explore and investigate the possibilities they see and hope for, and they do like rainbows.

Rainbow Thursdays Artists is a community-based art education program connecting developmentally disabled adults with professional artists who provide them with materials, training and encouragement to express themselves through art. High school students interested in art also visit as assistants.

Rainbow Thursdays Artists classes are presented free of charge, and are funded in part by a CDBG grant from the City of Bayonne. This weekly outreach art program, in cooperation with Windmill Alliance, is now beginning its sixth year of operation and many of our participants are advancing in their creativity and skills and are developing in their identities as artists.

The program encompasses a study of great artworks, the natural world, and images of people, through books and photographs. Each participant is encouraged to understand drawing as a unique visual language with which they can create realistic and abstract forms and systems, and express emotion and ideas through line and color. Everyone participates enthusiastically and pushes to expand their own abilities and they always come up with surprising results.

We organize exhibitions throughout the year for the Rainbow Thursdays Artists to share and show their work both at our Drawing Rooms location and at community spaces throughout the area, such as the Bayonne Public Library. The opportunity to exhibit and sell their artwork to family, friends and many supporters in the community allows our Rainbow Thursdays Artists to become visible and valued in a new way.

Special thanks to Fr. Greg Perez, Joanne Tassone-Dost, Kathy DeMaria and all the staff at Windmill Alliance, and to Bruno Nadalin who taught with us all this year.

*James Pustorino*
Executive Director

*Anne Trauben, Curator*
Exhibition Director

*Jill Scipione*
Progam Manager

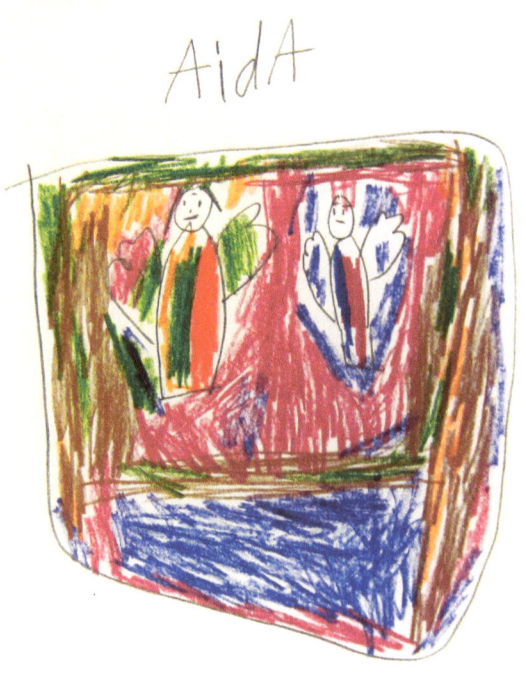
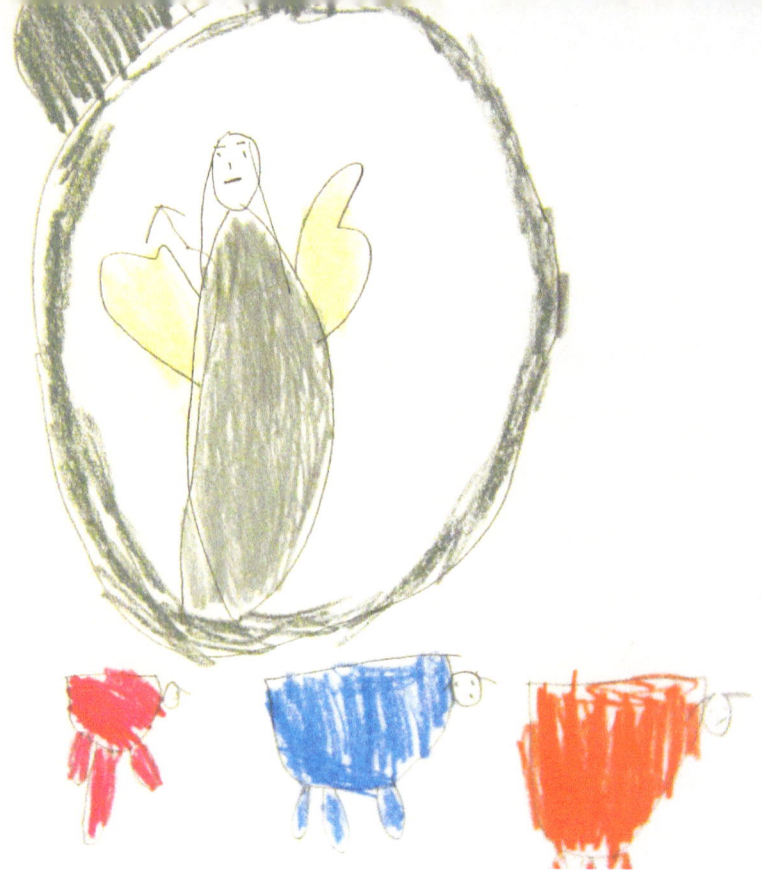

# Aida

Aida draws in colored pencils, working from early Christian icons and Renaissance paintings in books and mass cards. She will also often draw flower people in front of images of buildings where she lives or spends time. Aida translates her devotional imagery into simple, flat space and symbol, representing the table at The Last Supper by a circle, angel's wings by a double curved line and uses glowing, rich colors. An attention to details such as a book, a curtain, an architectural element, or animals, drives the expression of her work and conveys the significance of her subject matter.

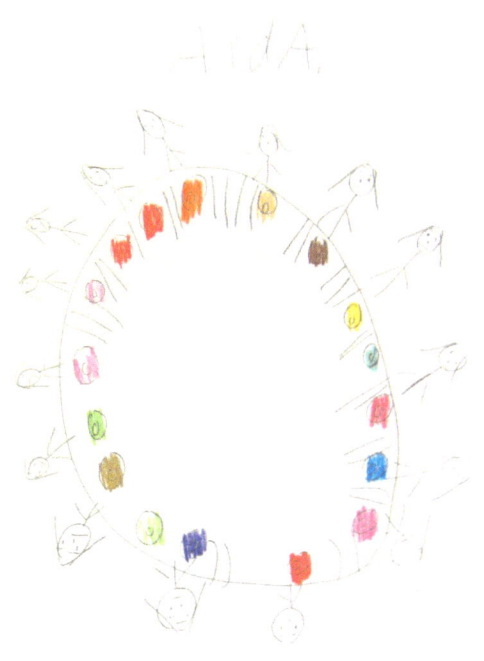

AIDA

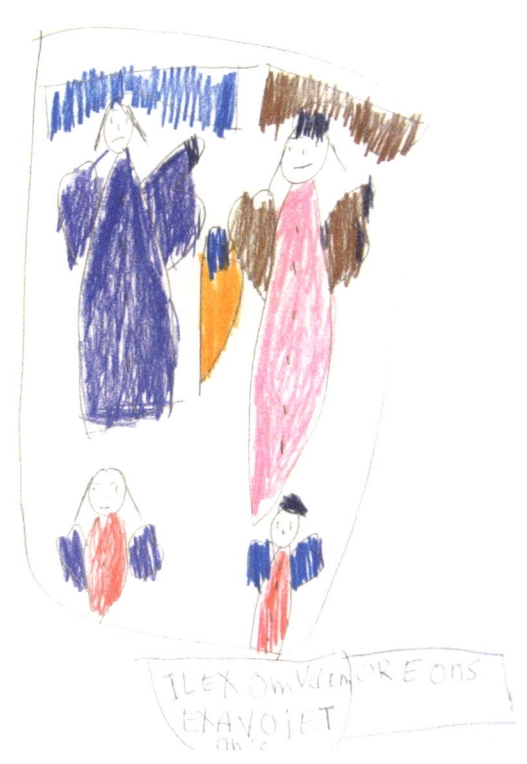

ILEX OmVden OR E ons
EMAVOJET

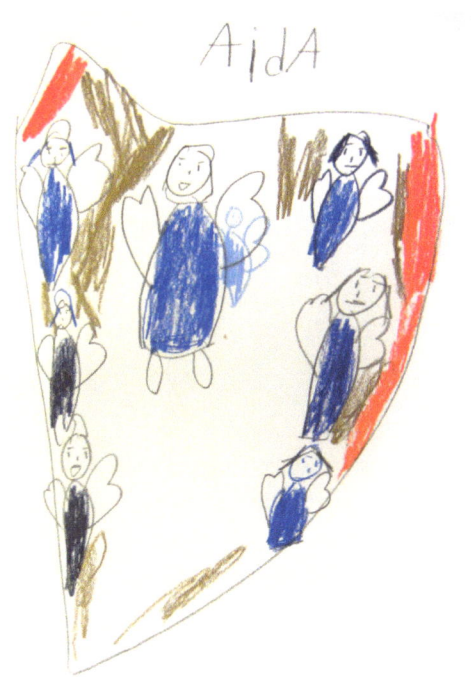

AidA

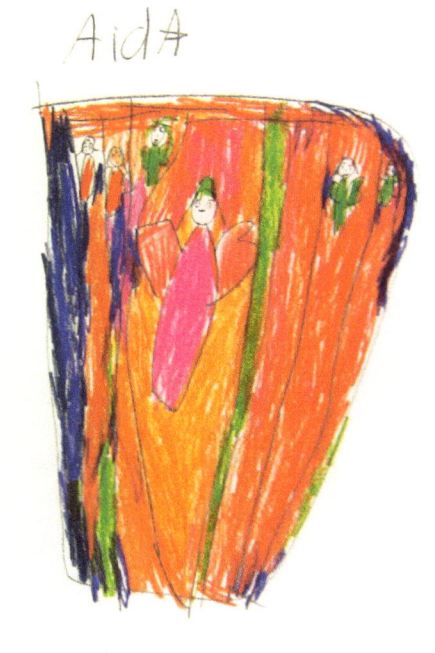

AidA

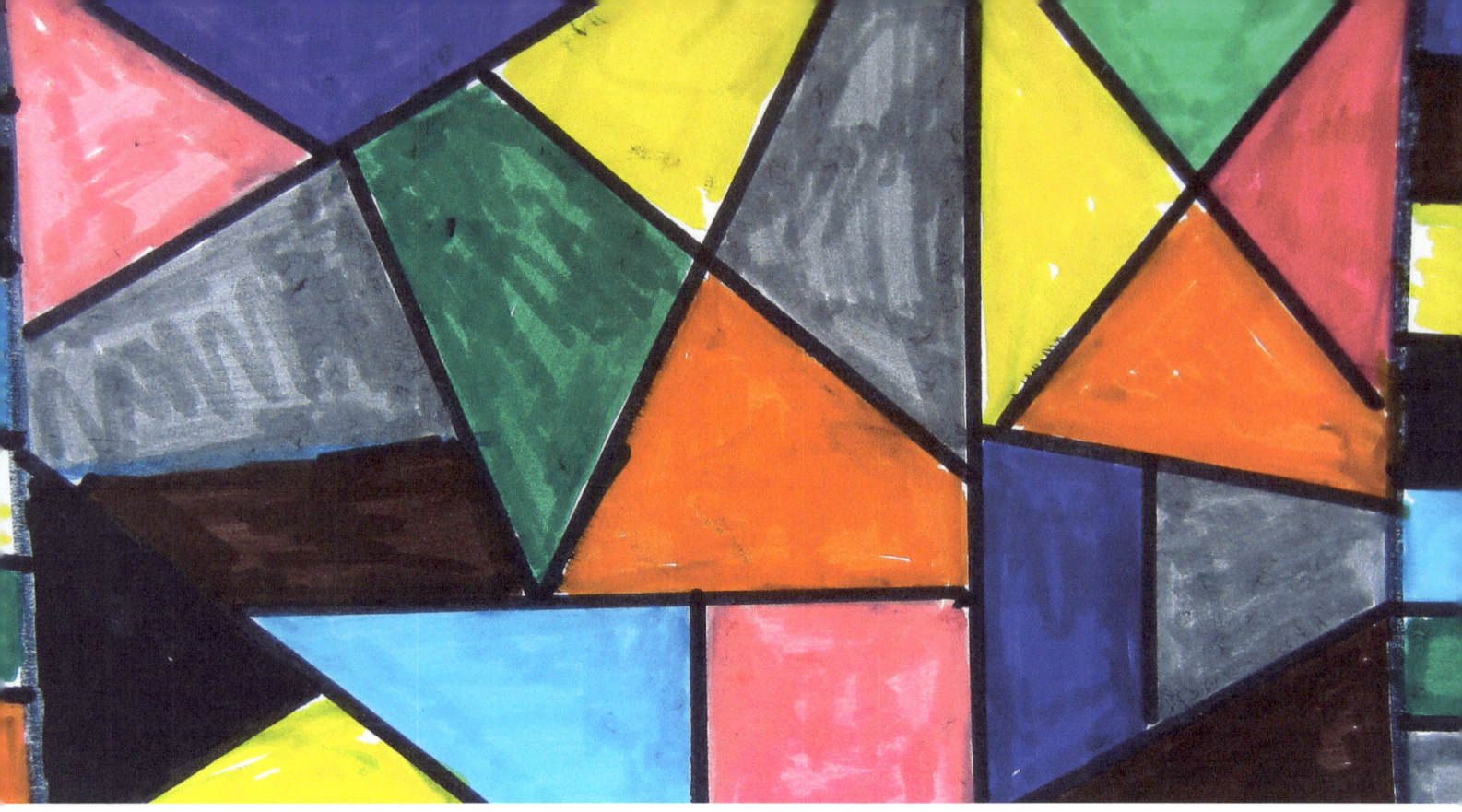

# Alan

Alan delights in the everyday and in the world around him. He celebrates the cyclical nature of the year in the changing of seasons and the calendar of holidays. These become the subjects of his work. He draws ordinary scenes such as city hall, the Bayonne bridge, local schools, trees and playgrounds. Using both words and imagery, Alan makes poem drawings and his own version of crossword puzzles about these subjects. Alan's approach to the different types of art show his sly and playful sense of humor. They examine the different types of art and the idea of what people see as art.

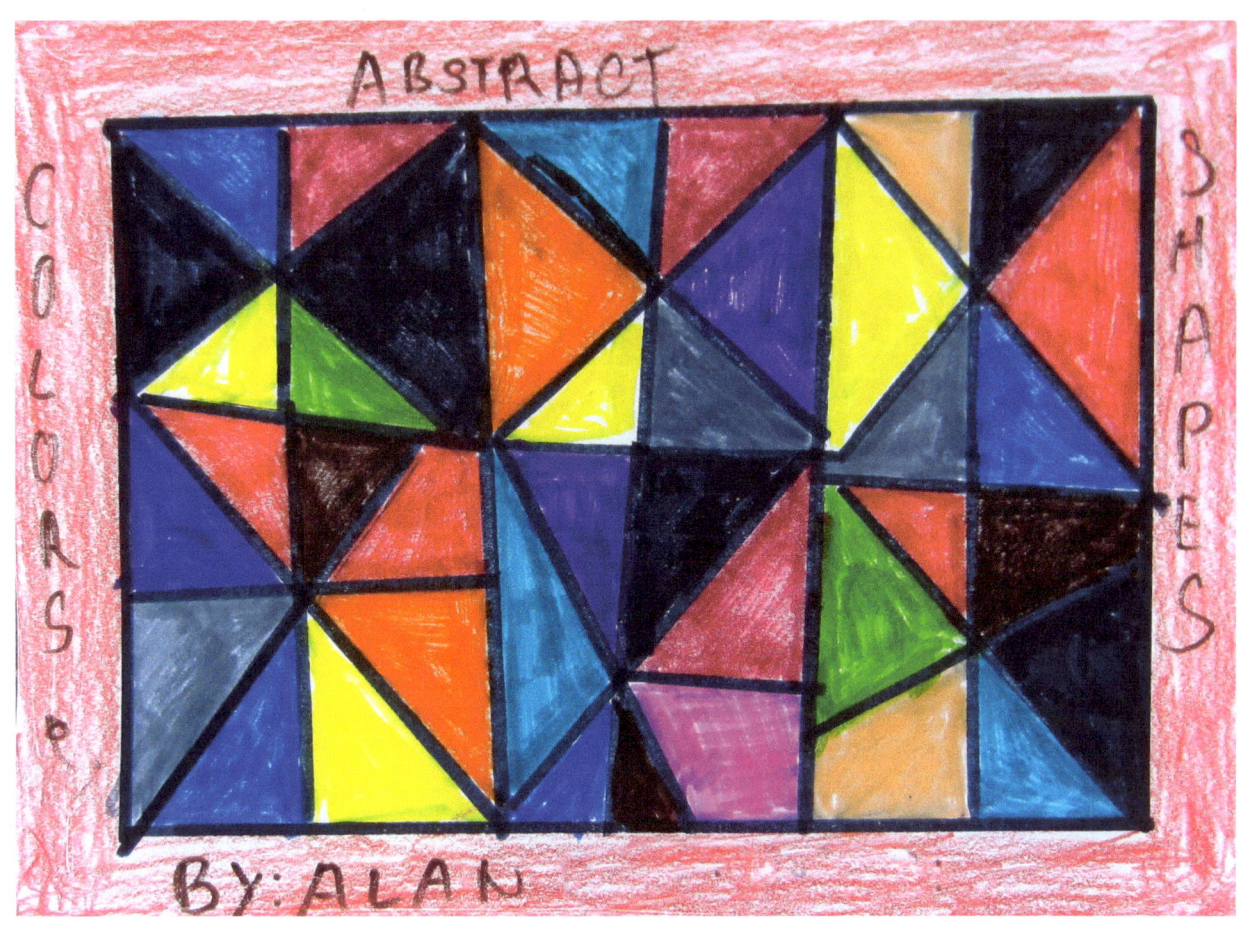

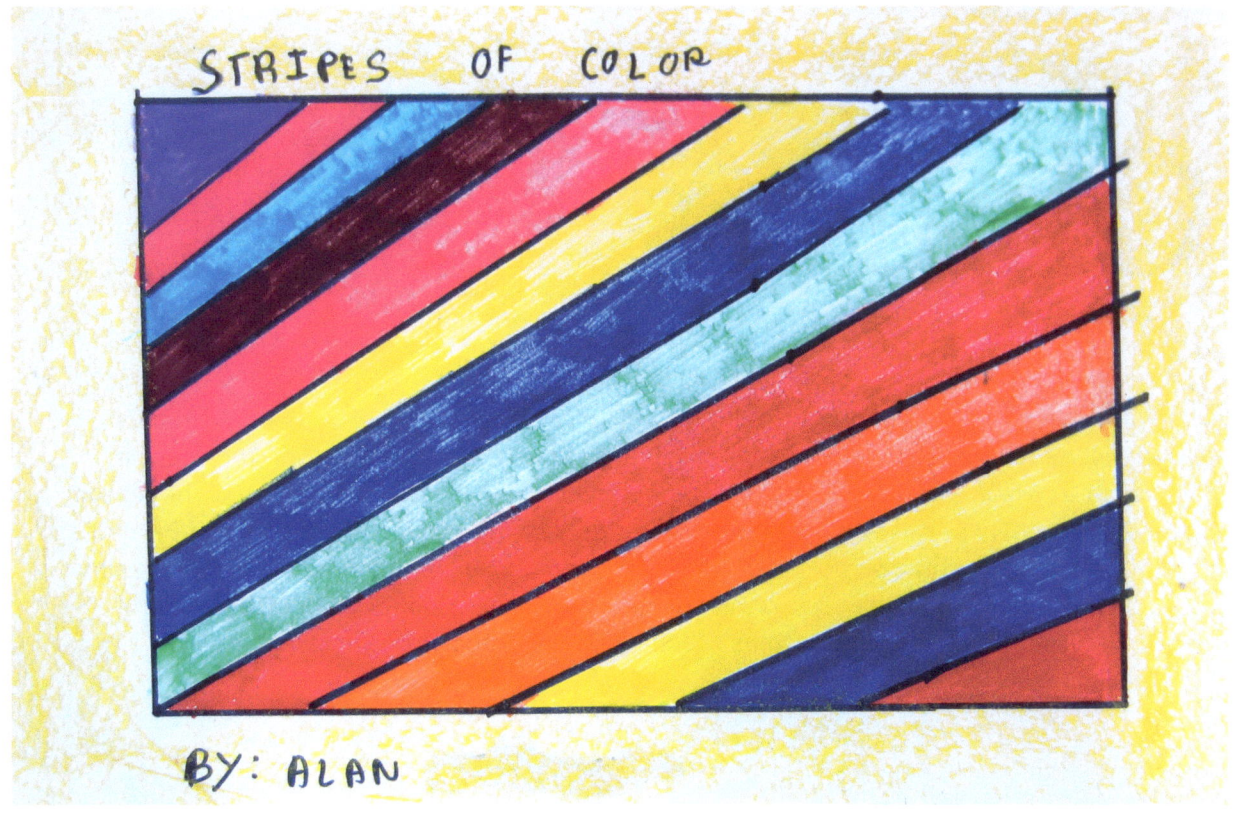

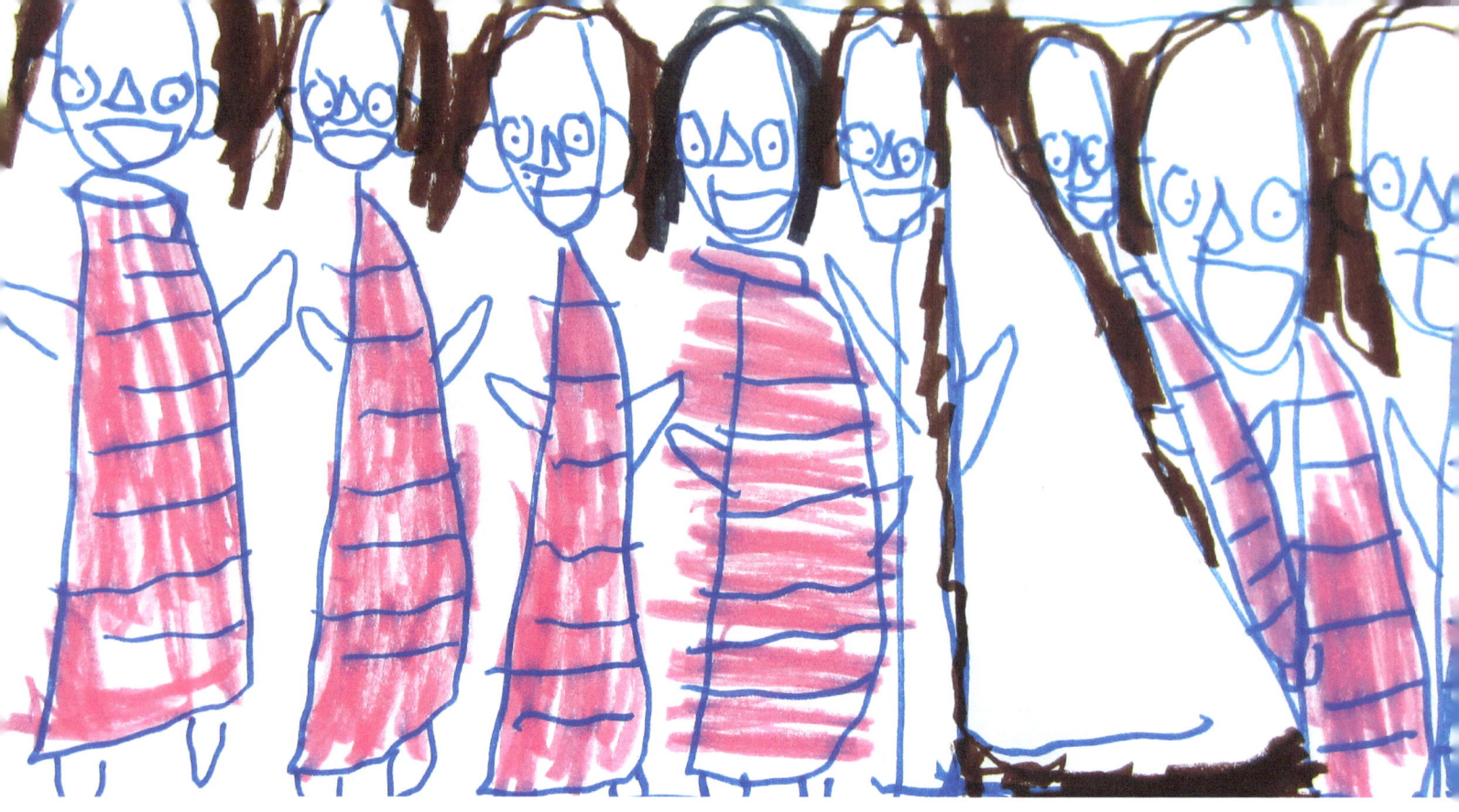

# Charles

Charles will tackle any imagery in his drawing: landscapes, animals, buildings or abstraction, but people are his true subject. He is one of the few of the group who will draw from life. He can look at a person and draw them and he will sometimes make his own version of the artwork that the person next to him is making. He has worked his way through entire books of paintings or fairy tales, creating his own animated versions of each image in which each person or animal has Charles' trademark happy smile. When he has nothing to work from, he will draw many versions of his favorite subjects, such as snowmen or the grape stomping scene from I Love Lucy.

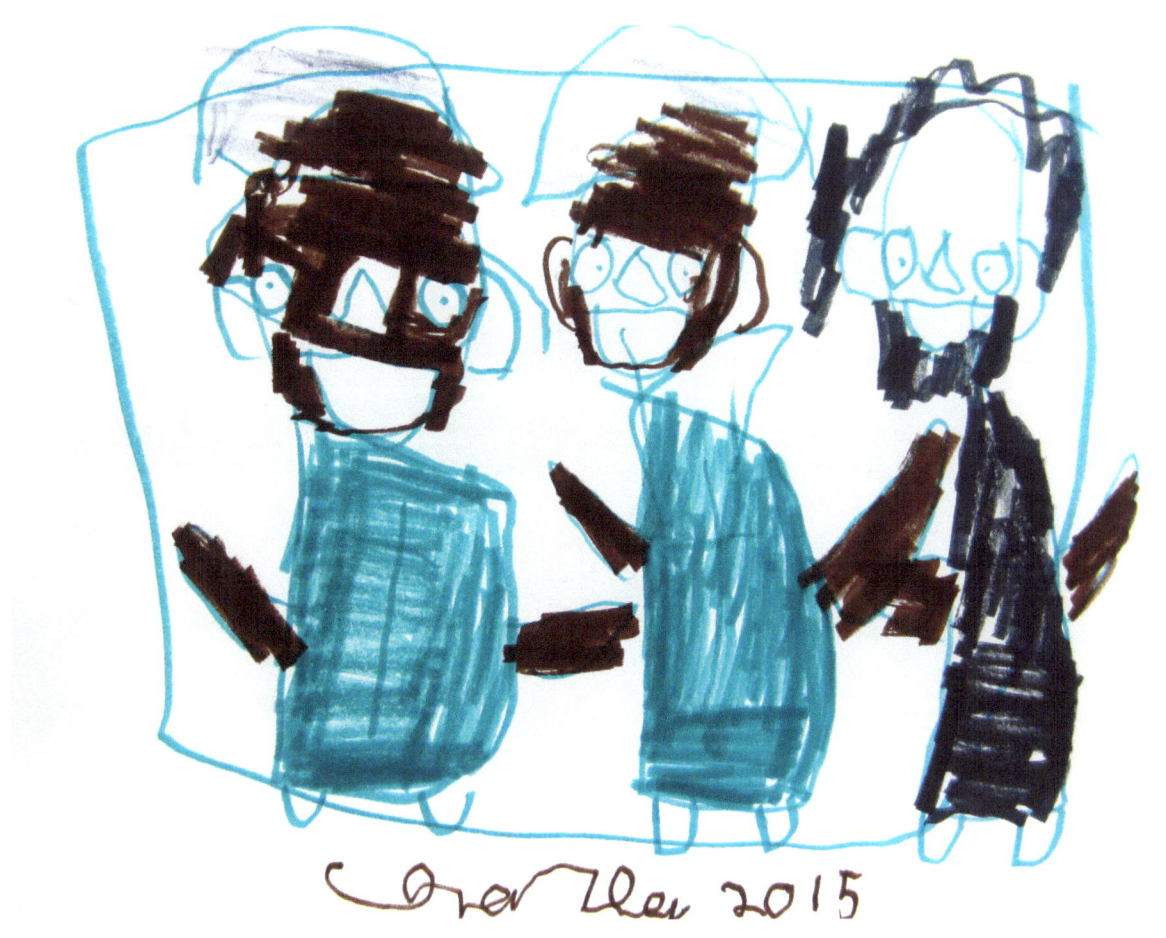
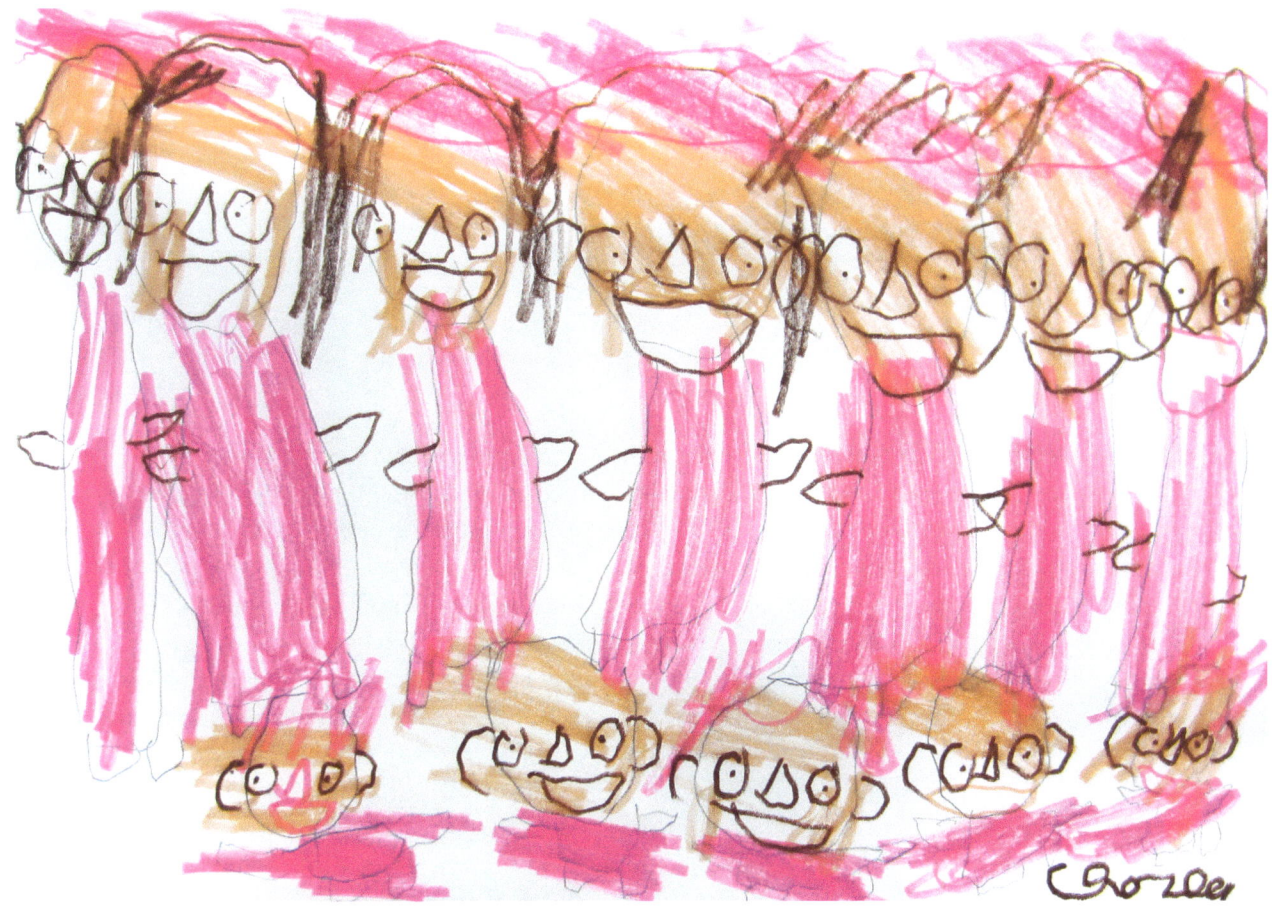

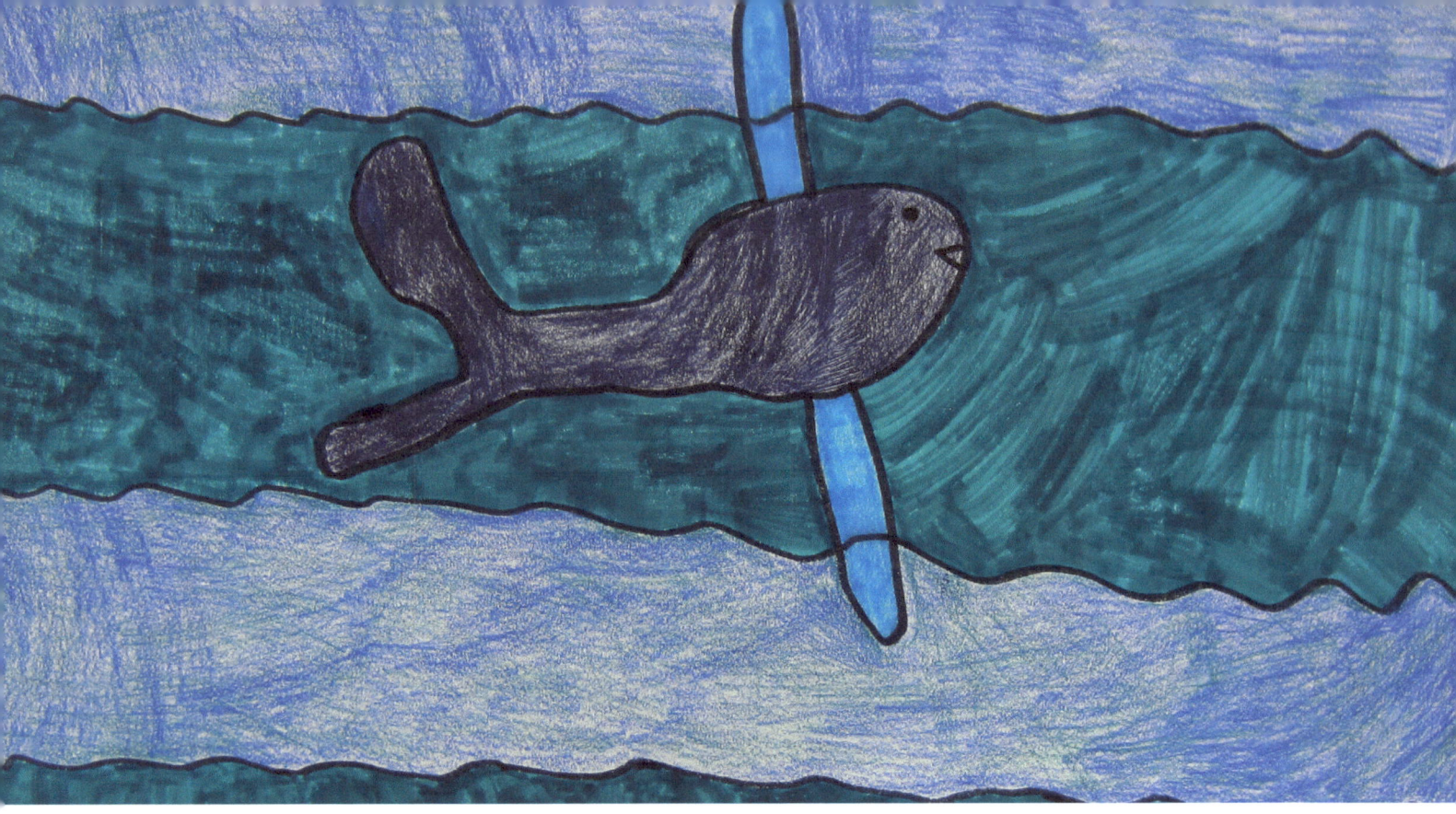

# Cheryl

Cheryl has a strong sense of pattern and sees pattern in nature. Her work has a graphic quality, stylizing the elements of nature. An underwater scene becomes stripes of color, the sky becomes arcs dipping down, the ground becomes a stage for birds or sheep or deer to walk across. Her color is vibrant and saturated. Cheryl will spend time searching through photo books of birds or marine animals before choosing her subject. Then she creates a design in pencil, breaking the scene into horizontal layers and repeating images from the photographs. She outlines the major shapes and then may lightly fill areas with colored pencil before developing more vibrant tones in marker or crayons. Each picture can take two to three sessions to complete.

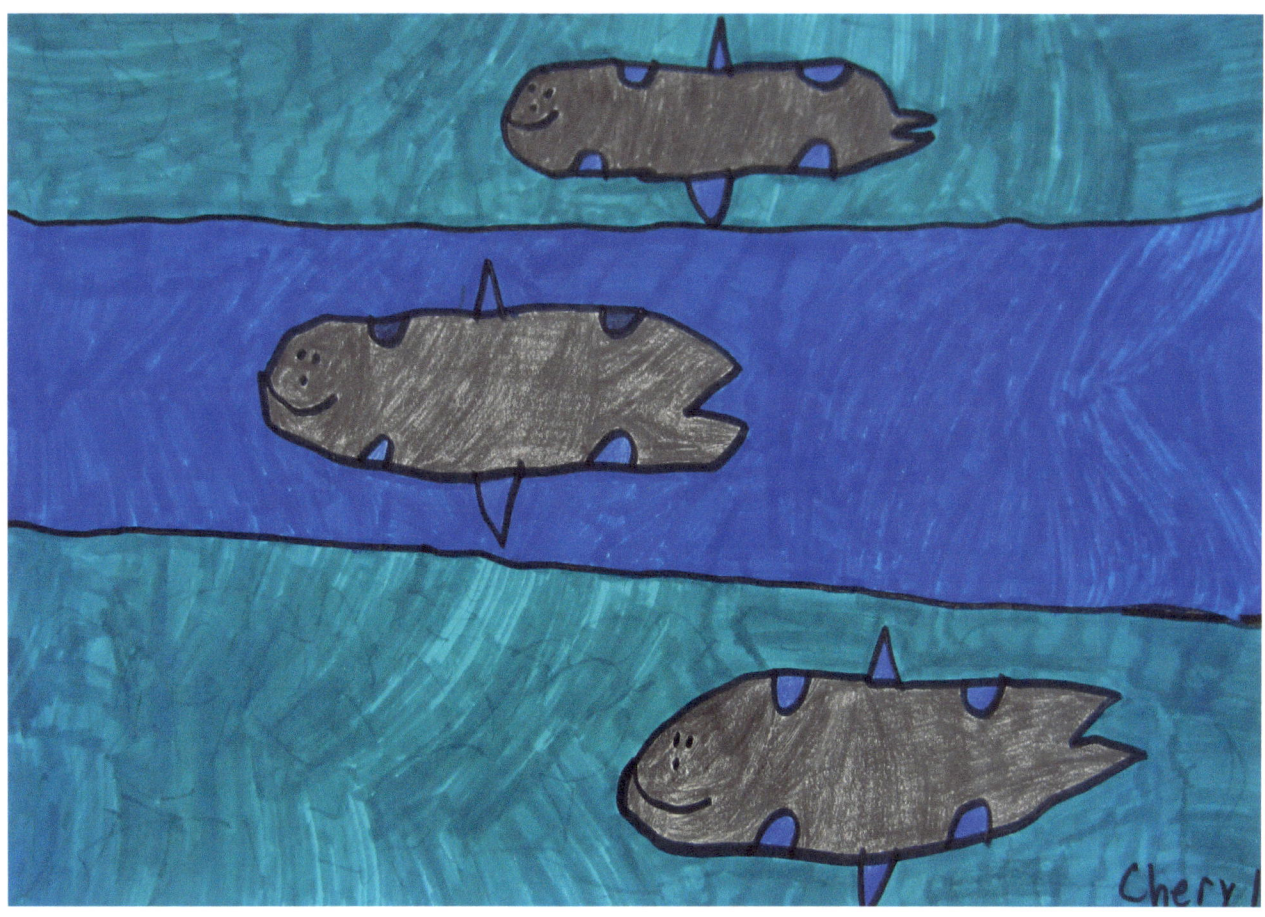

2/16/17
CHRIS

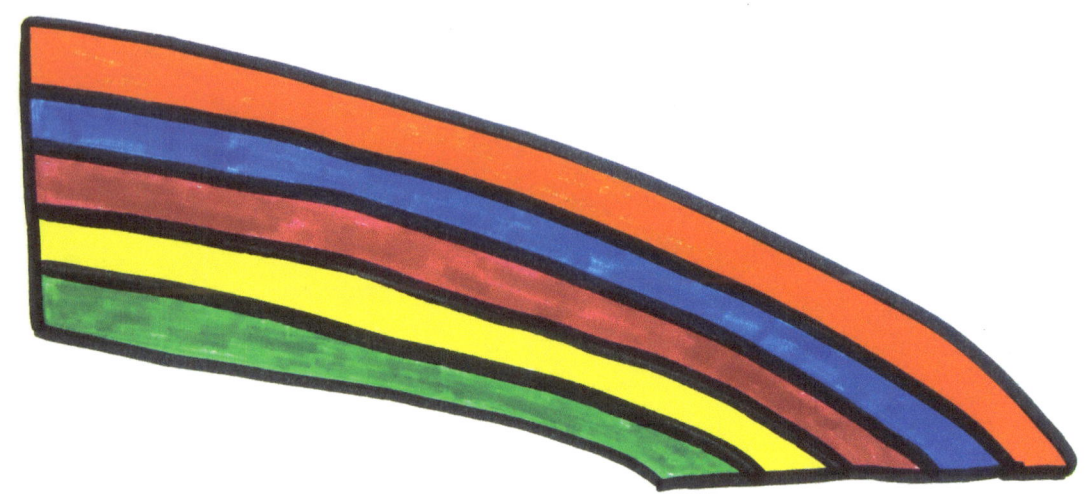

# Christopher

Christopher's work stands out as having a conceptual basis and his imagery is often iconic or symbolic. His images include: the tree of life, a rainbow, a windmill, his precise geometric abstractions, and his word pieces are portraits of alternative personas. He makes pictures in focused flashes of concentration, standing at the table and creating distilled and precise images. Christopher creates absolute expressions of order and organization out of the river of words and thoughts of his very active mind. It was Christopher who named the program Rainbow Thursdays.

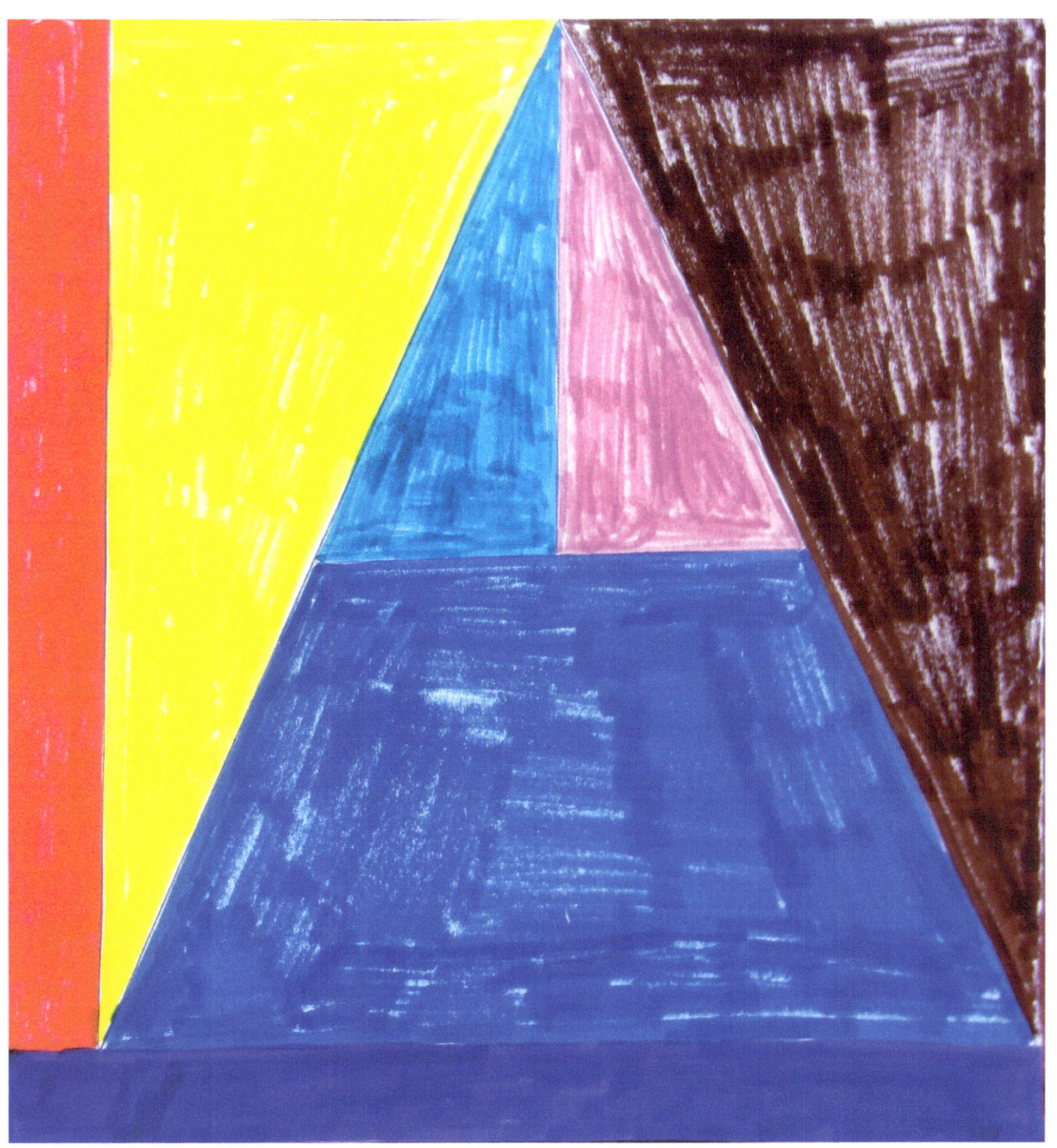

Casey Aldrich
6/21/72

He can hold a steady
job without having
any problems.

I'm moving out
Thursday morning.

WHERE DOES HE WORK?
Mike's Auto Repair.

6/21/72
CASEY ALDRICH

8½ shoe
Casey Aldrich
5'7"  31"

(Casey Ian)
Casey Aldrich

10:12 A.M.
6/21/72
Casey Aldrich

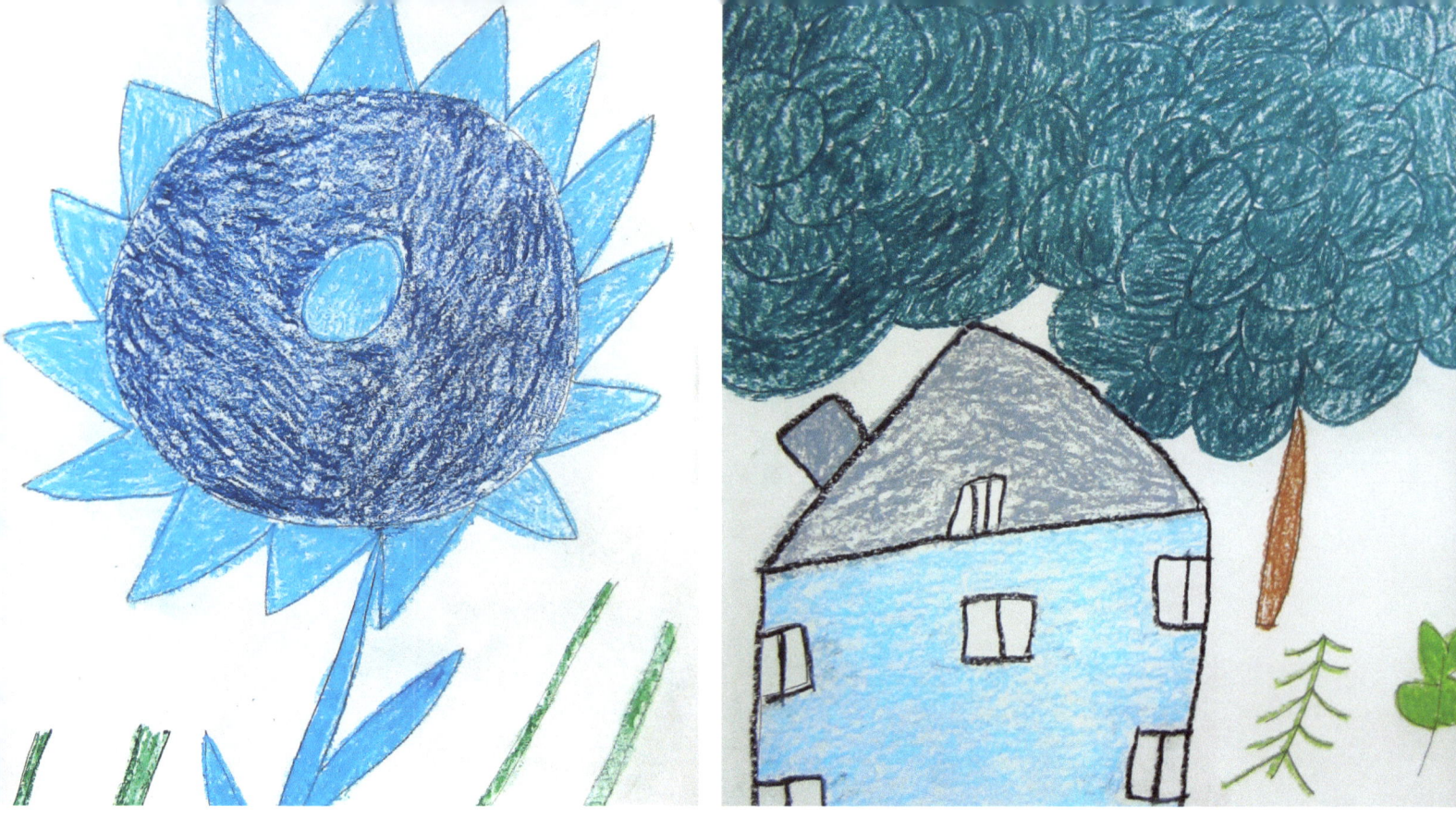

# Debbie

Debbie has worked from paintings by modernist painters such as Van Gogh, Cezanne and Matisse, and American scene painters Thomas Hart Benton and Grant Wood, as well as from animal drawings or photos. She has a way of making all of these images part of her own unique world, simplifying forms and rearranging spatial compositions. Debbie brings her direct, thoughtful sense of order and gentle sense of color to all she does. Most recently, she has been working from Aboriginal designs, recreating their geometric forms in earth tones.

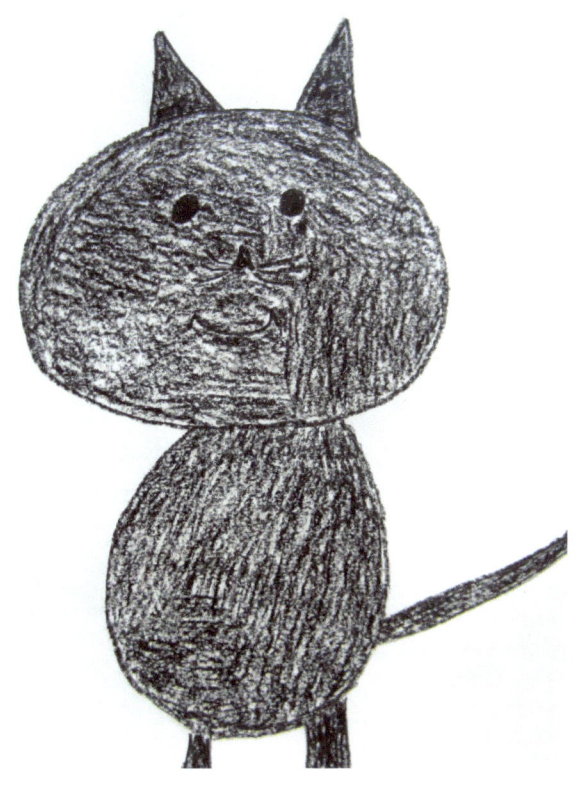
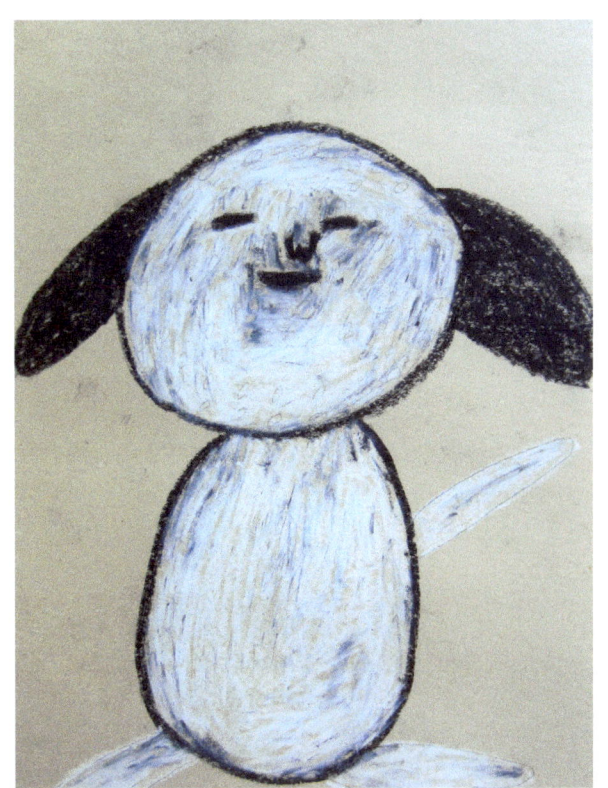
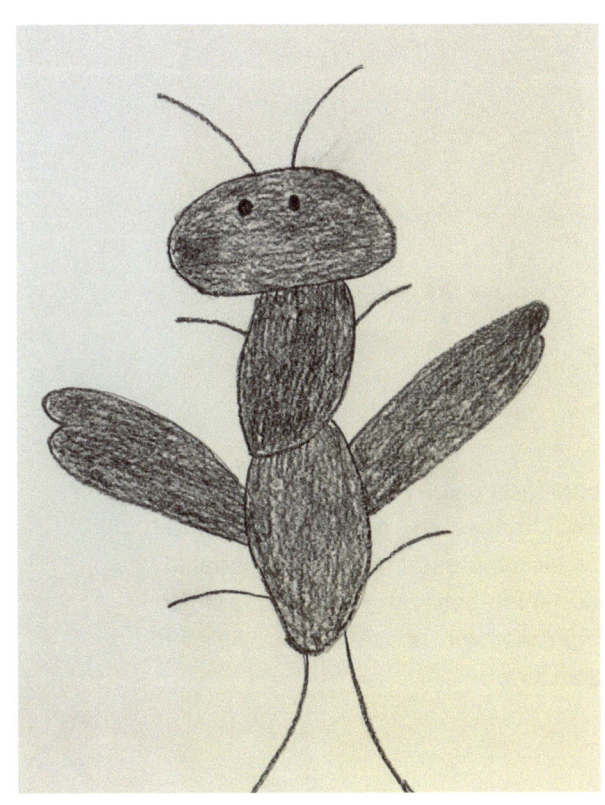
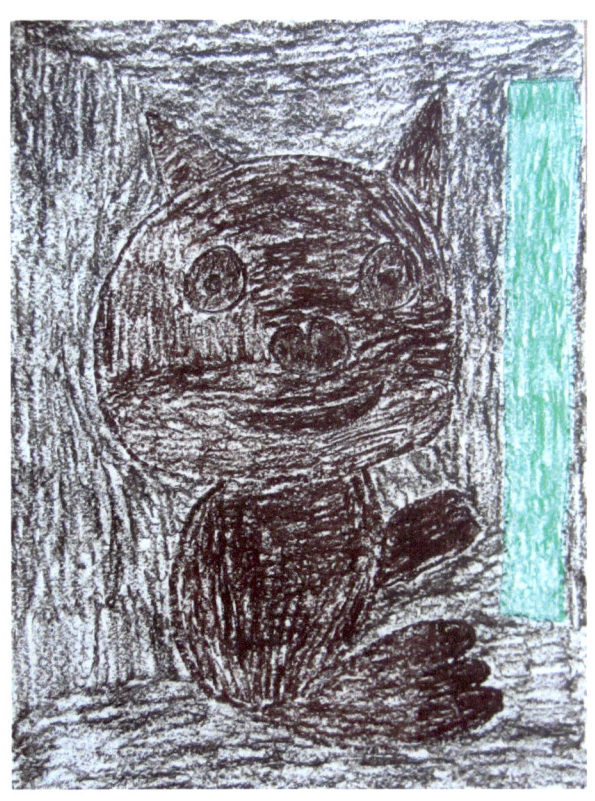

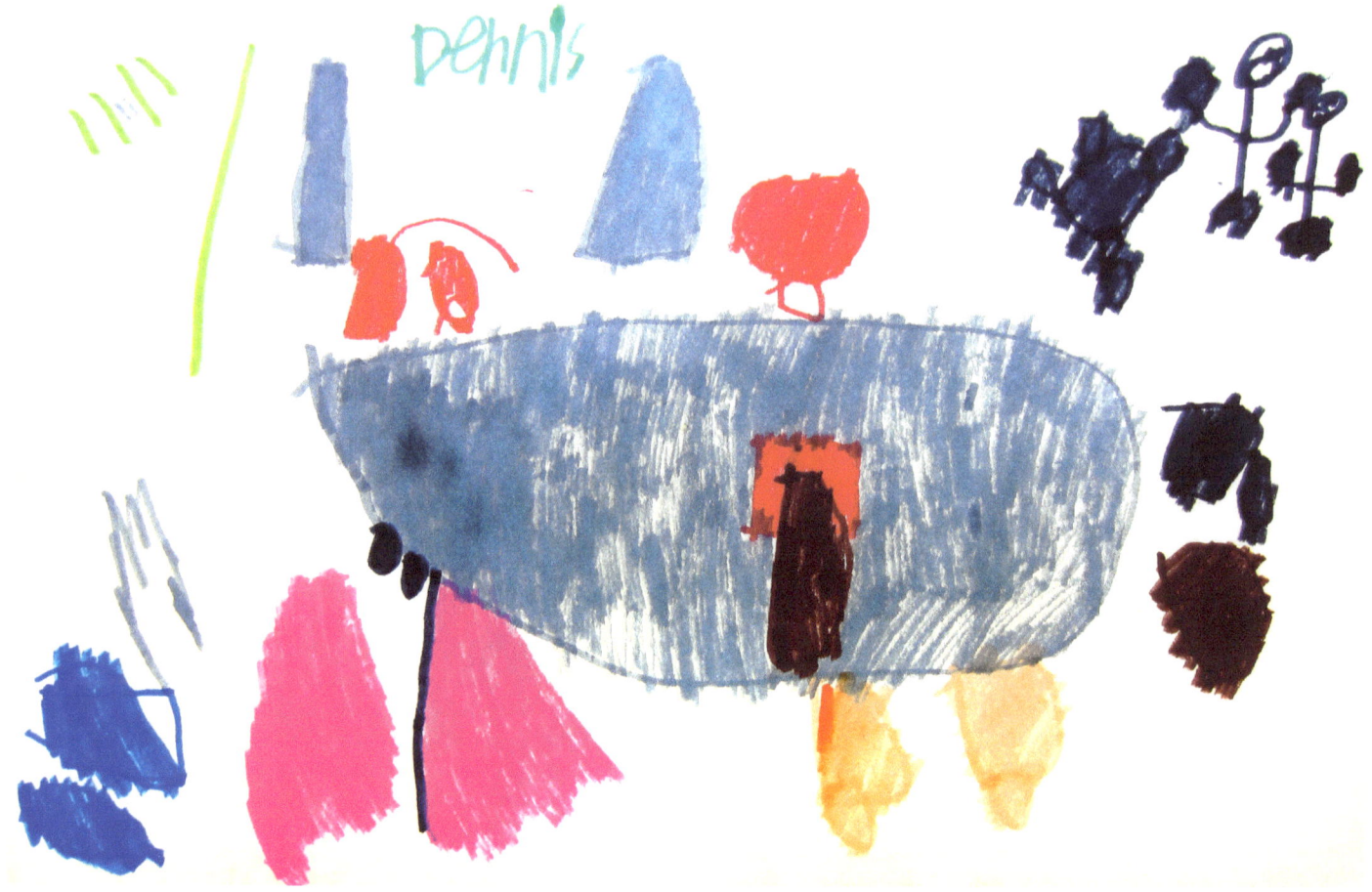

# Dennis

Dennis works very quietly and will spend time studying the pictures given to him to draw. Sometimes he will take aspects that interest him from different images and combine them into his drawing. Dennis seems to like drawing from current outdoor pictures of helicopters, boats, bridges, mountains, whales, buildings, trees and finds relationships between forms and colors. He builds a picture by outlining major shapes and developing mass with a careful accumulation of color marks, adding on details or figures with a deft graphic touch.

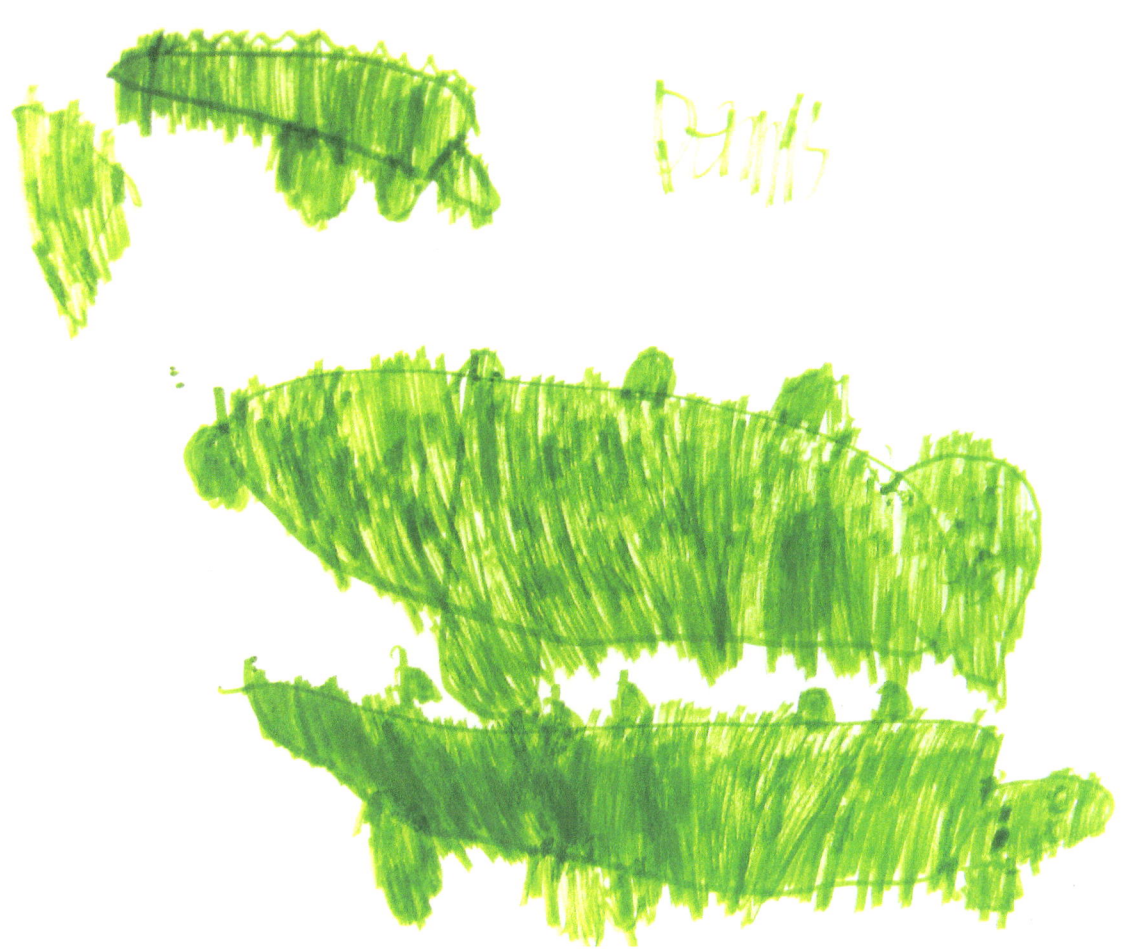
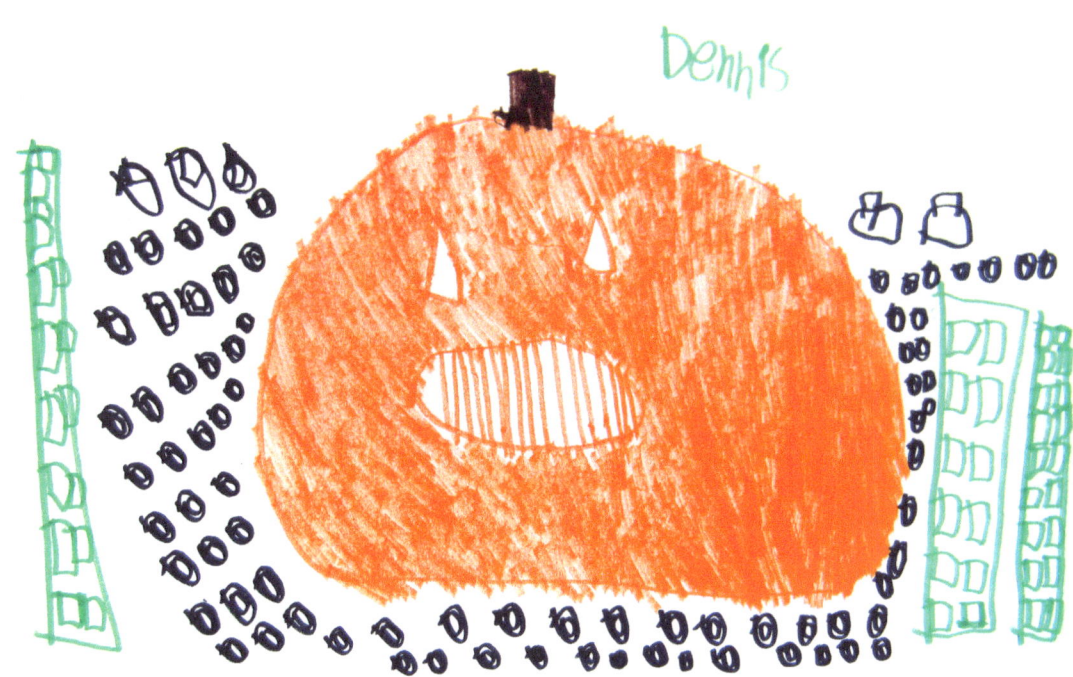

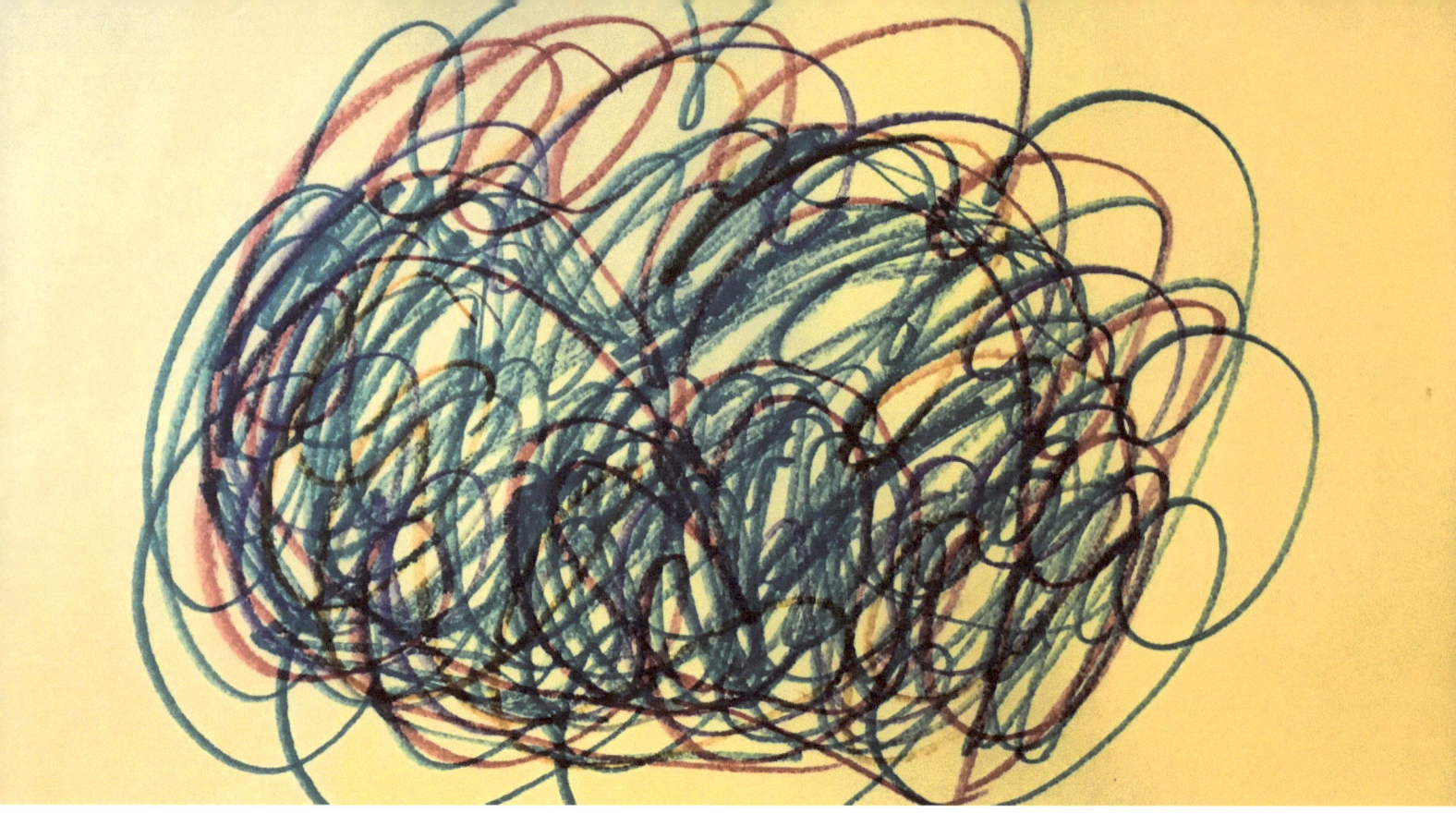

# Dina

Dina's work is very gestural and almost kinetic. She draws very quickly and actively and can produce many drawings at a sitting. Her subjects are often hearts, flowers and seasonal themes, such as Christmas trees and Easter baskets, or snowmen drawn from her imagination. She turns these into designs that she can repeat over and over, and she is starting to put her designs on all kinds of objects, such as aprons or t-shirts, that people can use. Dina is a people-person and being with people makes her happy.

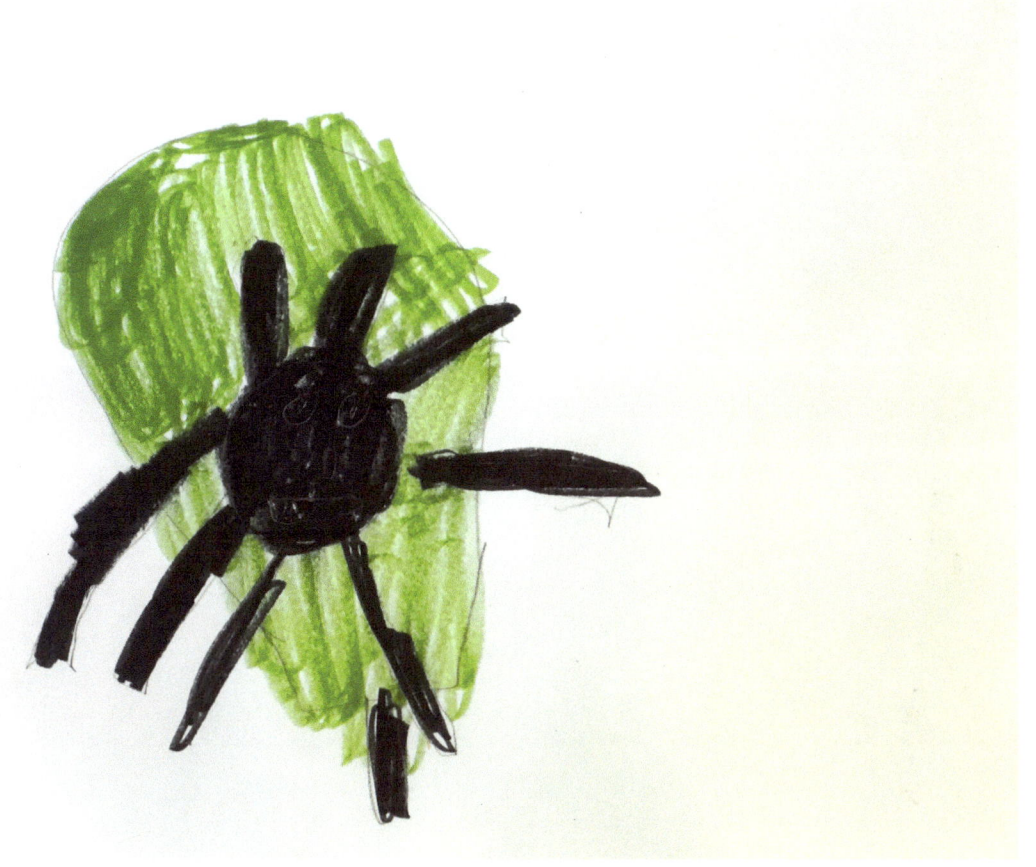
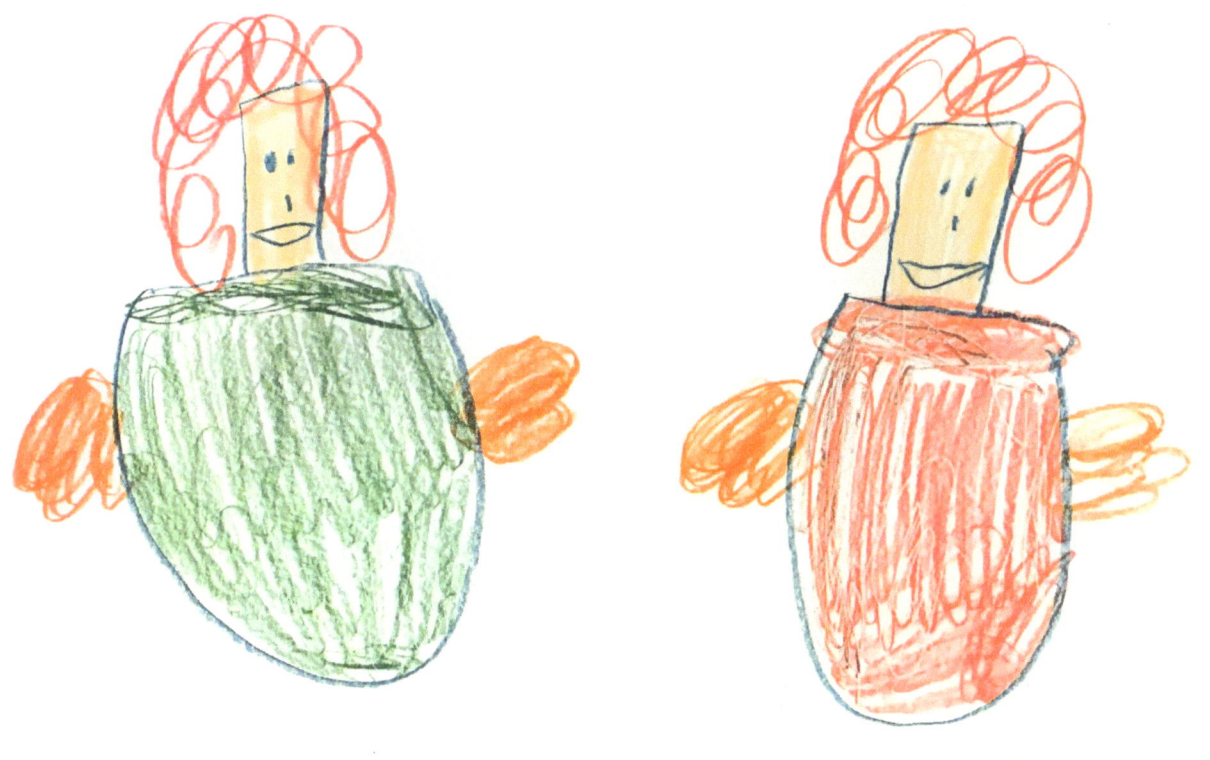

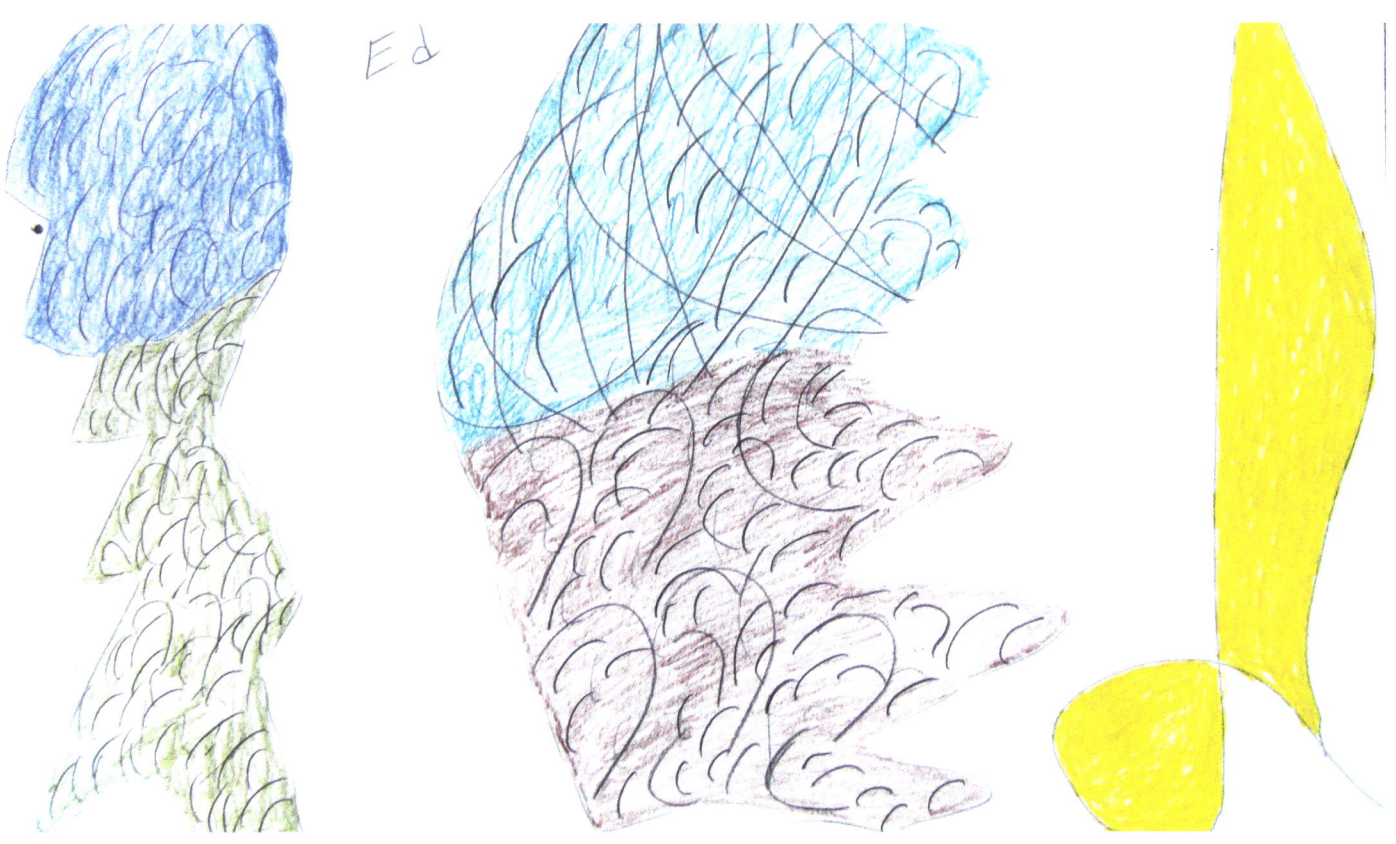

# Ed

Ed's artwork has become a vast array of images and shapes, some drawn from his mind and others from photographs or his response to books on African or Aboriginal art. In some pictures, he will use a ruler to create color structures, in others he employs his curving line to create balanced, asymmetrical forms. Ed's masterful build-up of marks and linear colors and textures energize the surface of all his pictures. The colors are never flat and never solid. The white spaces peeking through his lines make the creatures of his drawings shimmer with a life of their own.

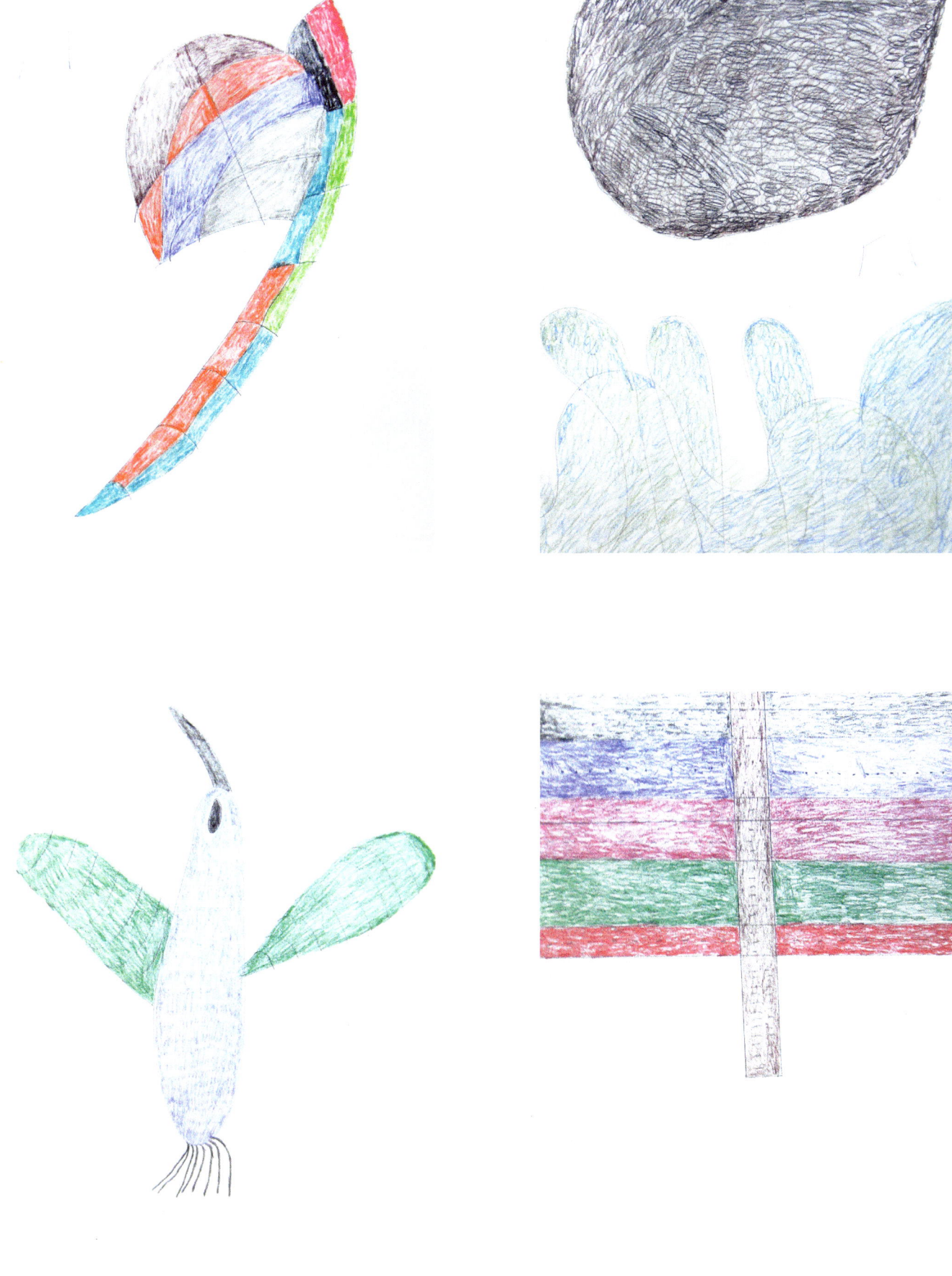

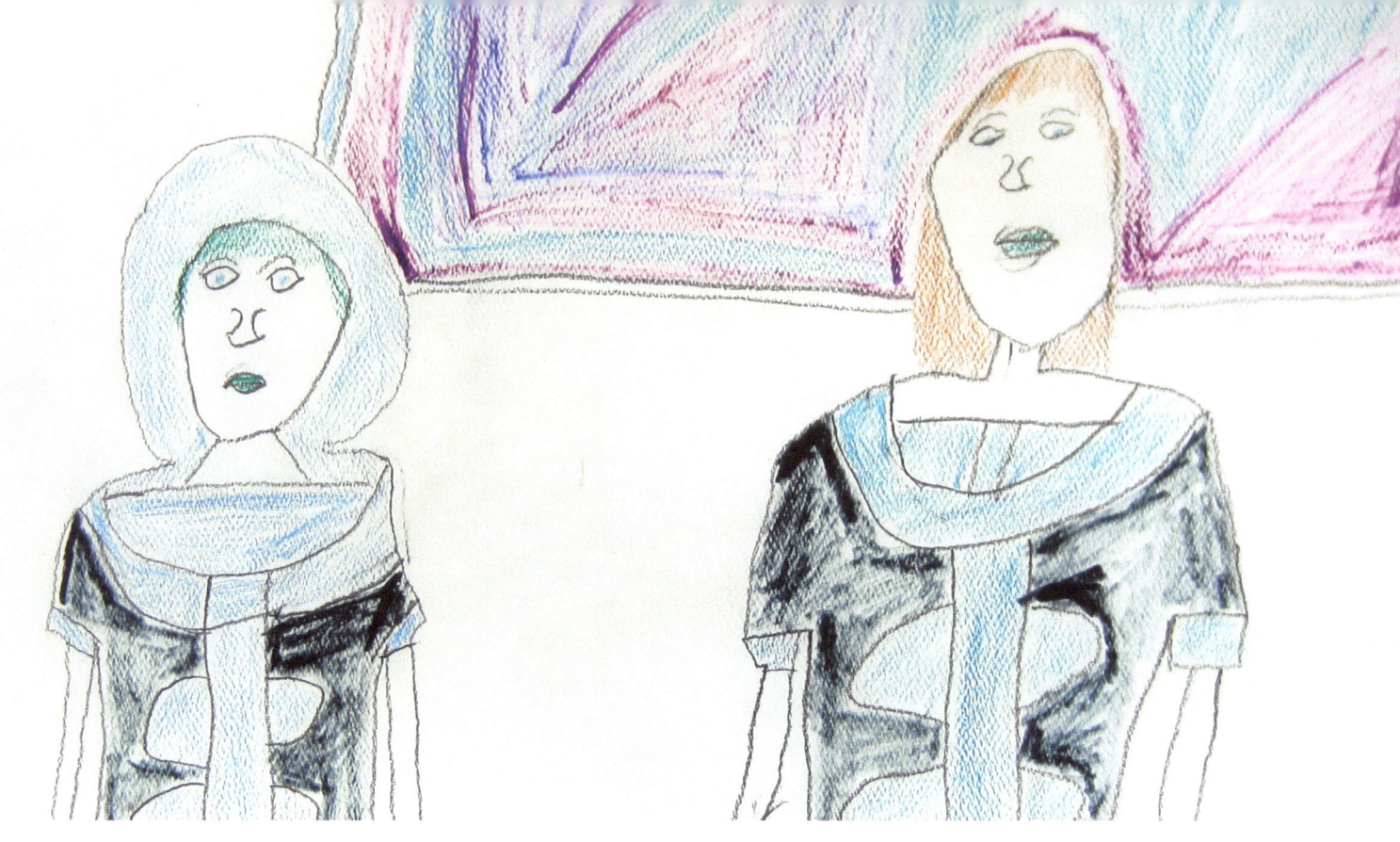

# Eric

Eric works hard at learning to translate what he sees into the proportion, line and form of drawing. He likes to draw from books of paintings or photos of his favorite television stars, and strives to get a good likeness. His work is animated by a delicate sense of line and gesture and is notable for its liveliness and great attention to detail. Eric recently completed a drawing series celebrating every major character in the TV show Full House, along with a picture of the Golden Gate Bridge from the opening credits.

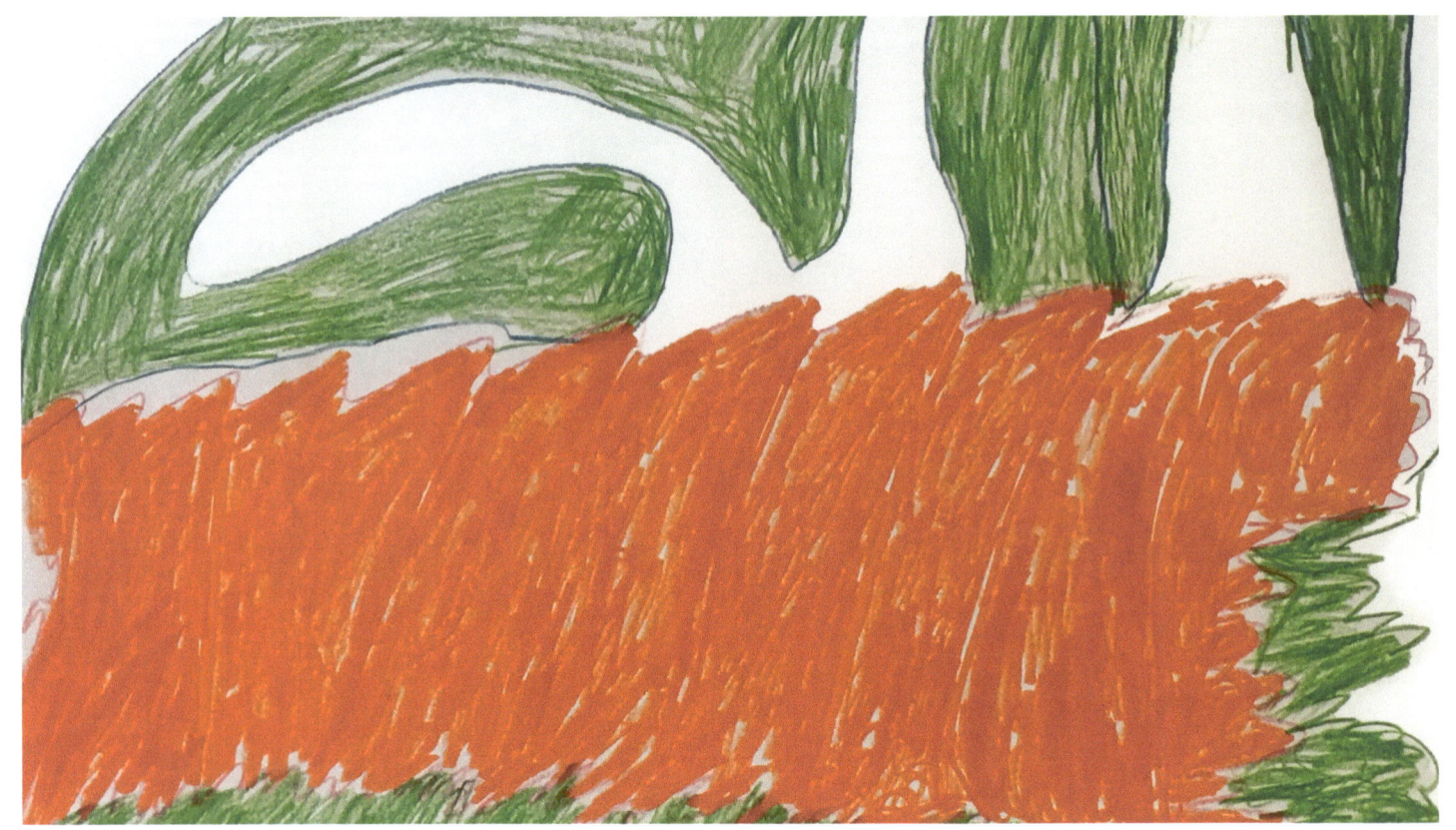

# Eugene

Eugene has an innate sense of color and form. His brilliant shapes of pure color seem to come entirely from within and do not obviously refer to anything he is looking at. He responds to art-making in a completely abstract way, always creating new designs and imagery. His intuitive understanding of these aspects is similar that of early 20th century artists, such as Matisse.

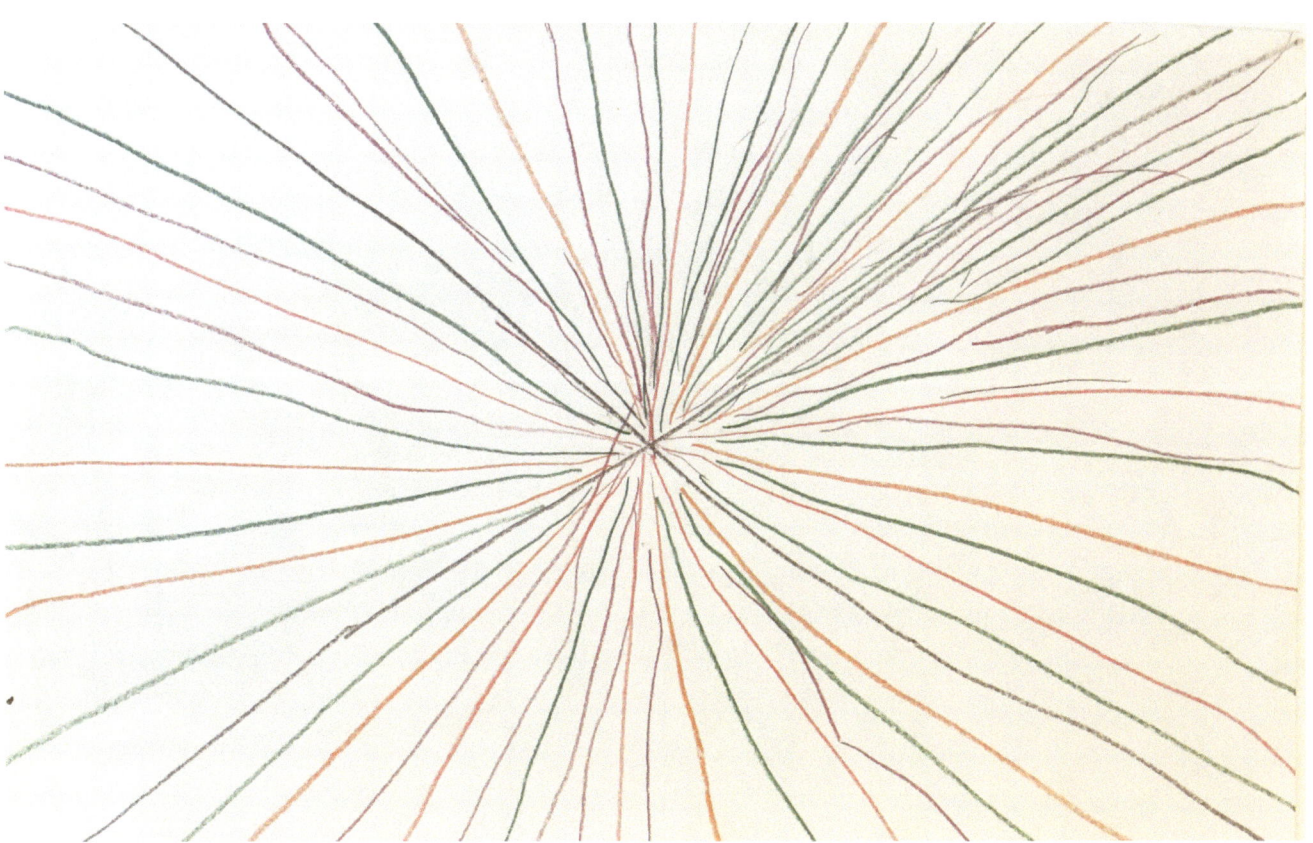

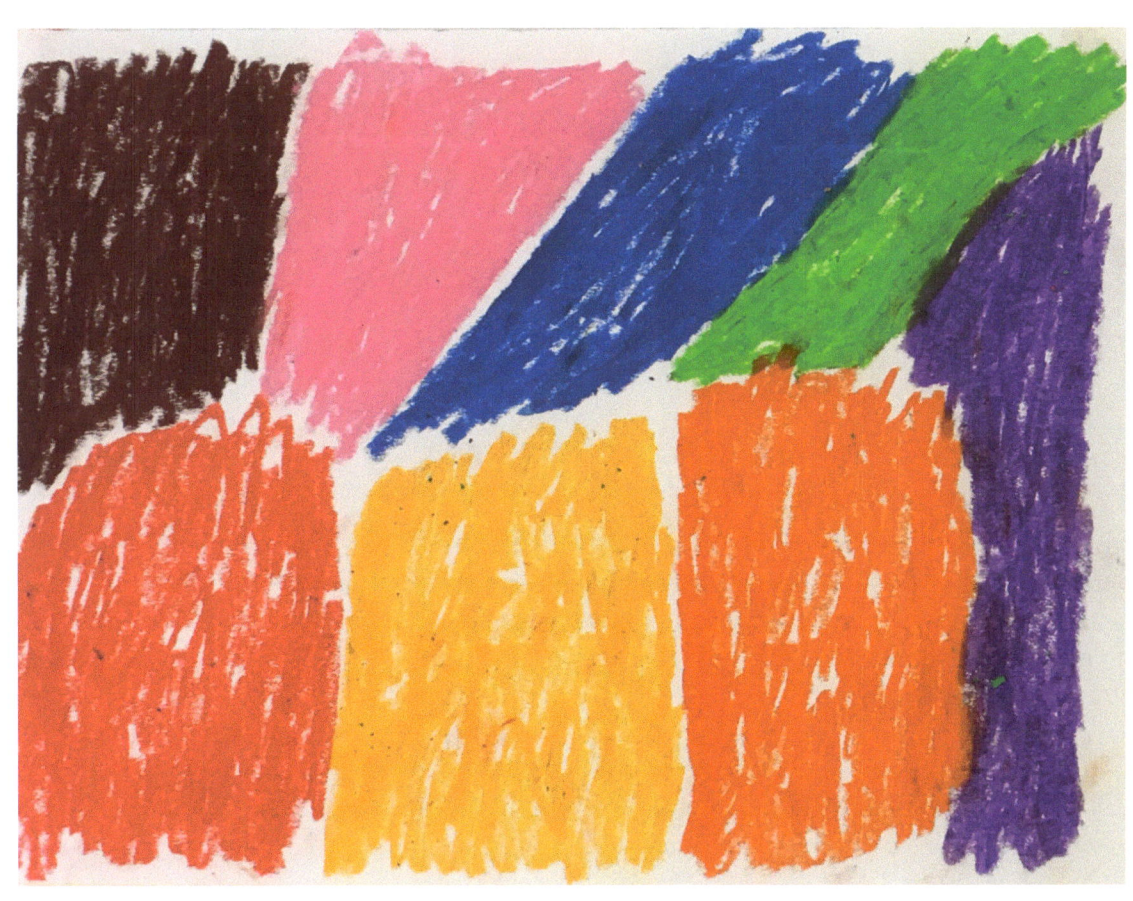

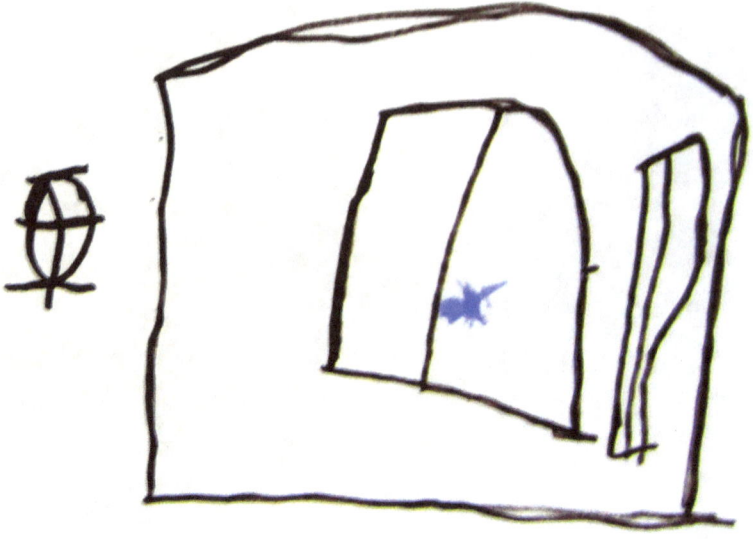

# Hirra

Hirra's drawings engage writing and symbol-making, and remind one of hieroglyphs. The vocabulary of her works includes tents, churches, houses and people, with crosses scattered everywhere. In her works she is working towards developing a sense of structure, and like a quiet graffiti artist, she wants to express what is on her mind.

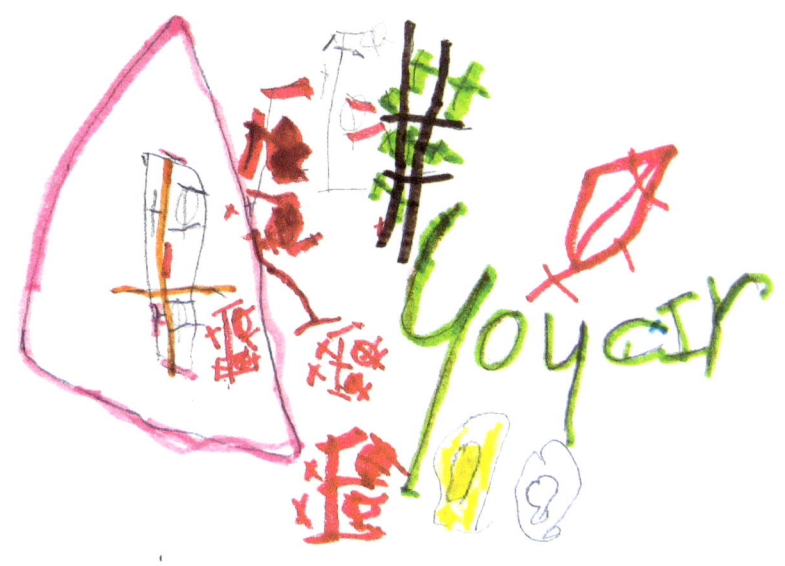
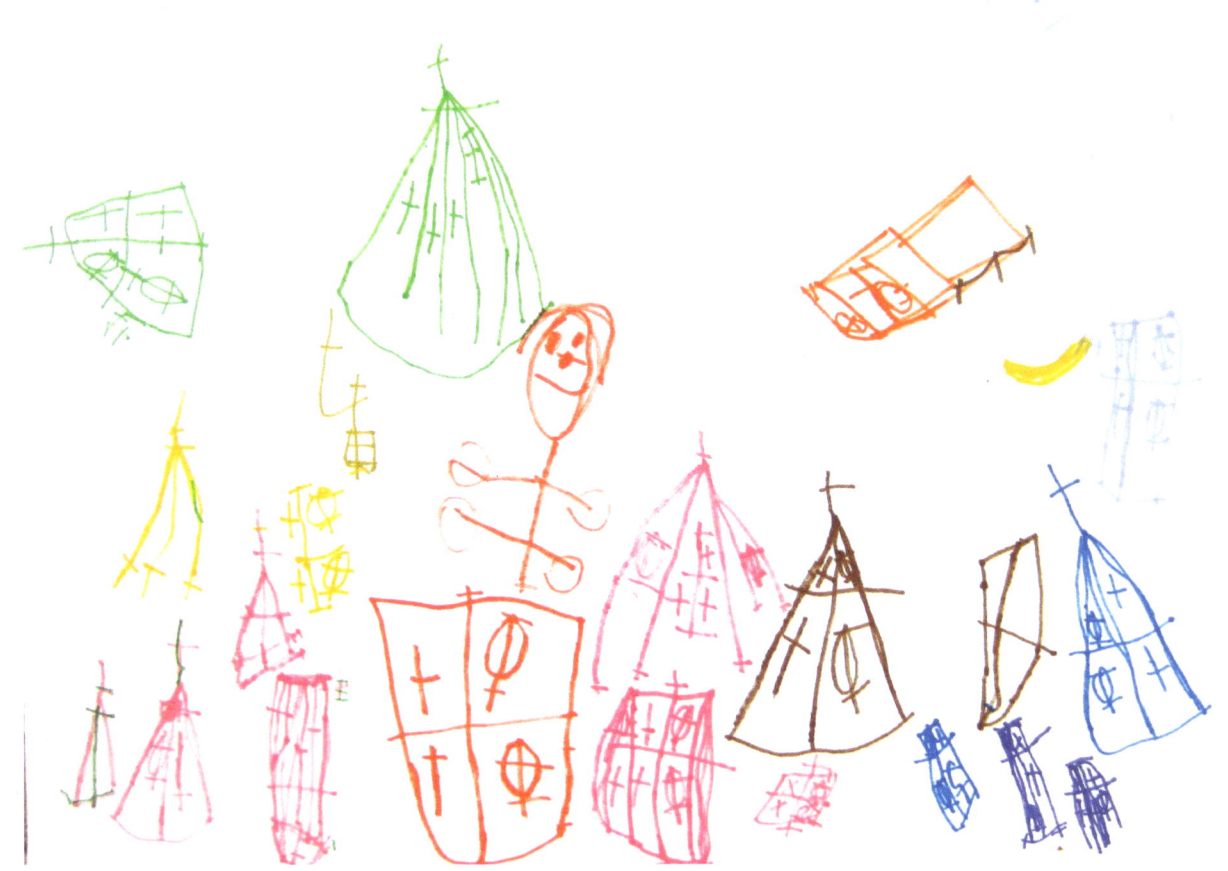

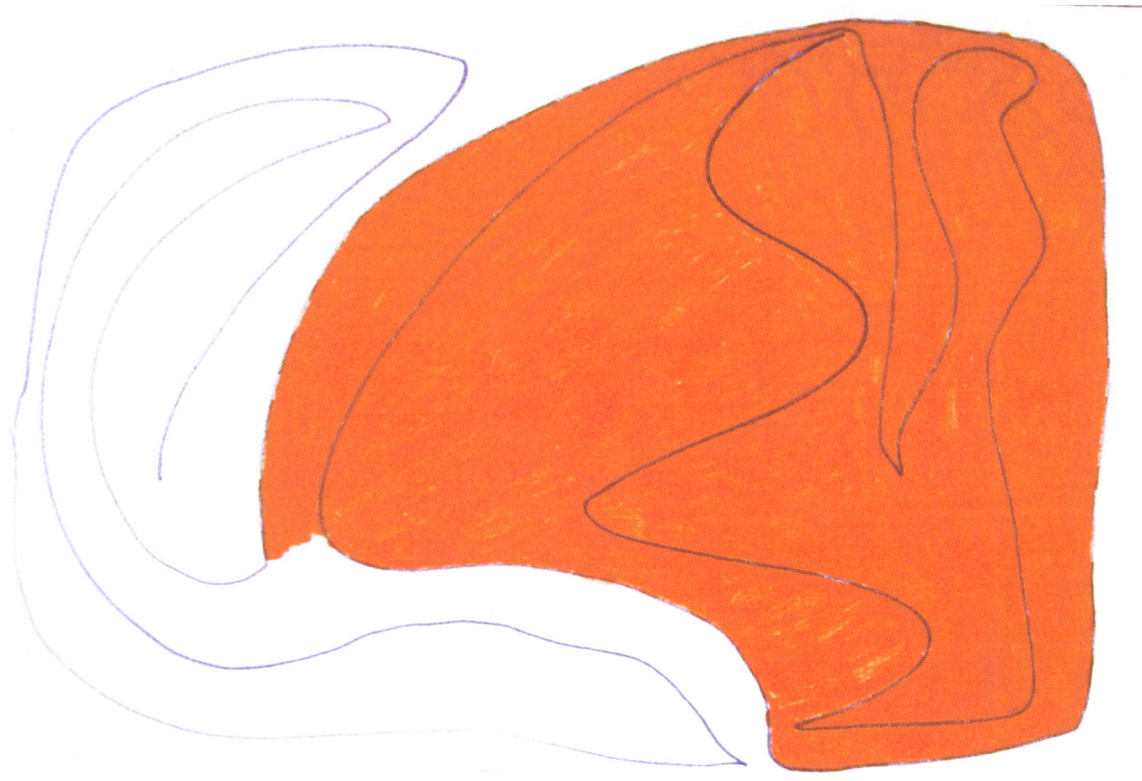

# Jimmy

Jimmy draws with a very consistent formula. First he makes smooth, looping lines as if they were drawn while listening to music. These are always done in one color, often, but not always, purple or blue. Next, he starts a slow process of filling in color, usually one specific color, that he will use for a series of several drawings, The group shown here is his orange series. There is also a red series and a crimson series. Jimmy always draws with markers. He never intends on completely filling the forms with color. The point at which he stops and knows that they are done leaves a strong positive/negative balance within the work. The color and white areas switch back and forth as to which dominates the composition. Jimmy's art has a beautiful, lyric sense of form.

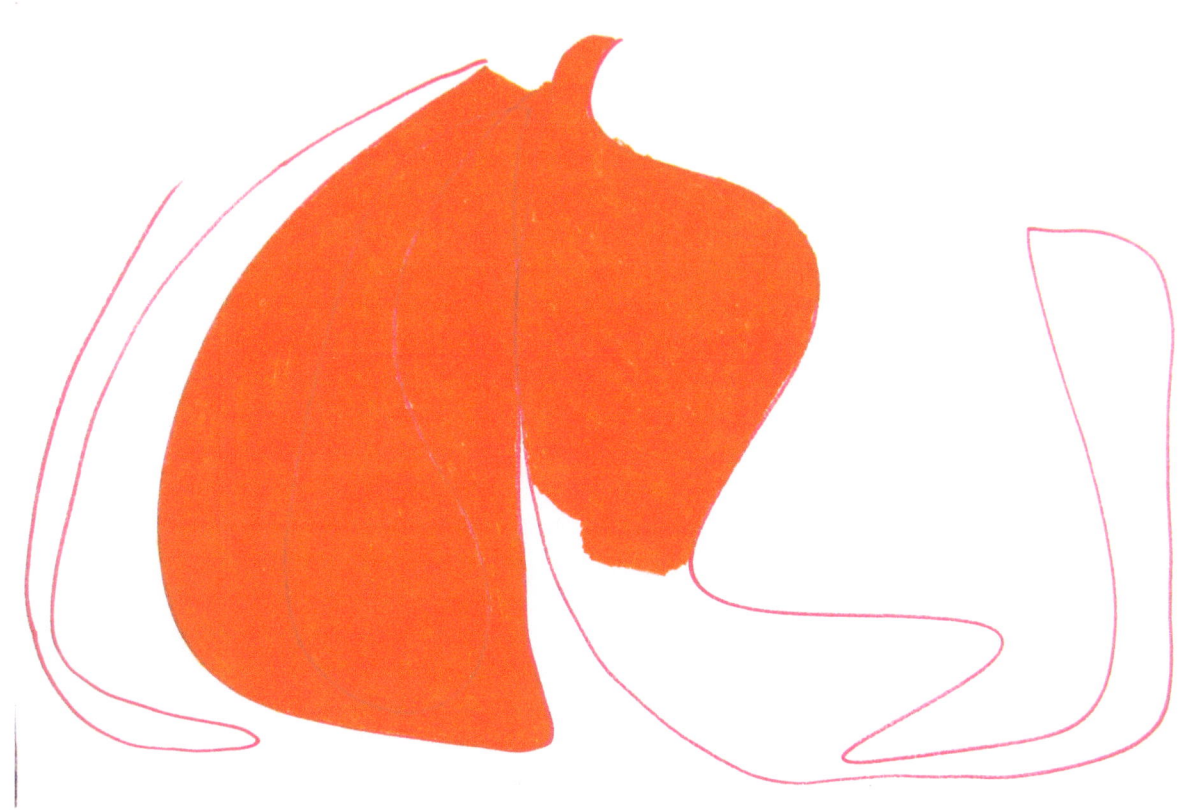
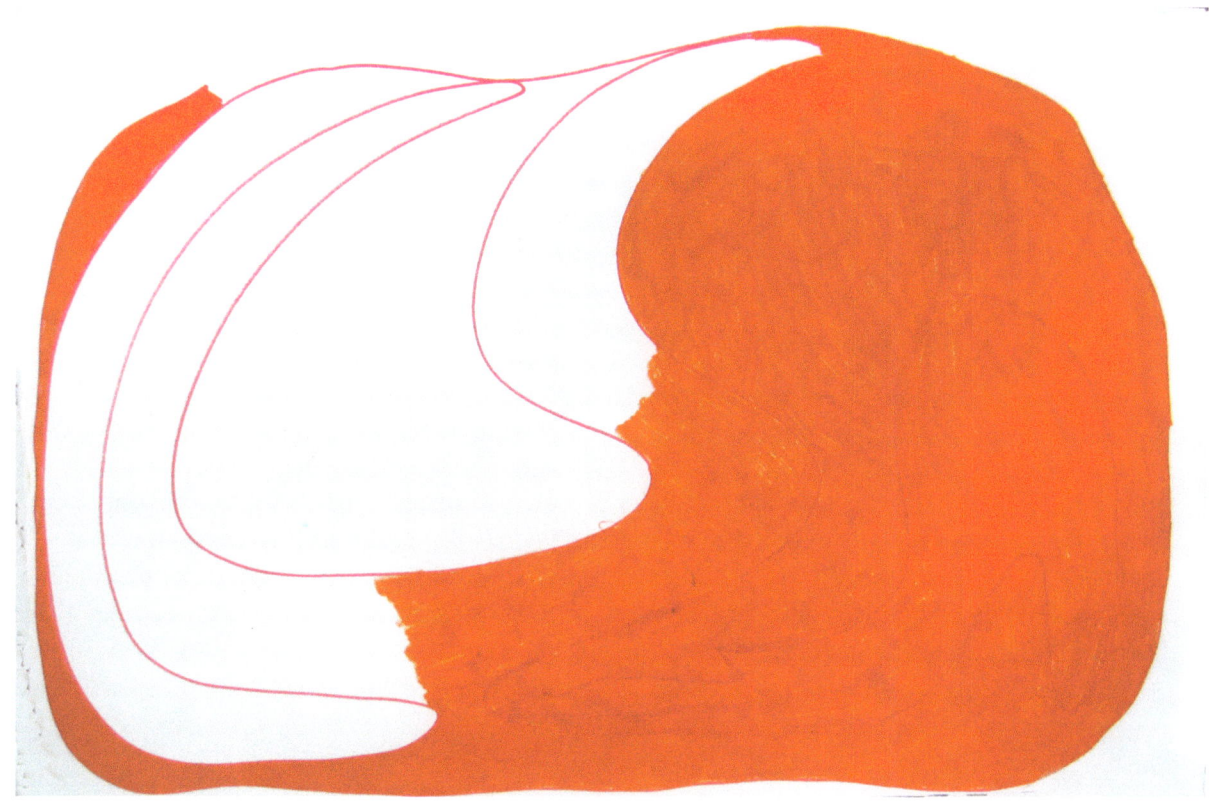

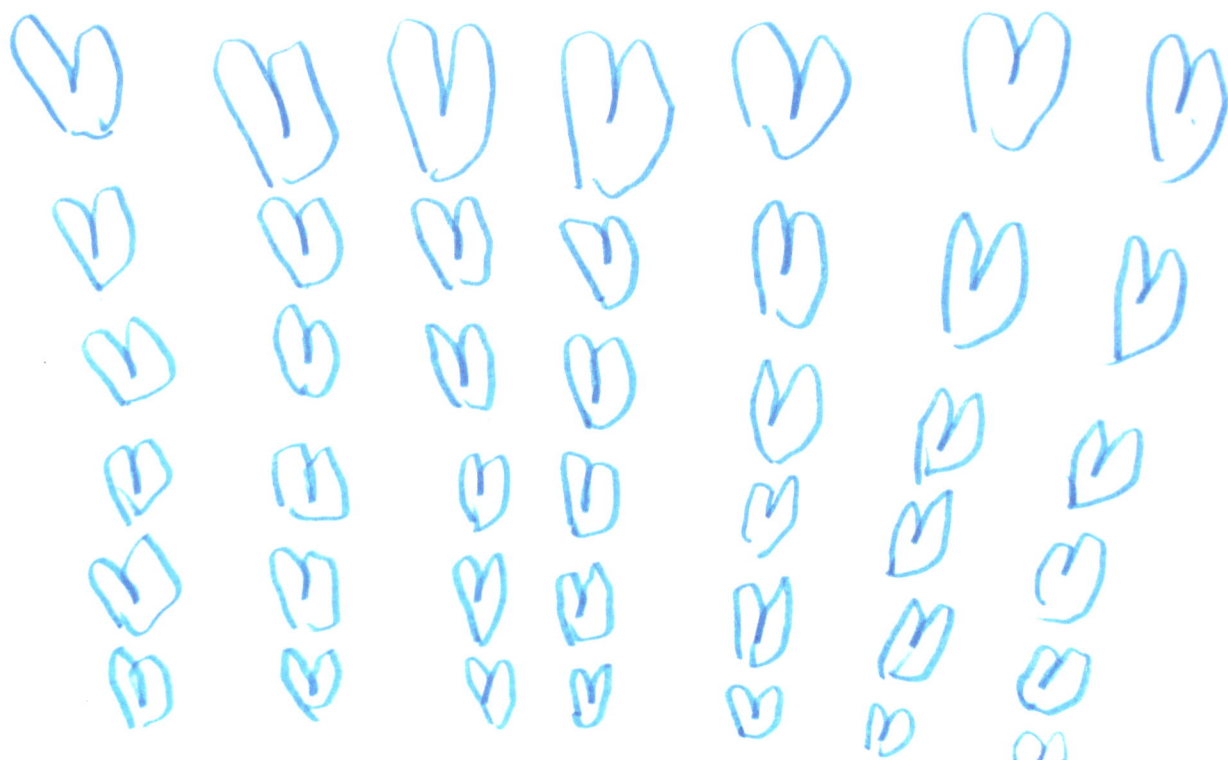

# Jude

Jude's pictures consist of emblematic imagery: a clock, a person, a house, which repeat often, along with symbols such as hearts and shamrocks. Whatever he draws is expressed with a spindly, electrified line that enlivens the forms. When drawing from other pictures or photos, his sensitive line is bundled to create form or describe the edges of objects. His pictures reflect his playful and affectionate nature.

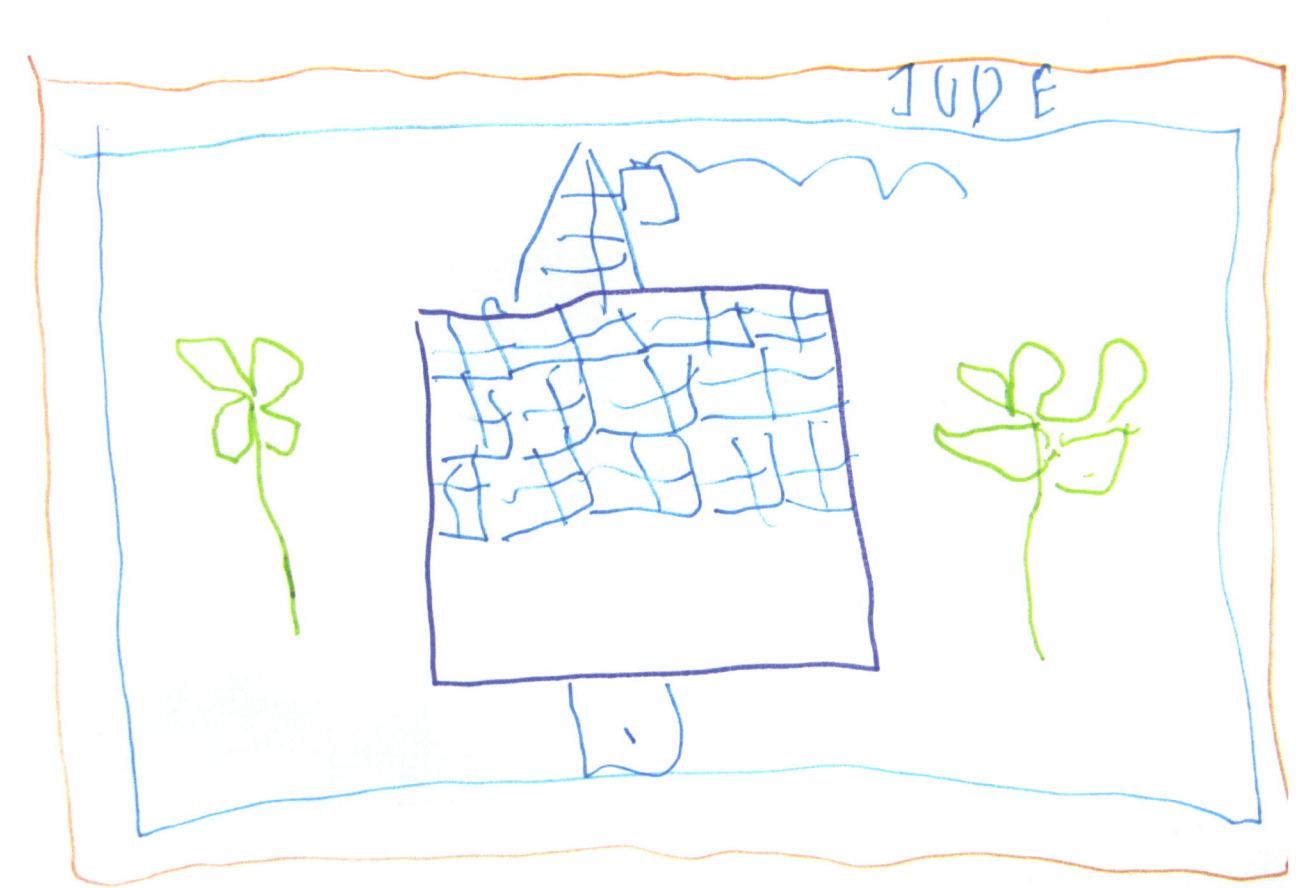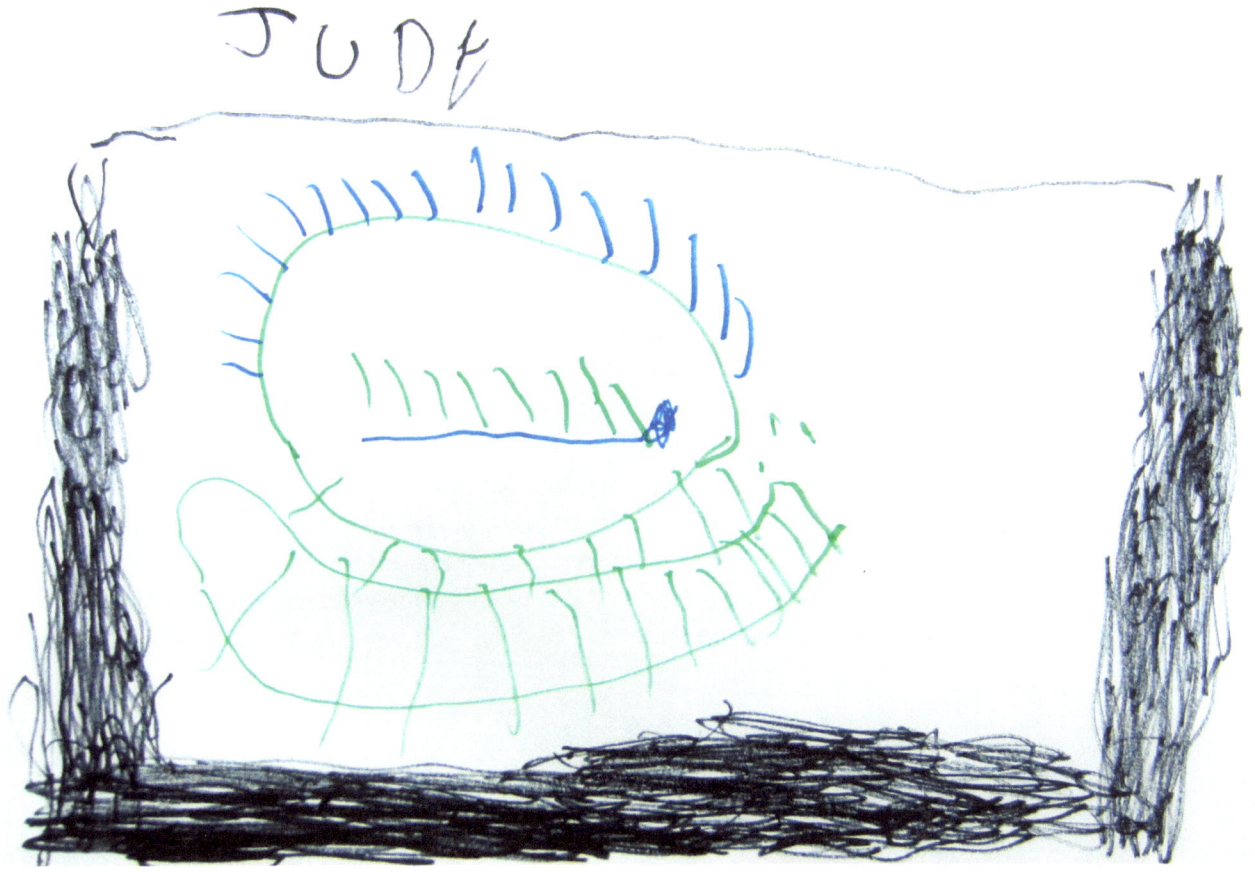

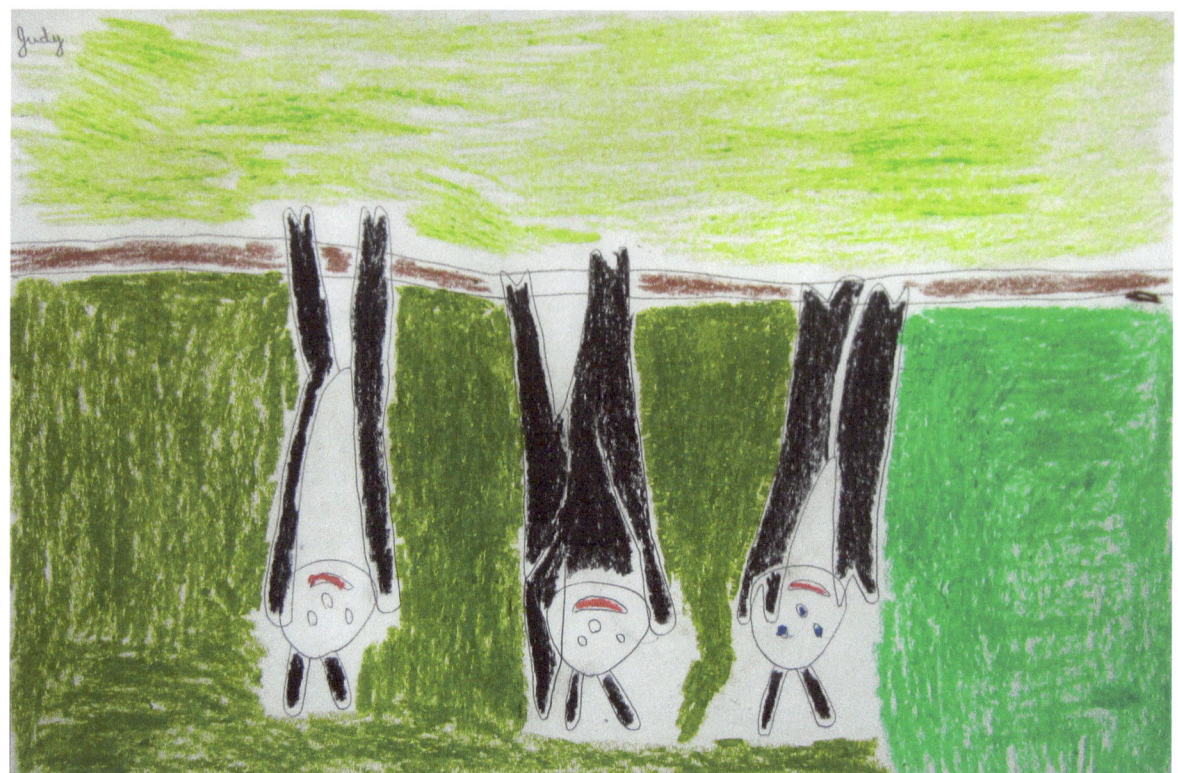

# Judy

Judy changes the images of animals or plants that she works from into drawn designs that engage repetition and variation to achieve a lively, bright pattern. Her dancing hares, floating dragonflies and leaping dolphins are animated by blocks of color juxtaposed with delicate linework. In her unique way of seeing things, legs and wings sometimes end up in surprising configurations, and overall there is an ordered sense of beauty.

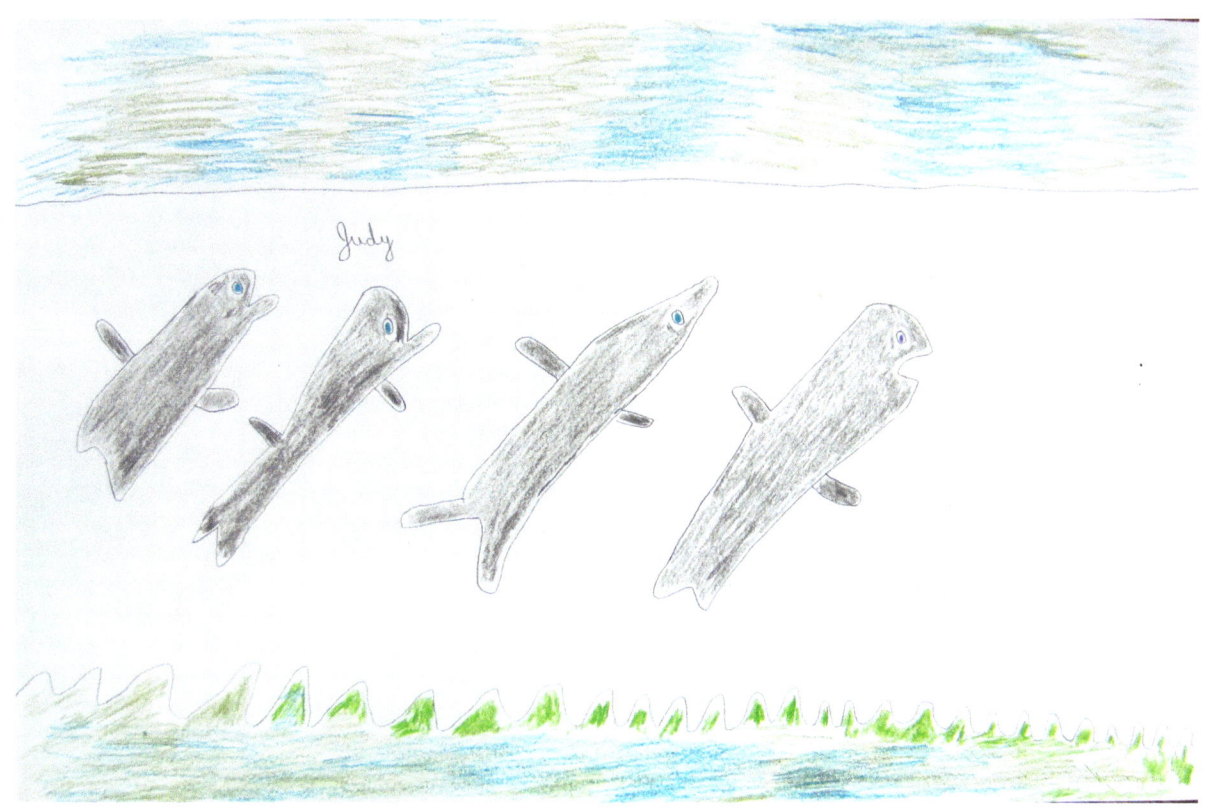

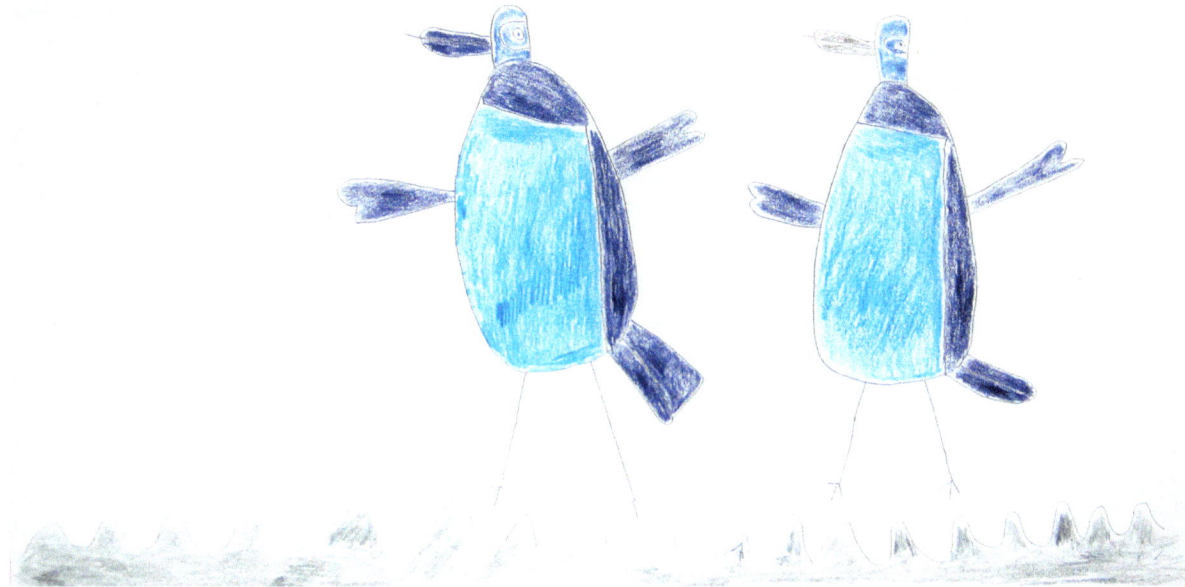

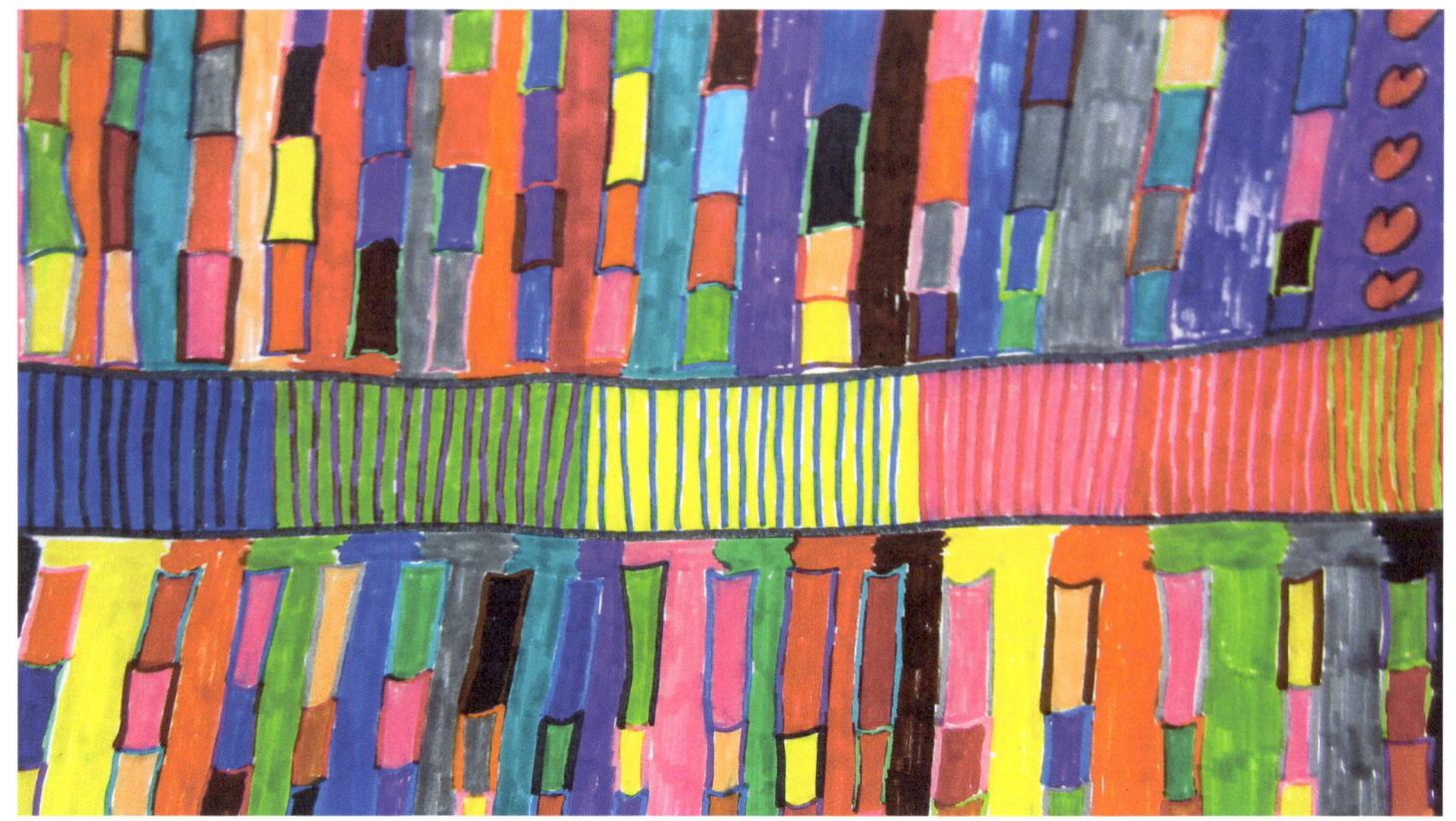

# Kaitlyn

Kaitlyn has studied works by Van Gogh and Paul Klee. Both are artists who worked with a multiplicity of vibrant color-forms to create complex images. Kaitlyn creates kaleidoscopic assemblies of lines and ribbons of color and arranges them like musical notes. Her work is always surprising to watch unfold and seems to have infinite possibilities.

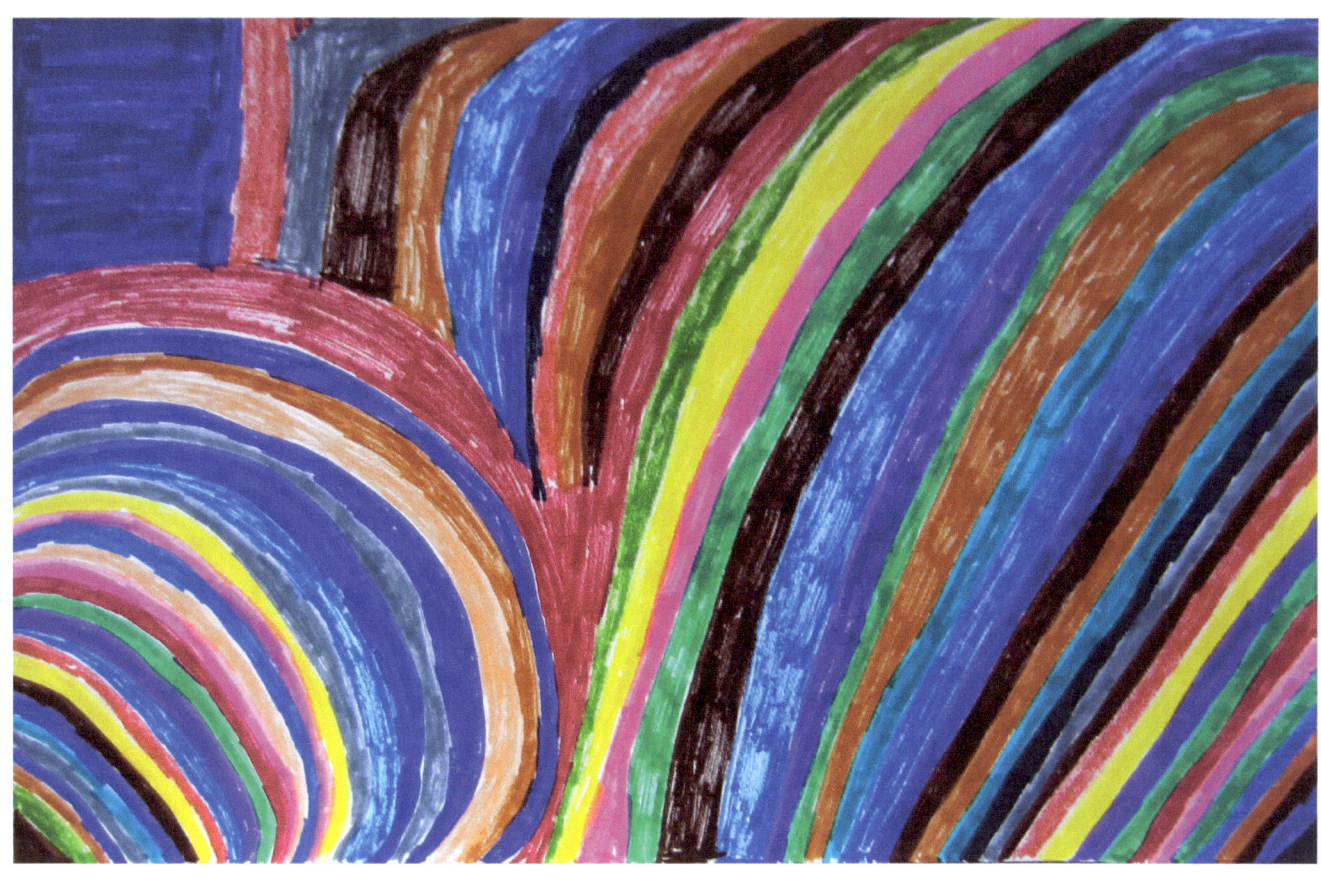

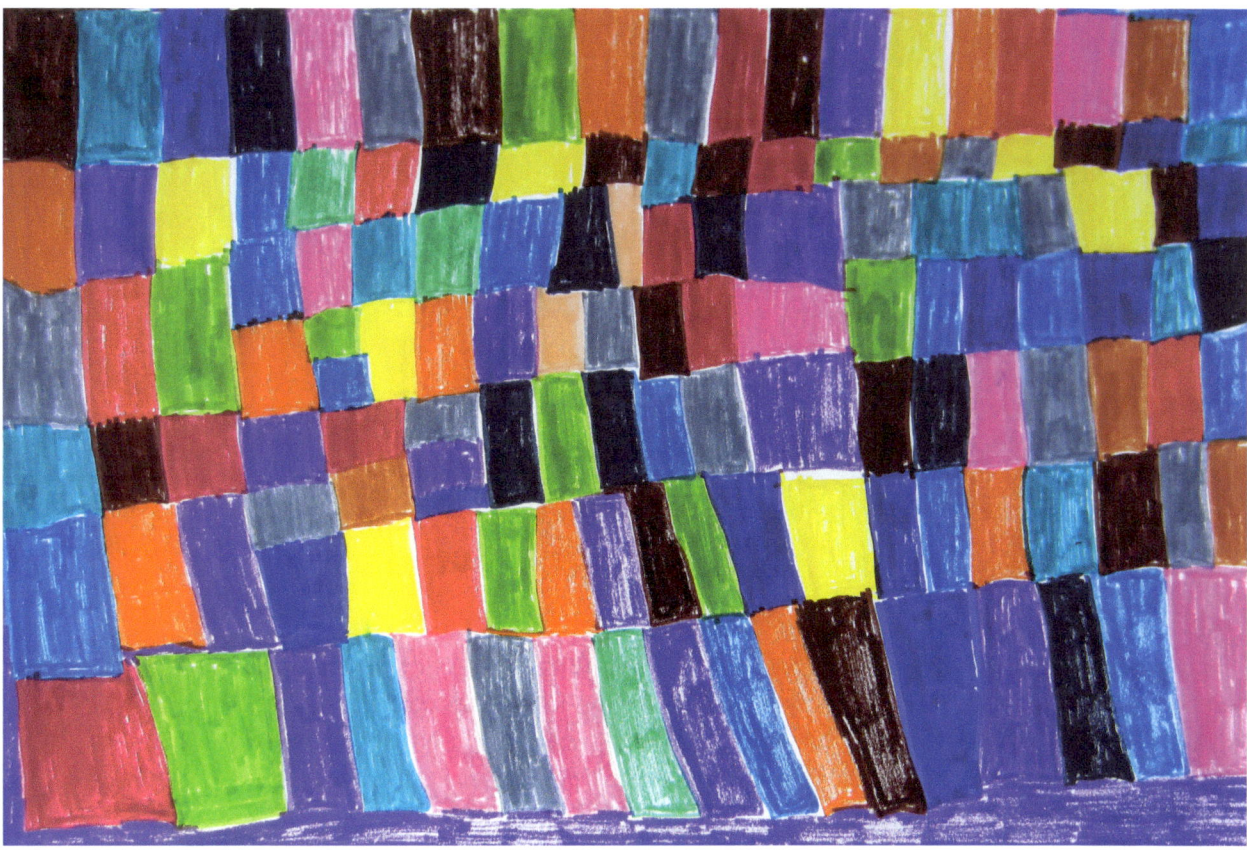

# Linda

Linda is new to our program and is just getting started. She takes inspiration from the style of coloring books. She draws with an emphatic outline to be later colored in. One of our only artists who draws with charcoal, her line is very expressive and unhesitant. Her style is similar to cartoonist drawings and would make wonderful children's book illustrations– the kind that adults really like too.

Linda Love

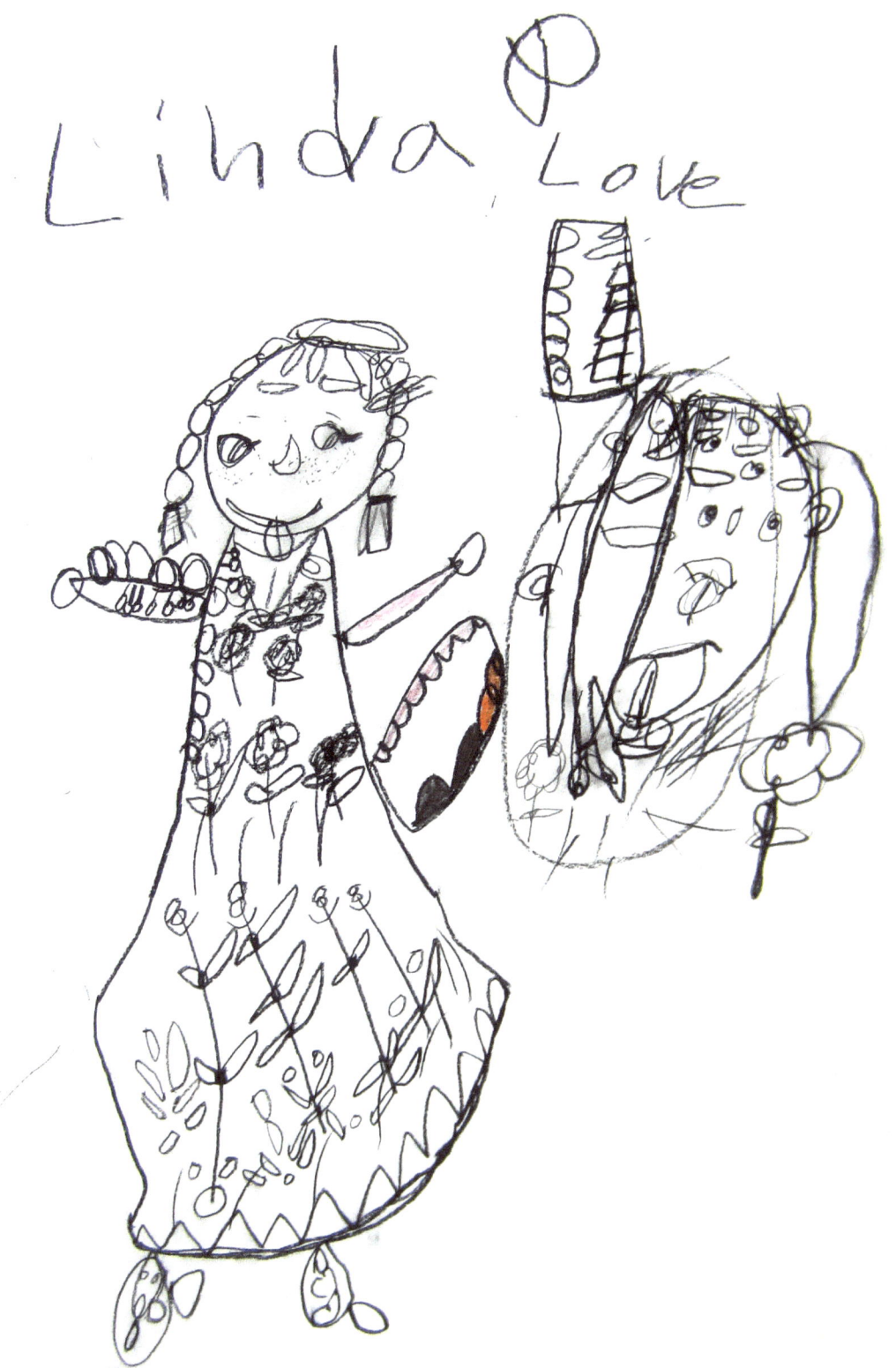

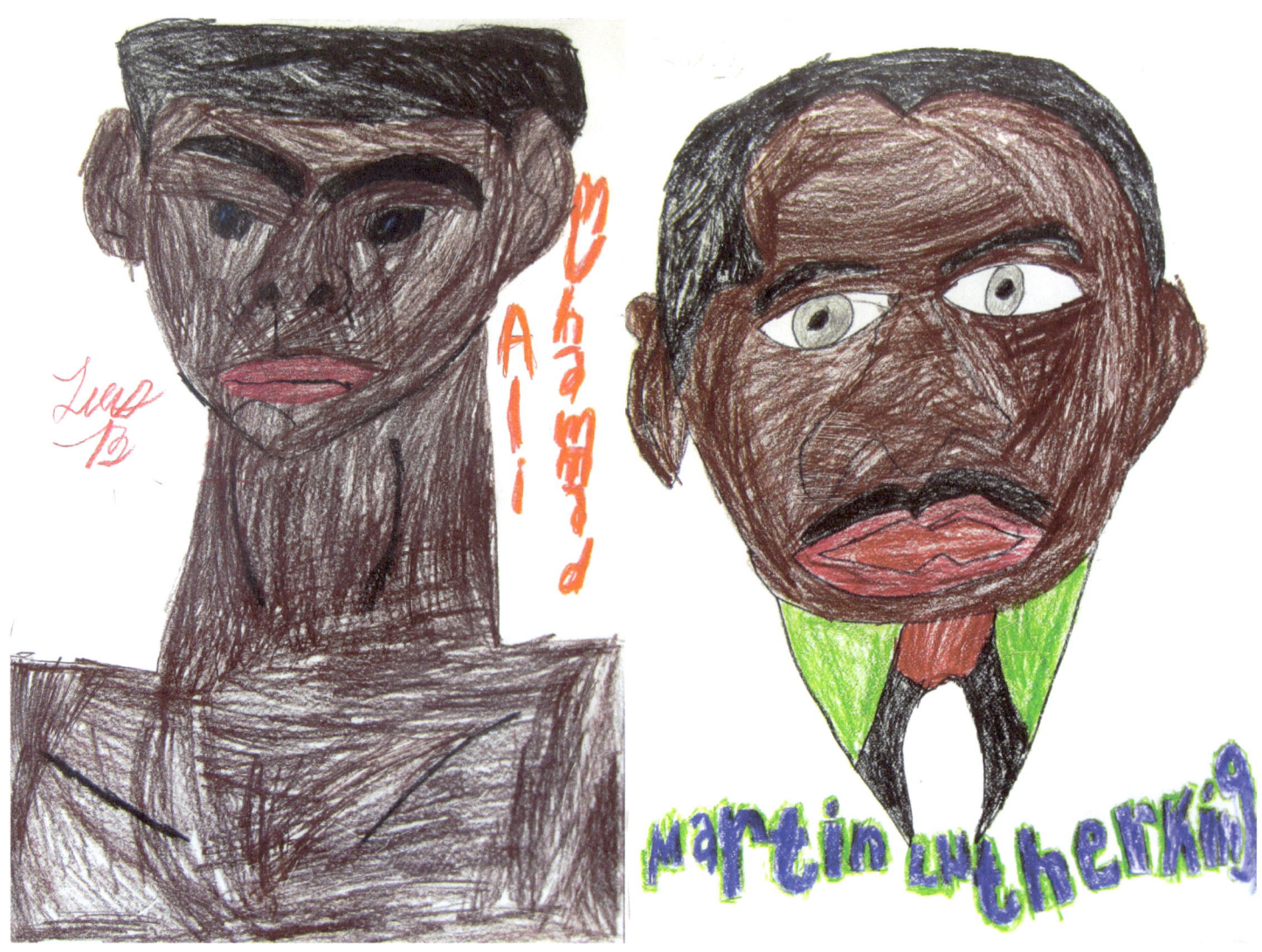

# Louis B.

Louis has a real talent for portraiture and there is a very strong graphic sense to his work, which is always a combination of words and image. There is nothing extraneous in his designs and even his signature becomes part of the picture. Louis always works from images he finds on his phone or in print, from pop-culture, black history, advertising, animals, indigenous art and other sources that come to his mind. His work is very bold, with no wasted space and a strong consciousness of the edge of the paper. His portraits can express a sense of character through the look of the eyes, the pose, and attention to details like interlocking fingers and hair styles.

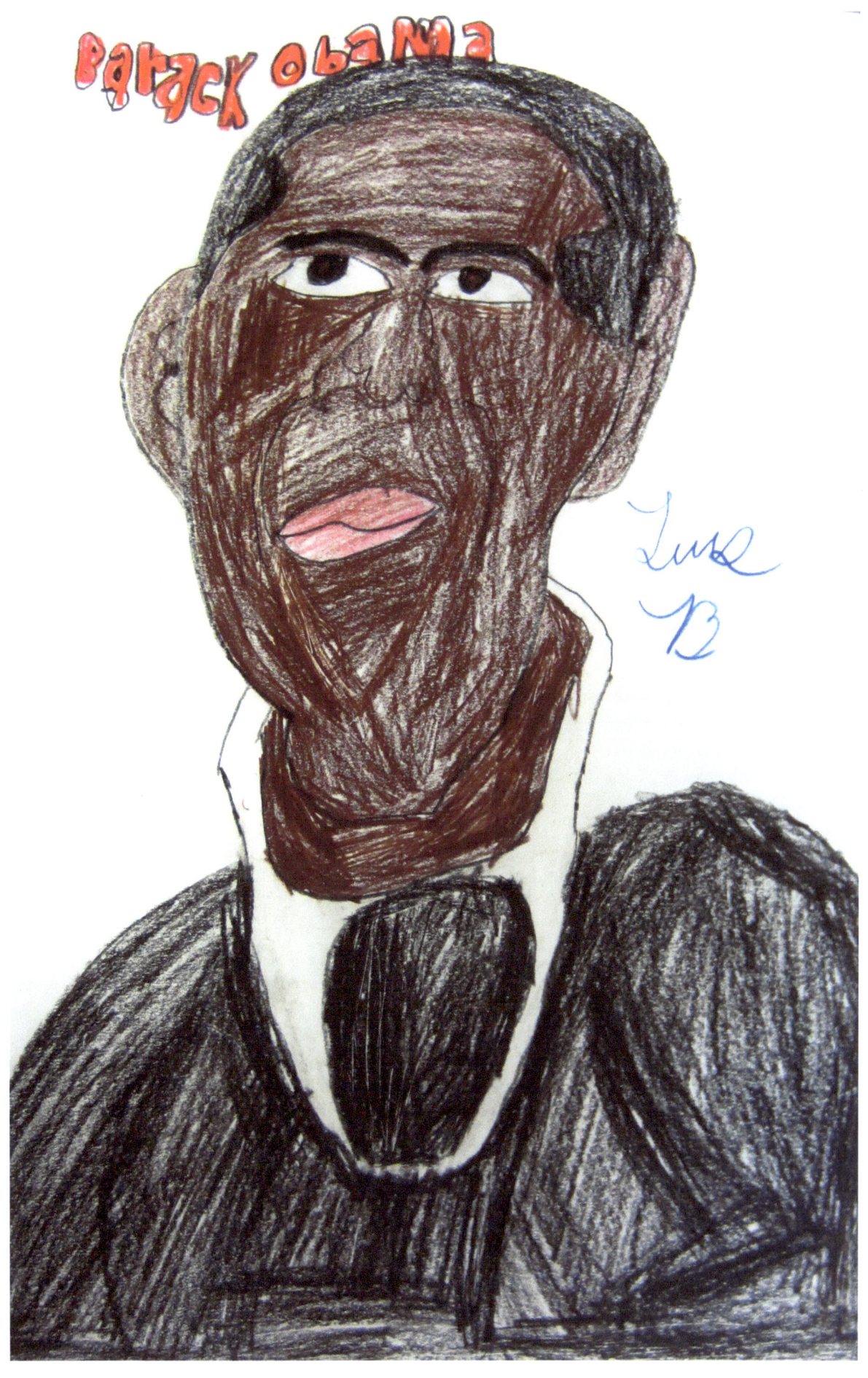

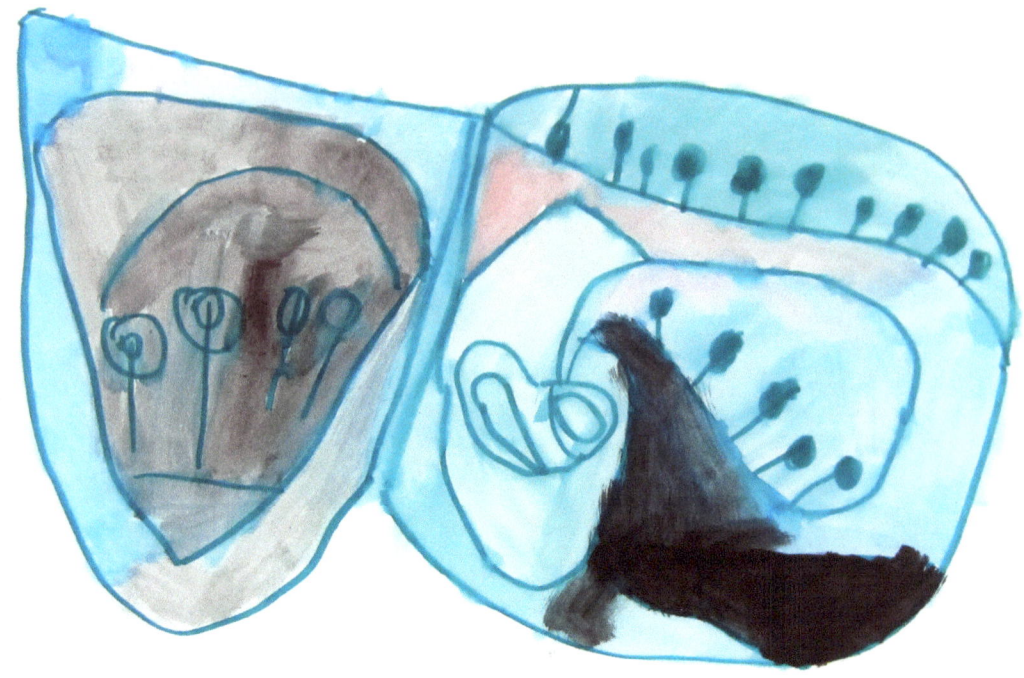

# Luis F.

Luis constructs his paintings out of fluid lines and painterly washes of colors. His work is free and inventive in any medium; the works shown here are his watercolors and acrylics. He will also use letters, numbers and words as pictorial elements in his drawings. He rearranges what he sees from his window or in pictures, into designs that are purposeful, yet unbounded by representational rules. Luis' work is like poetry; he creates complex, mysterious structures that we can look at and appreciate again and again.

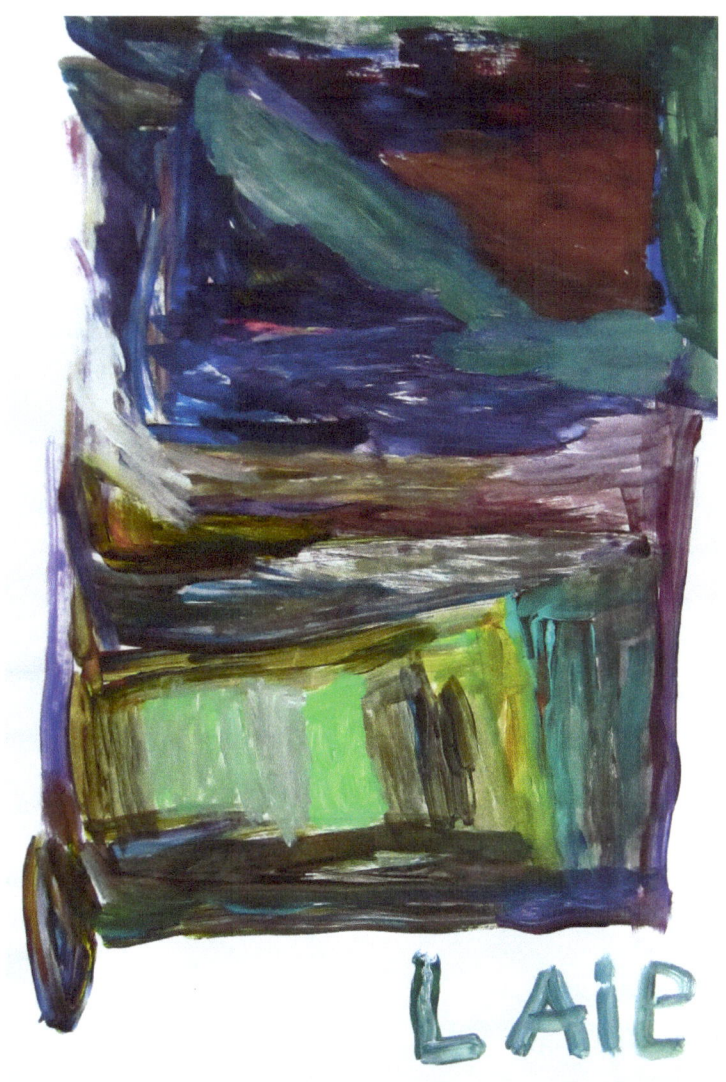

LAie

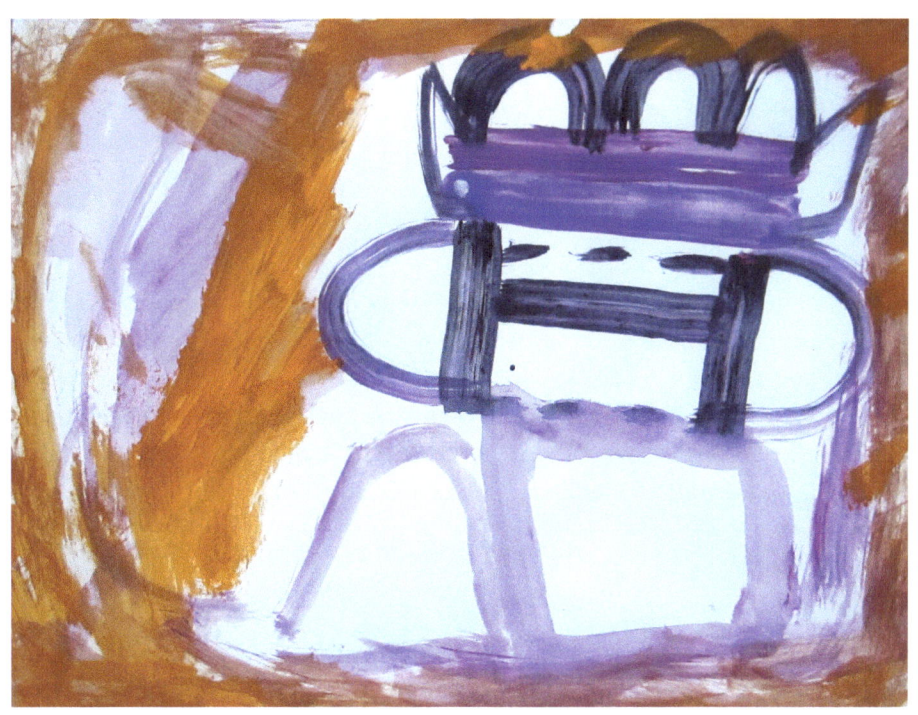

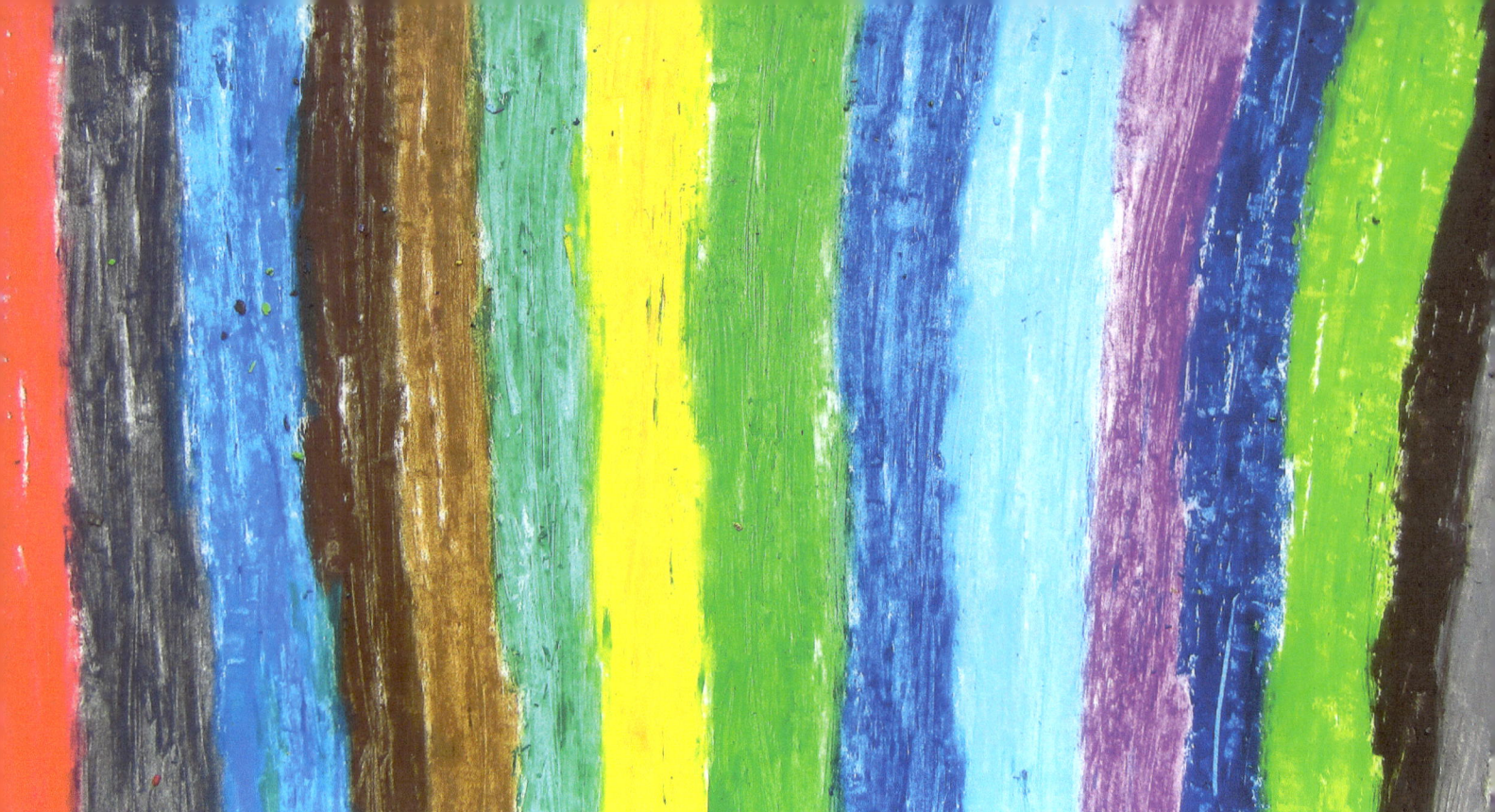

# Marcello

Marcello's rainbow pictures are just one of the three groups of work that he currently makes. For the rainbows, he uses oil pastels and thinks carefully about his color choices and the order, width and intensity of each band. He speaks very quietly, but often will be naming the colors that he is deciding to use. Marcello's Wall of Rainbows puts several of his pieces into a large grid formation. When taken together, we see that he explores a wide variety of possibilities in this series and his palette is always developing. Marcello also makes line drawings in marker and watercolor paintings that also order color and form.

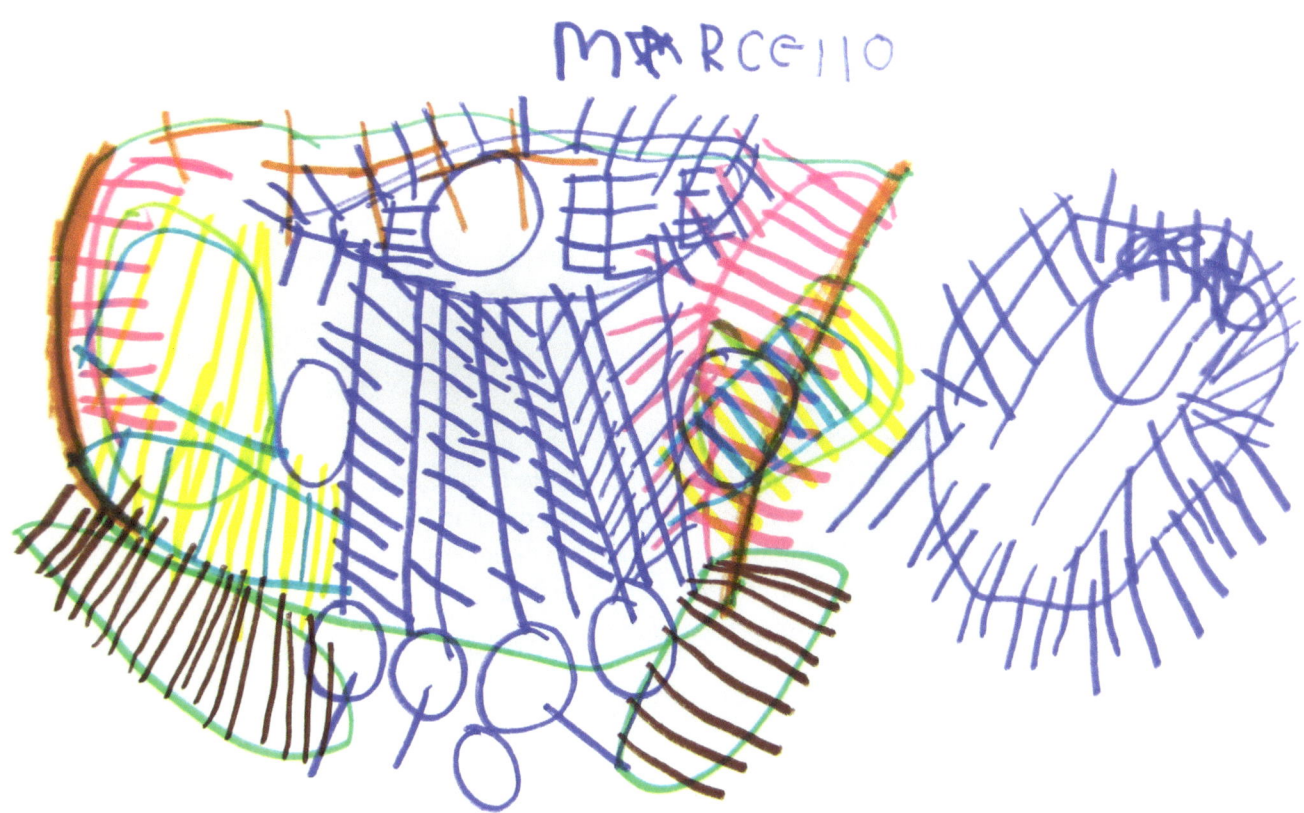

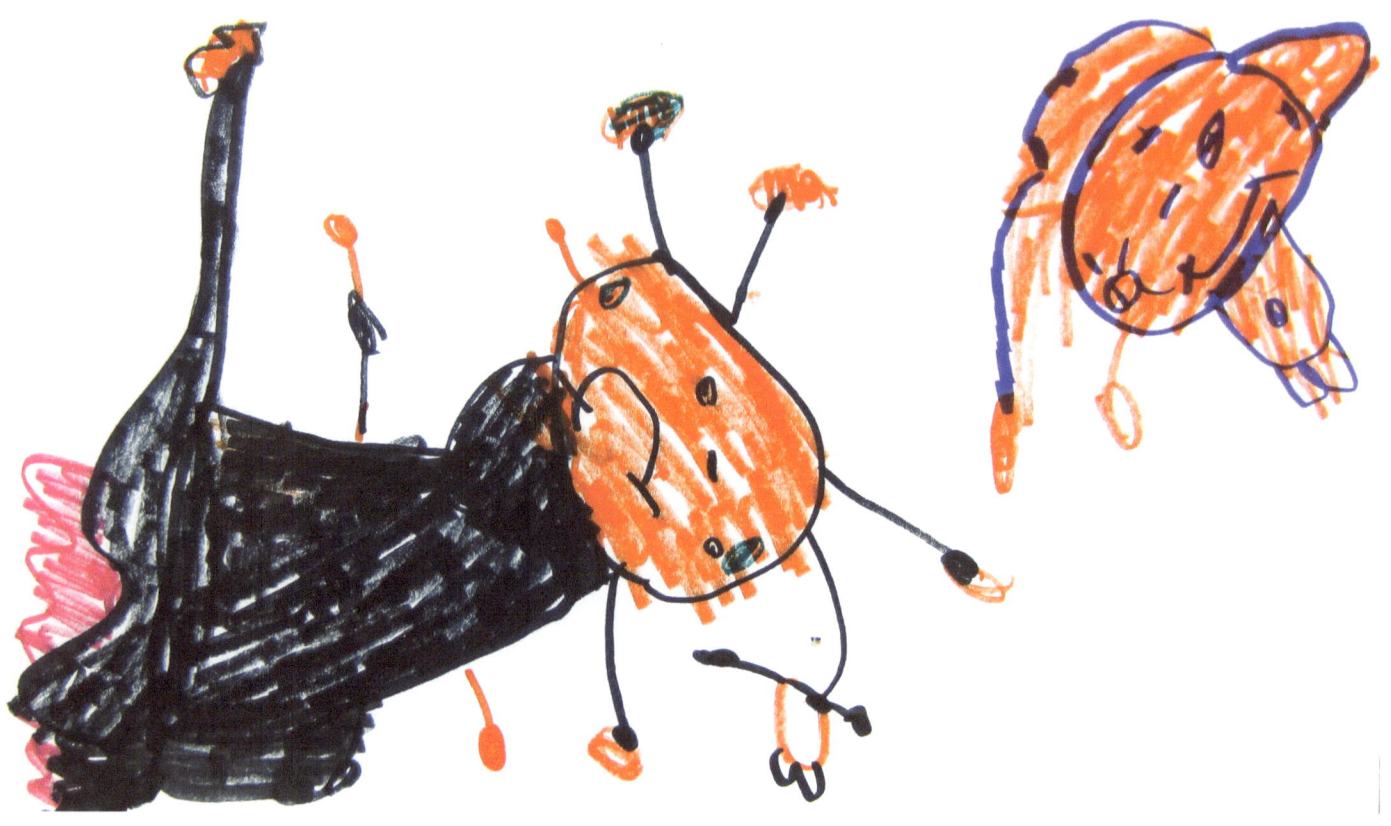

# Mary Beth

Mary Beth draws with a cartoonist's sure sense of line and quick confidence. Her subjects, shmoos, are almost always a mix of right-side up and upside down parts. There are many varieties of shmoos. She will blend them with other objects or living things. There are coffee cup shmoos, tree shmoos, animal shmoos, various shmoo people, and many more. In her pictures, she expresses the personality of animate beings and inanimate objects. She often draws details such as belly-buttons, hats and earrings.

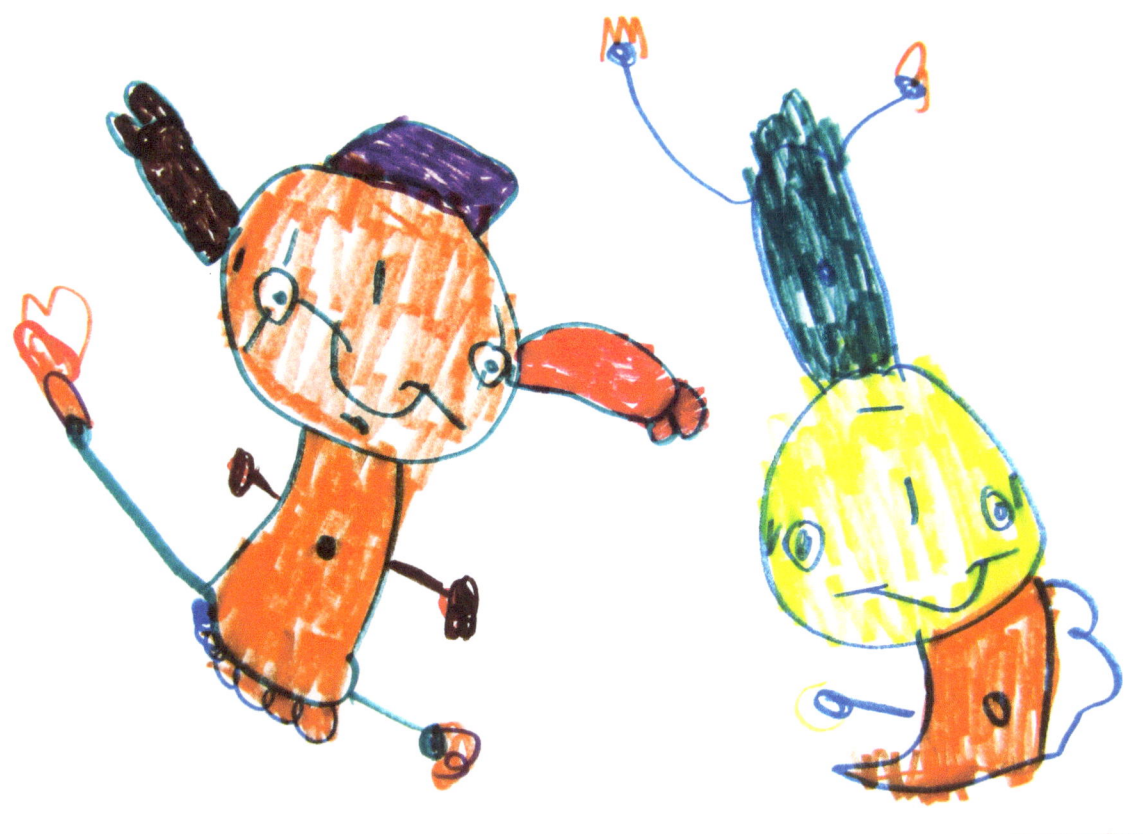
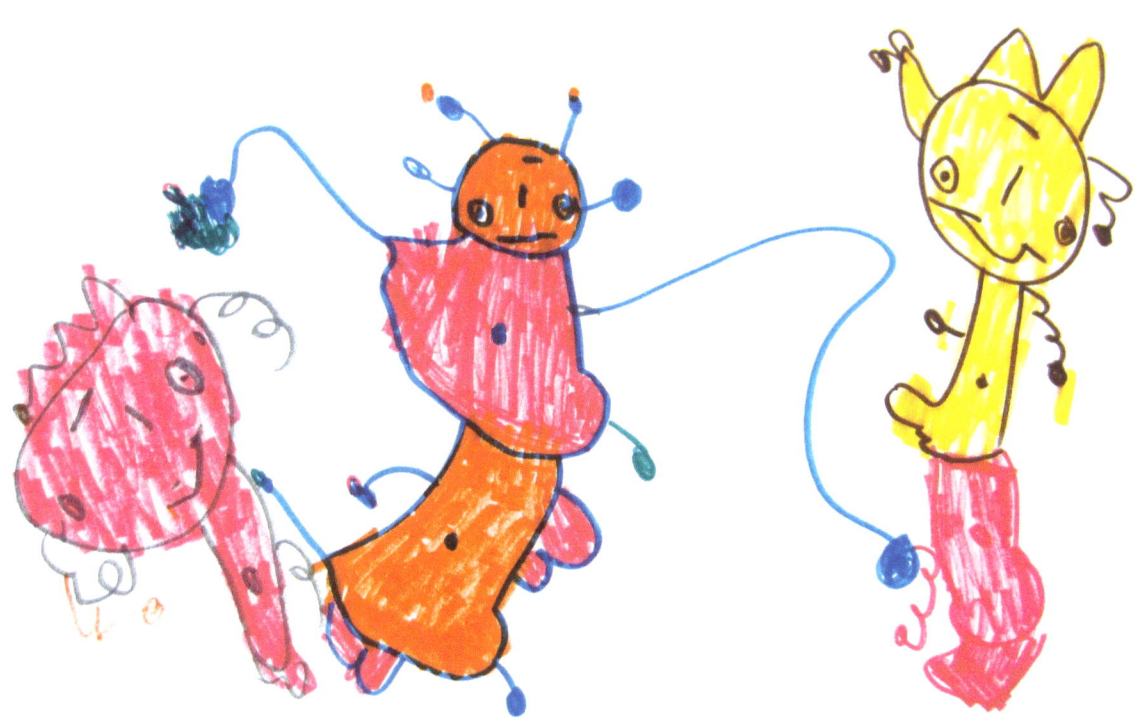

# Michael

Michael's art is coloring. He will either work from drawings started by Dina, or will work in coloring books. He sometimes will make a new drawing by creating systems of blocks or grids with his crayons. When working in coloring books, he often overrides the images underneath. He will fill the images with colors, but he also may create a color composition that works outside or against the lines of the picture. Michael doesn't give up his coloring pages easily, but with the help of the staff, we managed to convince him to give us some just for this show.

1. **MARBLED GROUPER** The marbled grouper is a fairly rare fish of the tropical American Atlantic Ocean. Its body color is greyish brown with marbled or mottled irregularly shaped light-beige markings and dark spots.

2. **MAJARRA** Called "shad" in the Bahamas, the silver-colored majarra is a bottom-feeder distinguished by a protractile mouth. This gives the fish the ability to search for food by extending its mouth downward. Majarras are found in the Atlantic, from Massachusetts to Brazil.

3. **MOONFISH** Little is known about the moonfish. It inhabits both sides of the Atlantic and the eastern Pacific from Southern California southward to Peru. Its very thin body is yellowish-silver with yellow dorsal, anal and caudal fins.

4. **MOORISH IDOL** The moorish idol feed on small sea animals and plants in the tropical Indo-Pacific Ocean. Distinguished by an extremely long, pennant-like dorsal fin, its body color consists of black, white and yellow to yellow-orange vertical stripes (see front-cover painting for details).

5. **MORAY EEL** Although highly grotesque and vicious in appearance, the moray eel is not dangerous unless provoked. Distinguished from other eels by its lack of pelvic or pectoral fins and small round gill openings, the moray will vary in color from a fawn-brown or green, to a striped yellow and brown, to mottled grey and black, depending on the species. Over 100 species are known to exist in the rocks and reefs of tropical waters worldwide. They are both predators and scavengers, and eat a wide variety of invertebrates and fish.

6. **NASSAU GROUPER** Numerous and common along the Nassau coasts, the Nassau grouper is found around the coral reefs in the tropical western Atlantic ocean. Beige to whitish in color with an overall brown mottled pattern, its diet consists of other fishes.

7. **NAUTILUS** The most primitive of the cephalopods, the nautilus has not changed its form in millions of years. It lives within a brown-and-white zebra-striped shell which is divided into more than thirty gas-filled chambers. By adjusting the amount of gas in the chambers, the nautilus can descend great depths or ascend to the shallows (see front-cover painting).

8. **NEEDLE FISH** With a narrow three-foot body, a sharp pointed mouth, and silvery blue-green skin, the needle fish is most aptly named. It can swim at very high speeds, and at times will leap out of the water in pursuit of small fish. The many small teeth that line its mouth are used to grasp prey only; the needle fish swallow its prey whole.

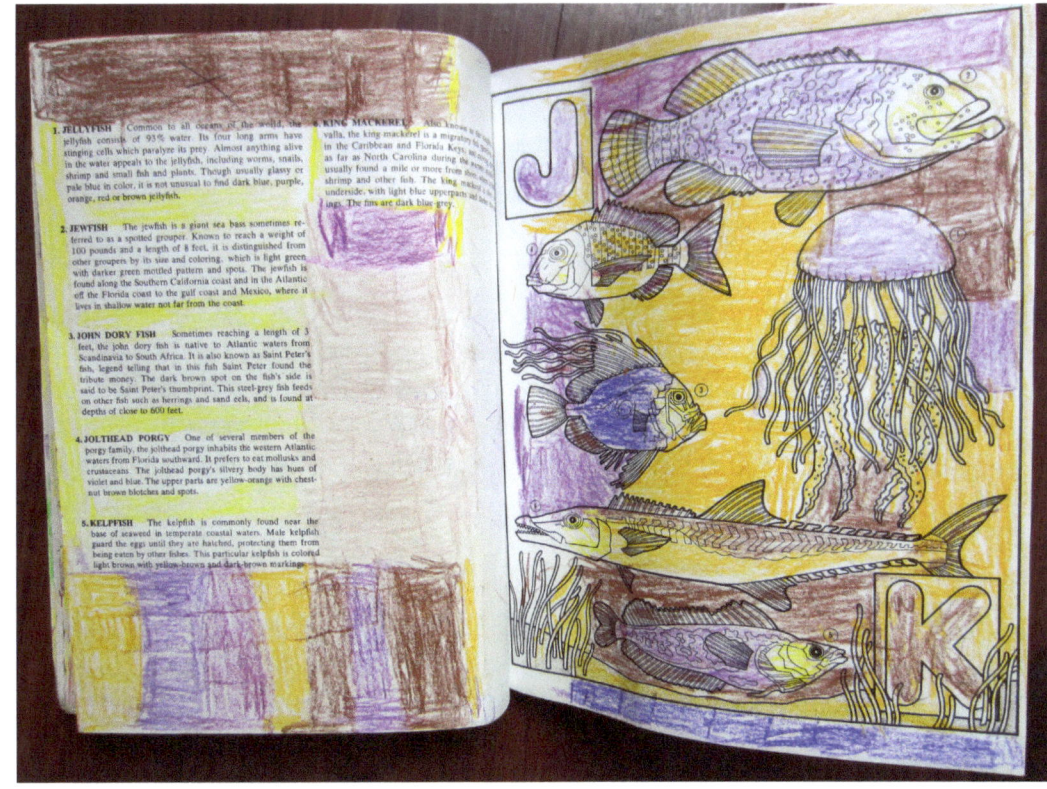

1. **JELLYFISH** Common to all oceans of the world, the jellyfish consists of 95% water. Its four long arms have stinging cells which paralyze its prey. Almost anything alive in the water appeals to the jellyfish, including worms, snails, shrimp and small fish and plants. Though usually glassy or pale blue in color, it is not unusual to find dark blue, purple, orange, red or brown jellyfish.

2. **JEWFISH** The jewfish is a giant sea bass sometimes referred to as a spotted grouper. Known to reach a weight of 100 pounds and a length of 8 feet, it is distinguished from other groupers by its size and coloring, which is light green with darker green mottled pattern and spots. The jewfish is found along the Southern California coast and in the Atlantic off the Florida coast to the gulf coast and Mexico, where it lives in shallow water not far from the coast.

3. **JOHN DORY FISH** Sometimes reaching a length of 3 feet, the john dory fish is native to Atlantic waters from Scandinavia to South Africa. It is also known as Saint Peter's fish, legend telling that in this fish Saint Peter found the tribute money. The dark brown spot on the fish's side is said to be Saint Peter's thumbprint. This steel-grey fish feeds on other fish such as herrings and sand eels, and is found at depths of close to 600 feet.

4. **JOLTHEAD PORGY** One of several members of the porgy family, the jolthead porgy inhabits the western Atlantic waters from Florida southward. It prefers to eat mollusks and crustaceans. The jolthead porgy's silvery body has hues of violet and blue. The upper parts are yellow-orange with chestnut brown blotches and spots.

5. **KELPFISH** The kelpfish is commonly found near the base of seaweed in temperate coastal waters. Male kelpfish guard the eggs until they are hatched, protecting them from being eaten by other fishes. This particular kelpfish is colored light brown with yellow-brown and dark-brown markings.

6. **KING MACKEREL** Also known as the sierra or cavalla, the king mackerel is a migratory fish, found in the Caribbean and Florida Keys, occasionally ranging as far as North Carolina during the summer months. It is usually found a mile or more from shore, where it feeds on shrimp and other fish. The king mackerel has a silvery underside, with light blue upperparts and dark blue markings. The fins are dark blue-grey.

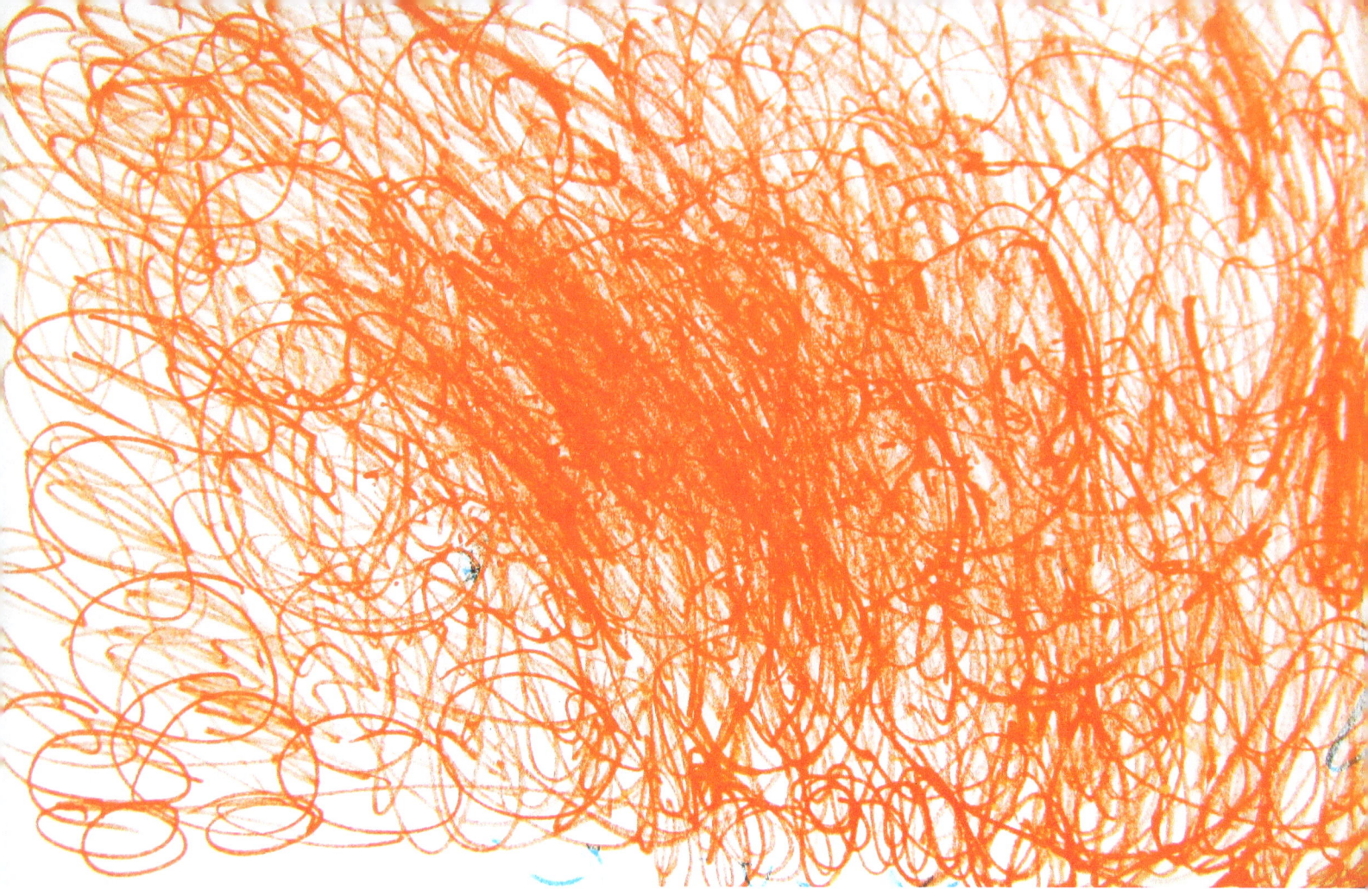

# Mina

The artist Richard Serra says, "There is no way to make a drawing– there is only drawing." All class long, Mina happily and enthusiastically shouts, "More paper!" Mina makes dense webs of scrawled, circling movements. His drawing is an activity, an expression of the motion and energy that he has within himself, as well as of the physical limitations he has to deal with. Mina connects color with the immediate situation he is in– blue could be for his shirt, brown could be for someone's pants. His drawings are very much about his intelligence and his personality. Each drawing is an accomplishment for him as if he were running a race.

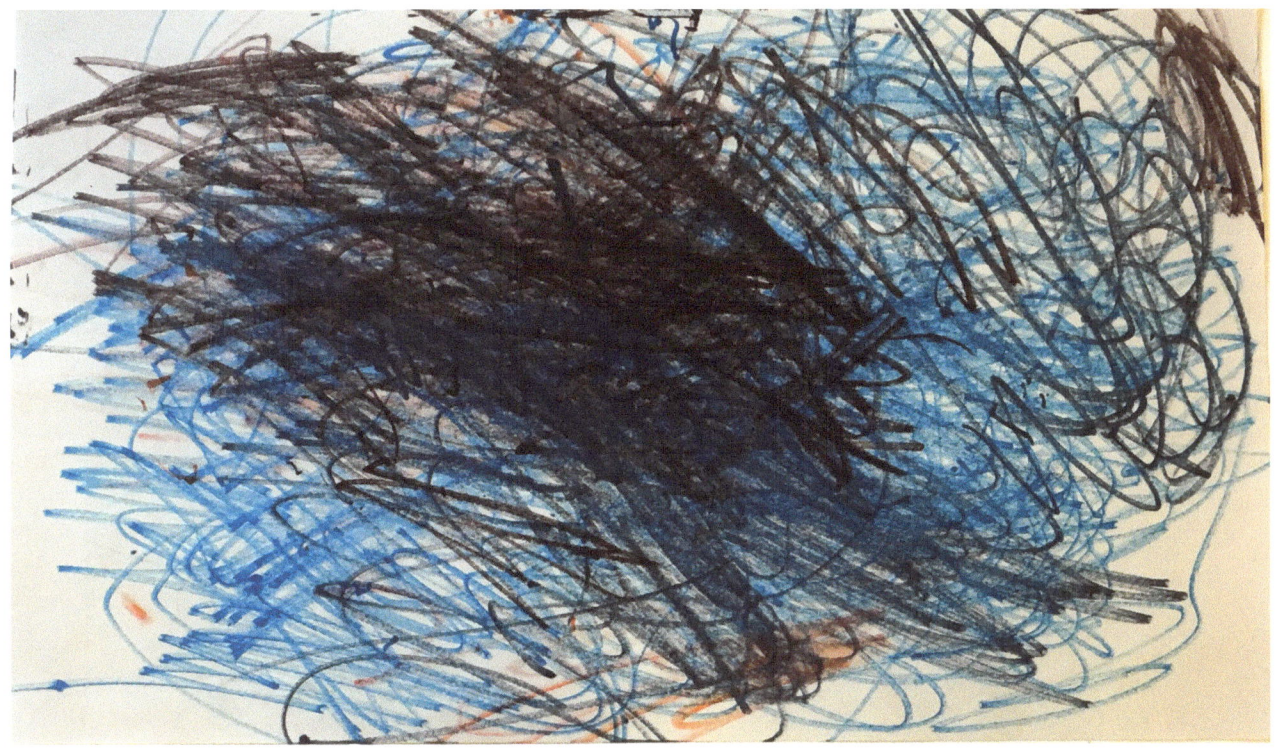

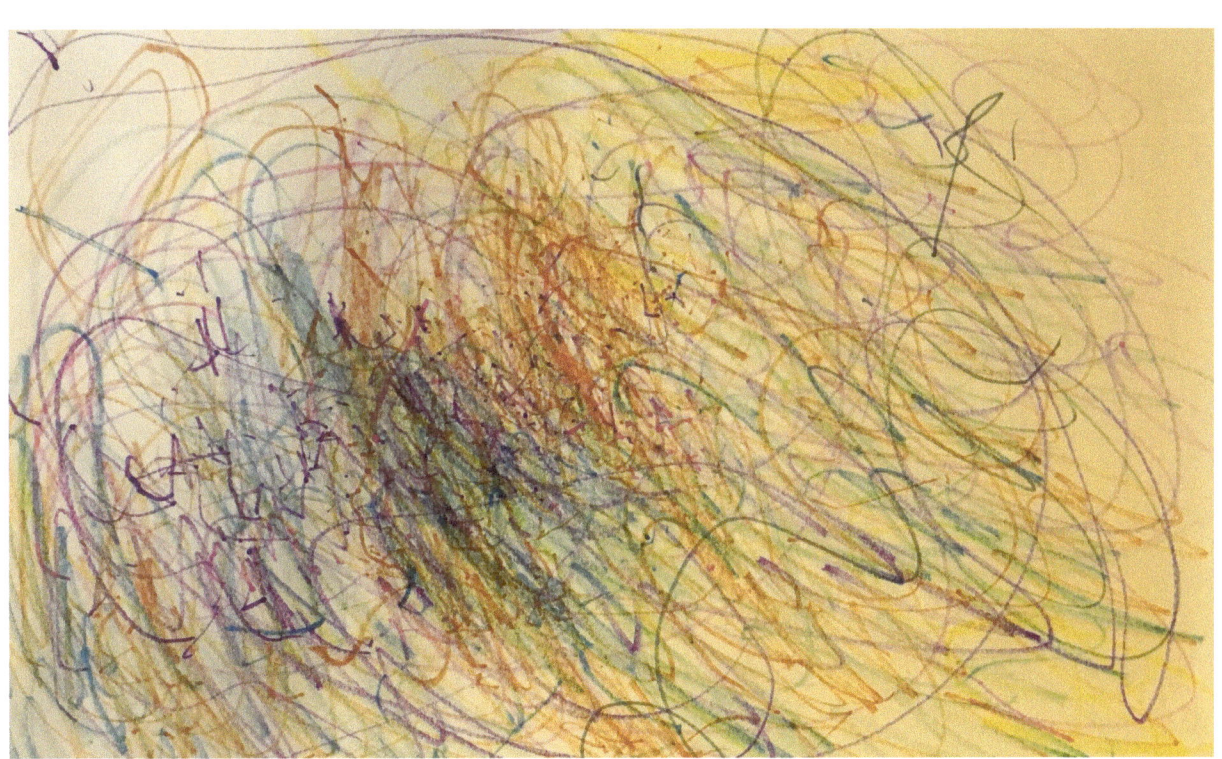

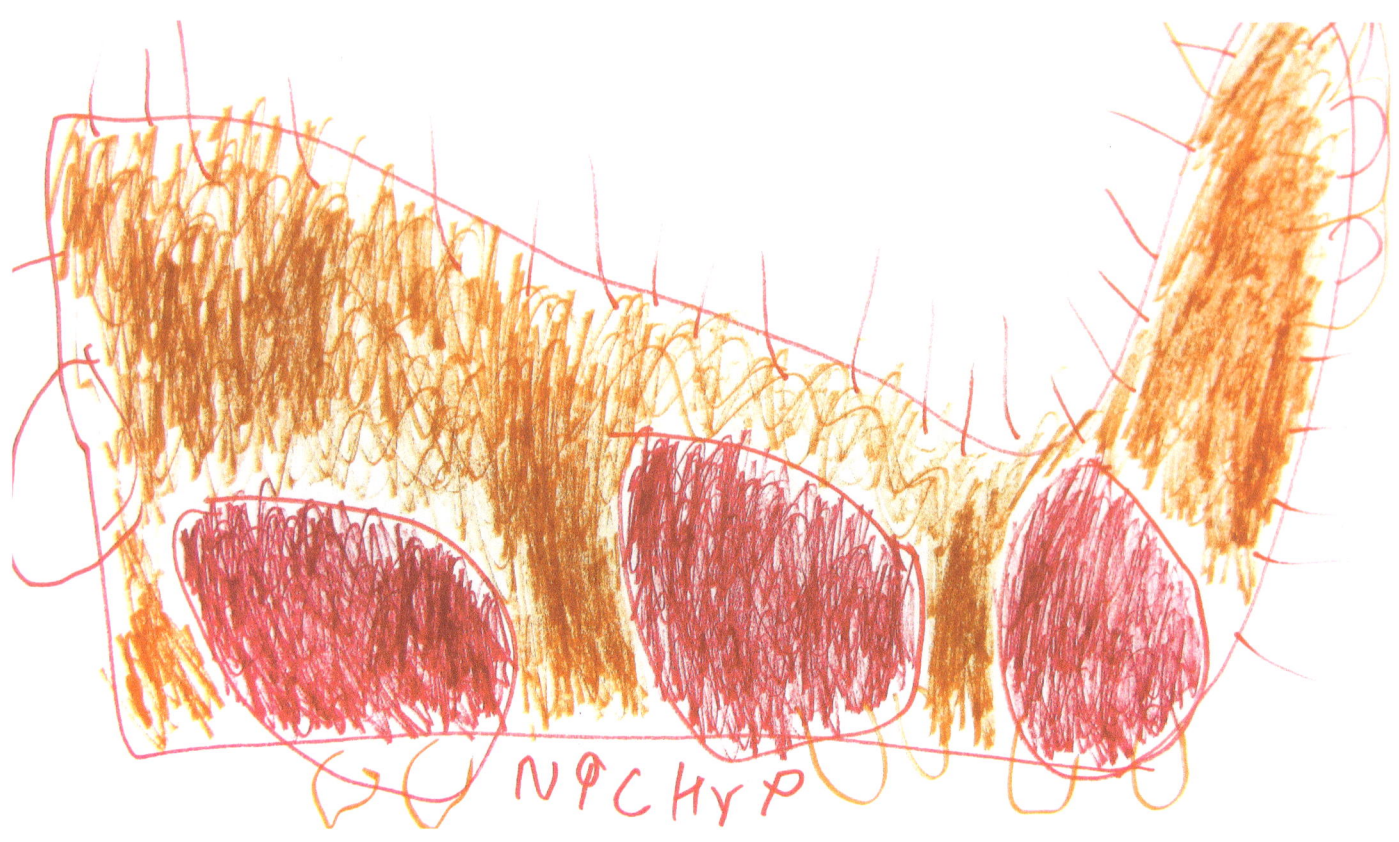

# Nicky

Nicky has a few major themes that he repeats in his drawings: cruise ships, dinosaurs, camels climbing hills of sand in the desert, and blimps. He is very interested in the larger things in the world, like the tallest buildings or the biggest ships. Nicky has a restlessly inquisitive mind and after making each drawing with emphatic speed, he will spend time looking at atlases, maps and encyclopedias of images from the natural world. He has a remarkable memory for detail.

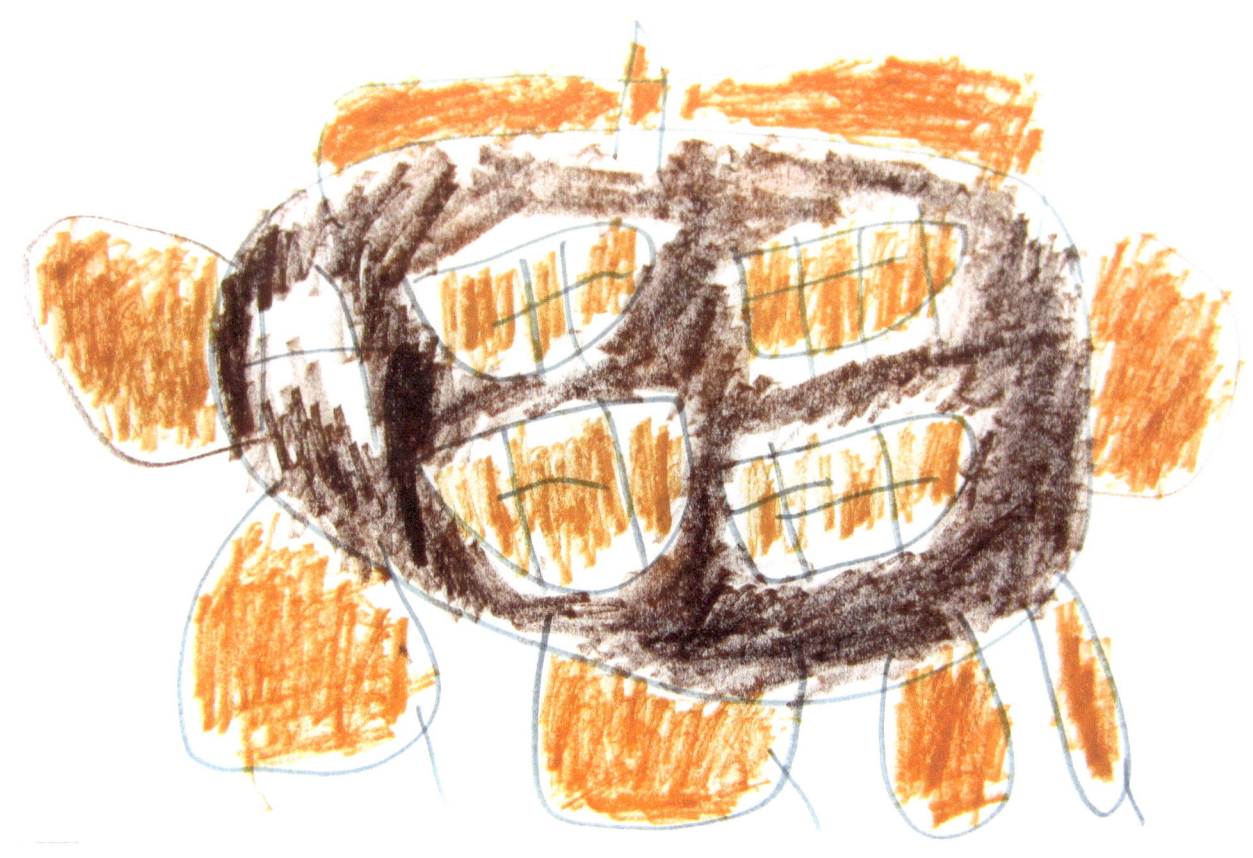

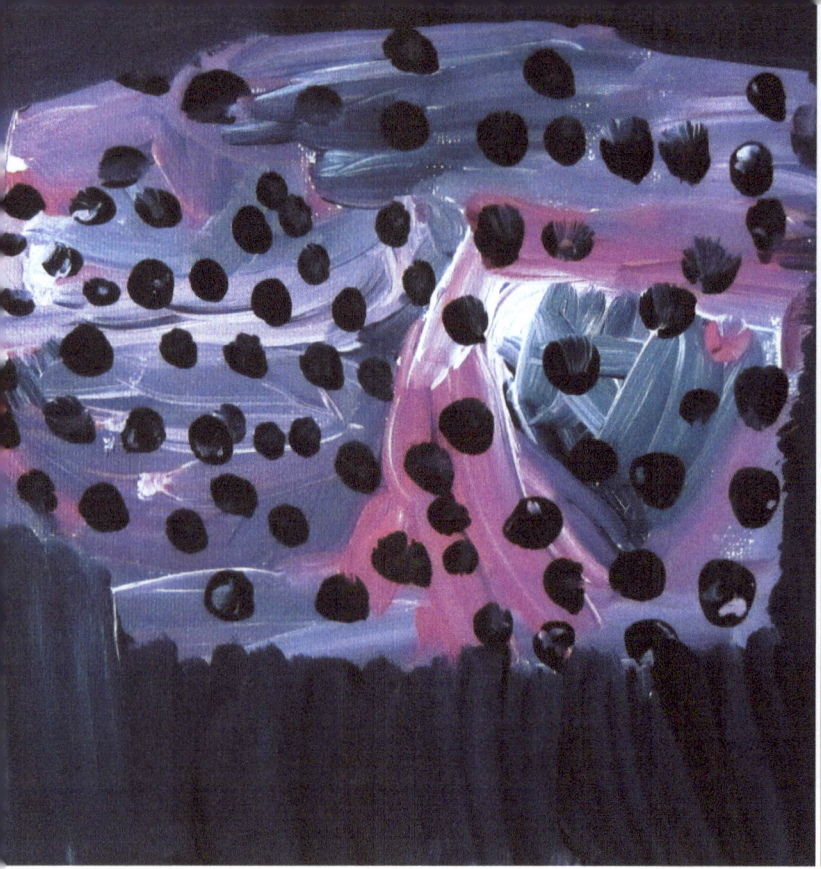 

# Nicole

Nicole is a natural painter. Her blending of tones and hues, and her use of brush strokes to activate and build-up the texture of her paintings is sophisticated and beautifully achieved. She creates a surface of shimmering color and light, breaking up space in surprising ways around her words and simple shapes. Her subjects are hearts, cupcakes and smiling faces, and these become the template for a complex interaction of paint.

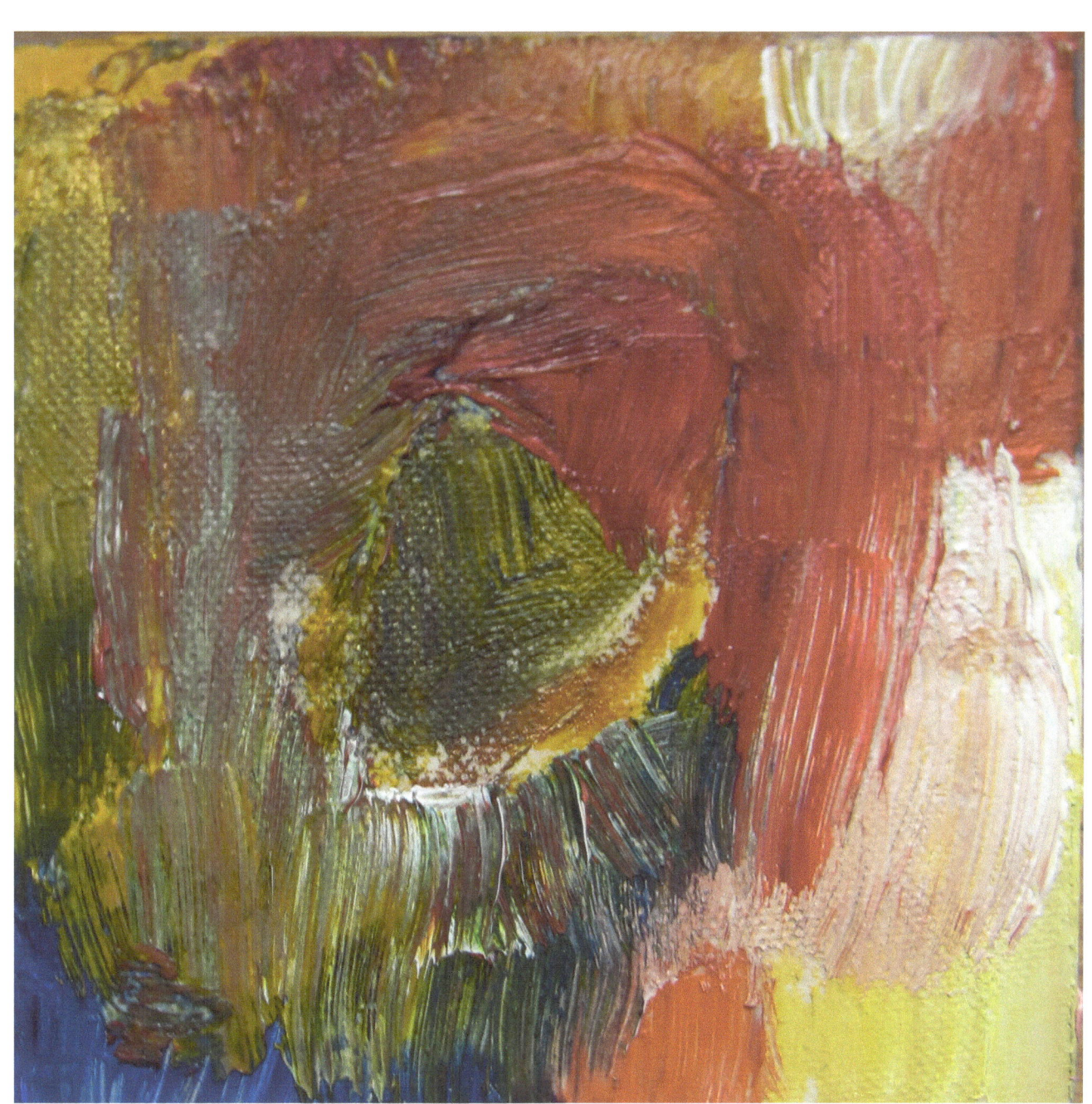

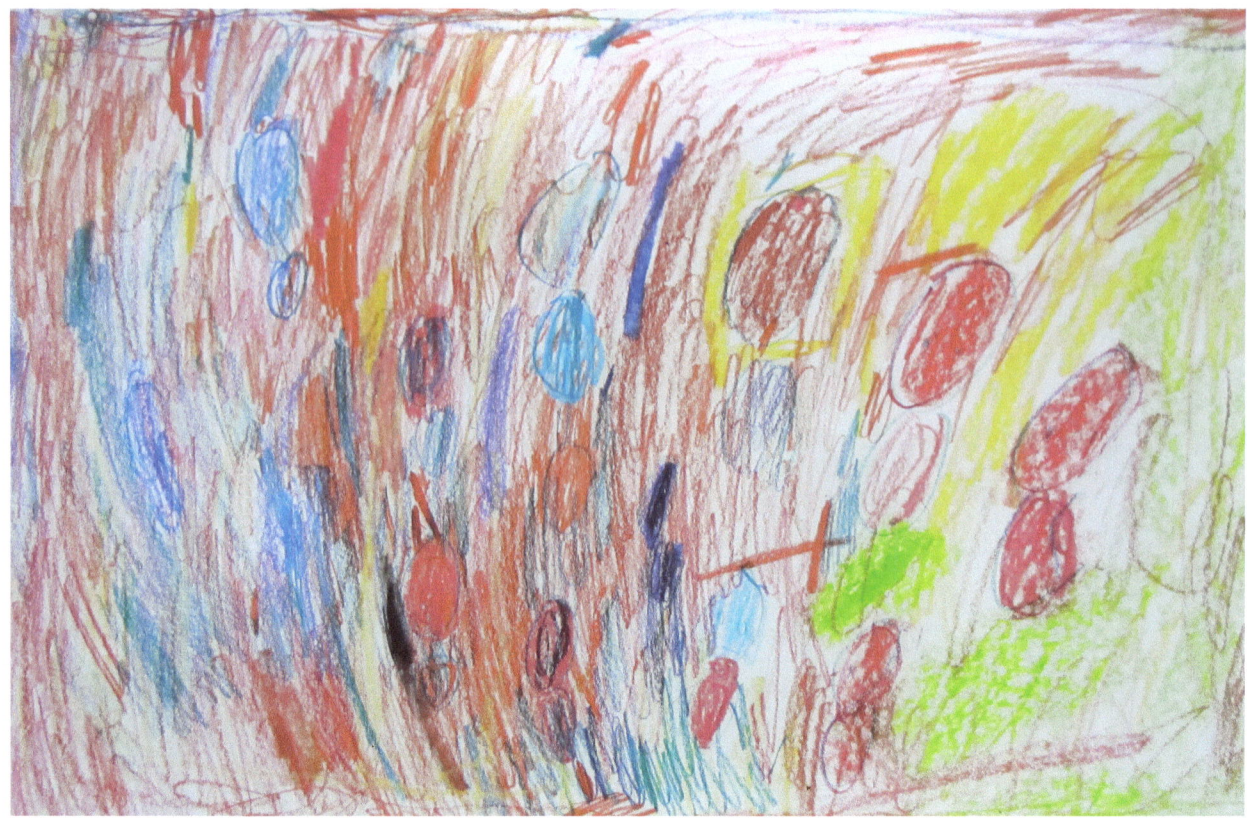

# Noreen

Noreen's artwork is often very abstract, but it also seems to be about something, and is expressive of her ideas and personality. She will draw in layers, often making a kind of face first and then layering over it with drawn colors, sometimes adding paint on top of that. She seems to know where her drawings are going almost all the time. Drawing is one of the many things that makes her happy.

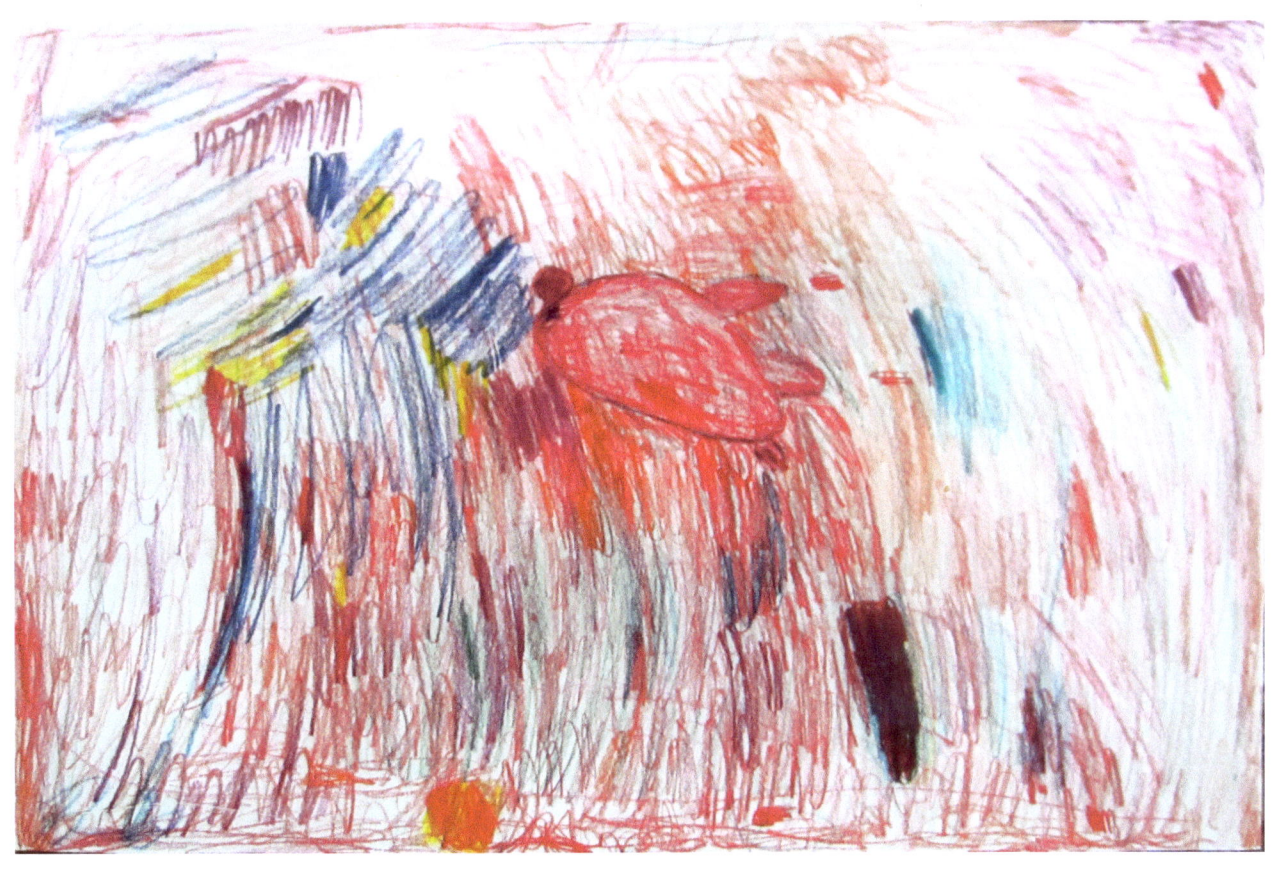
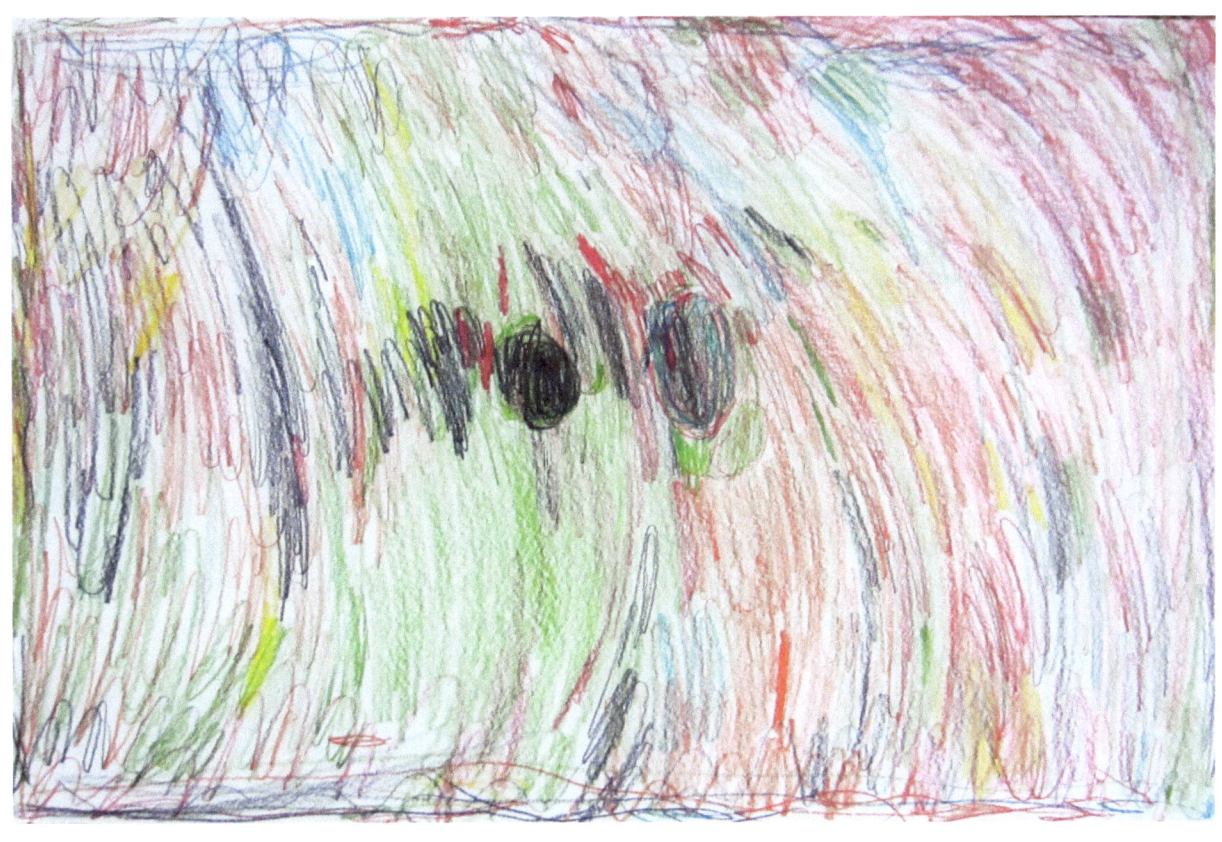

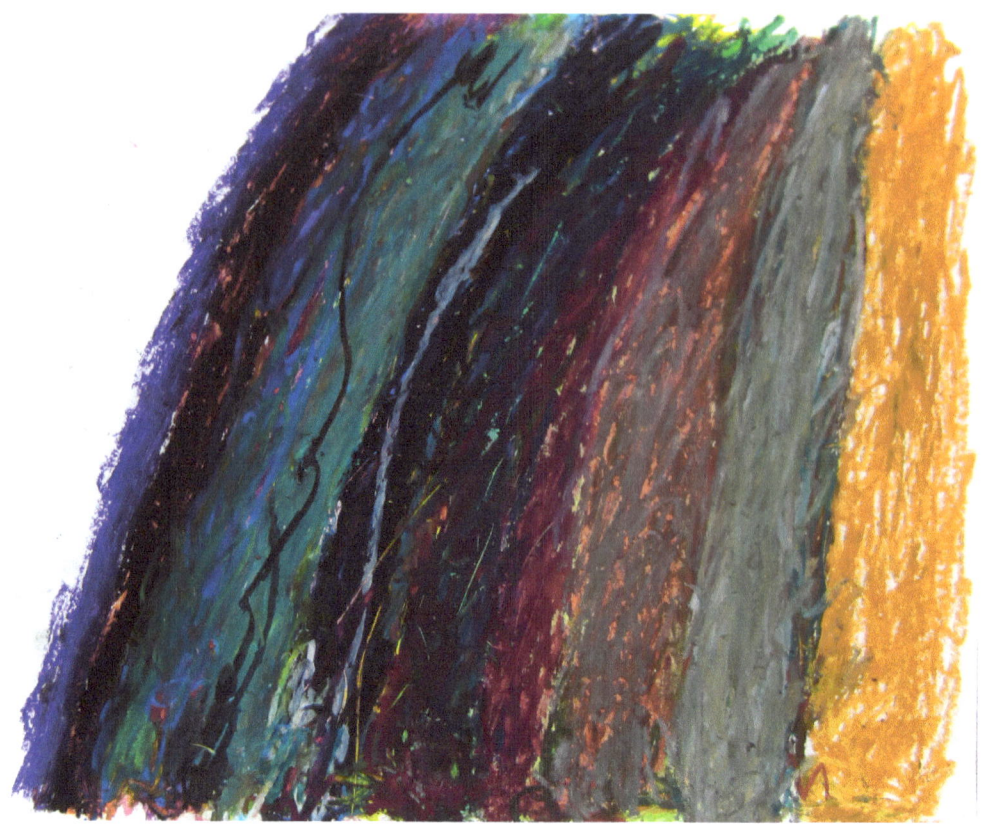

# Paulette

Paulette works very intensely, laying color line over color line and building up an often dense progression of drawn tone and texture. Drawing is one of the few ways she can communicate, and Paulette has a strong sense of focus each time she makes artwork. Her drawings have progressed over the years from her first tenuous experiments with color marks, to her current work with its bold, strong looping lines and dramatic contrasts. She is one of our artists for whom drawing is similar to making music; she arranges color and mark in sequences and takes great delight in the compositions she can create.

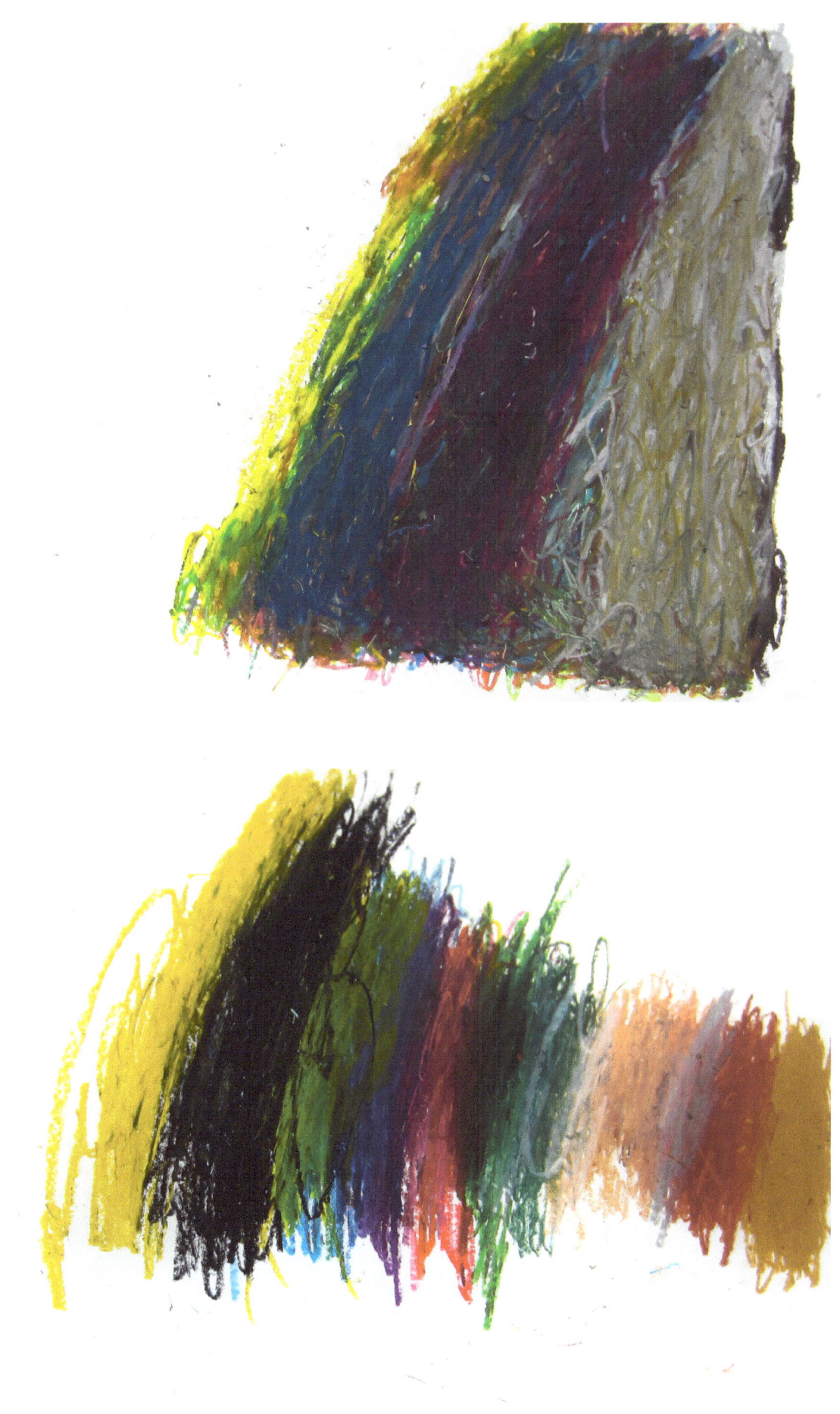

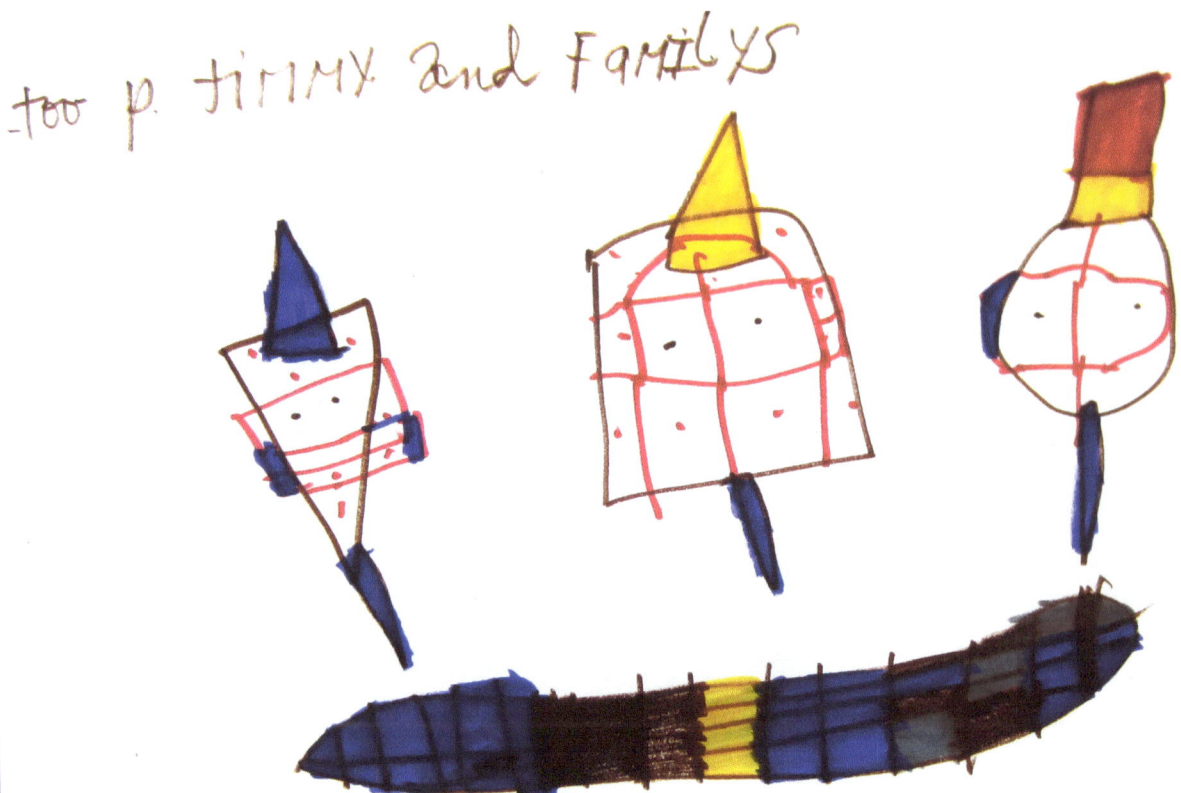

too p timmy and familys

# Sal

Sal draws from an inner graphic language of shapes, line and words. His drawings are systems of symbols that suggest hieroglyphs, and are usually inscribed and dedicated to the person to whom he gives the drawing to. The schematic of his drawing is always done first and color is then added as a flag for emphasis. World Wide Wrestling is often mentioned in his texts, along with thoughtful appreciations for the people in his life. Sal depicts his subject matter, whether people or objects, as connected arcs, lines and jointed structures in ways similar to the surrealists who worked in Europe and the US in the early 1900s.

too staff of the arts

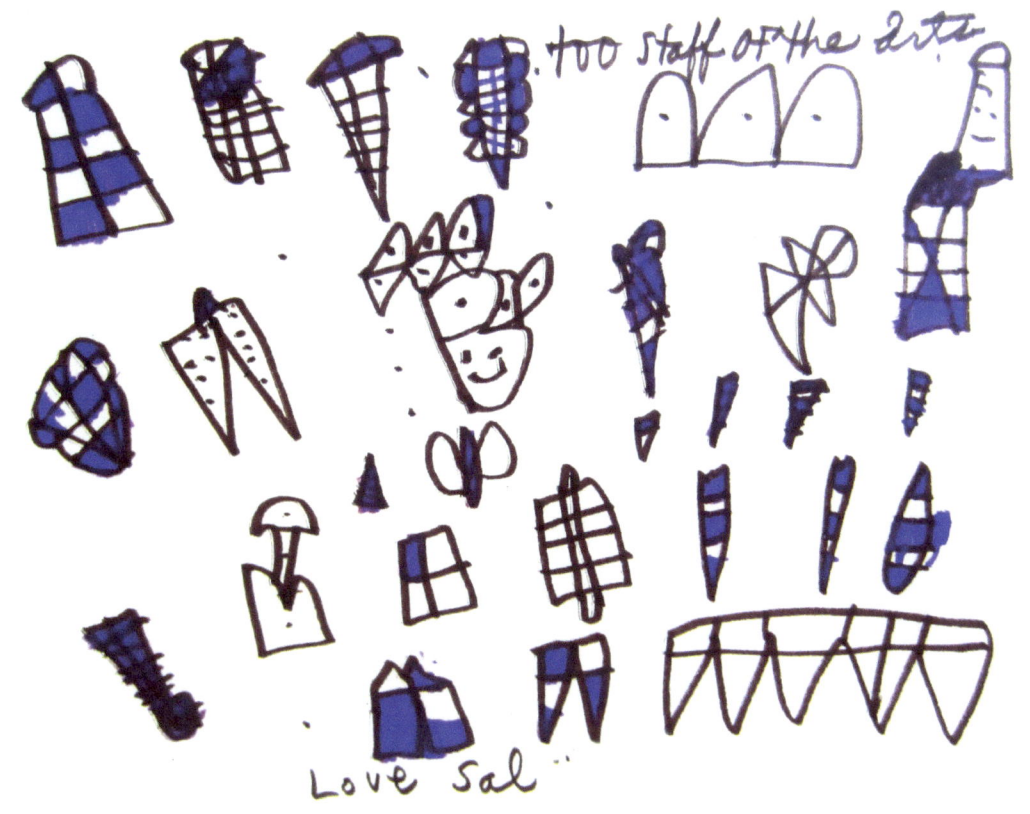

Love Sal

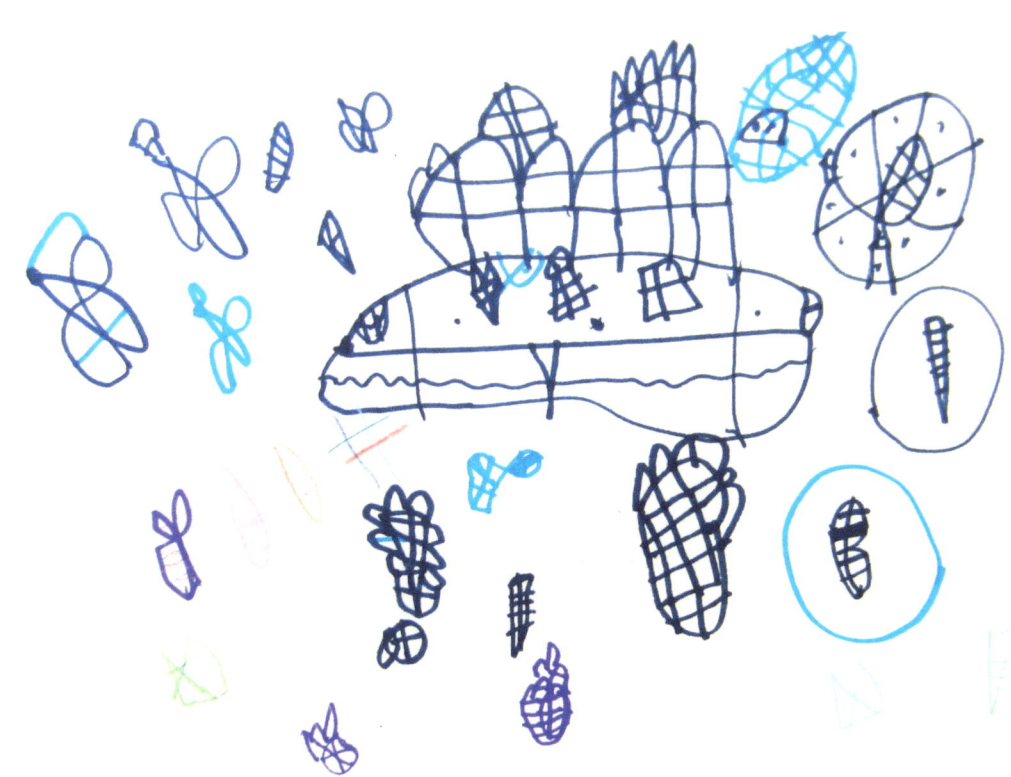

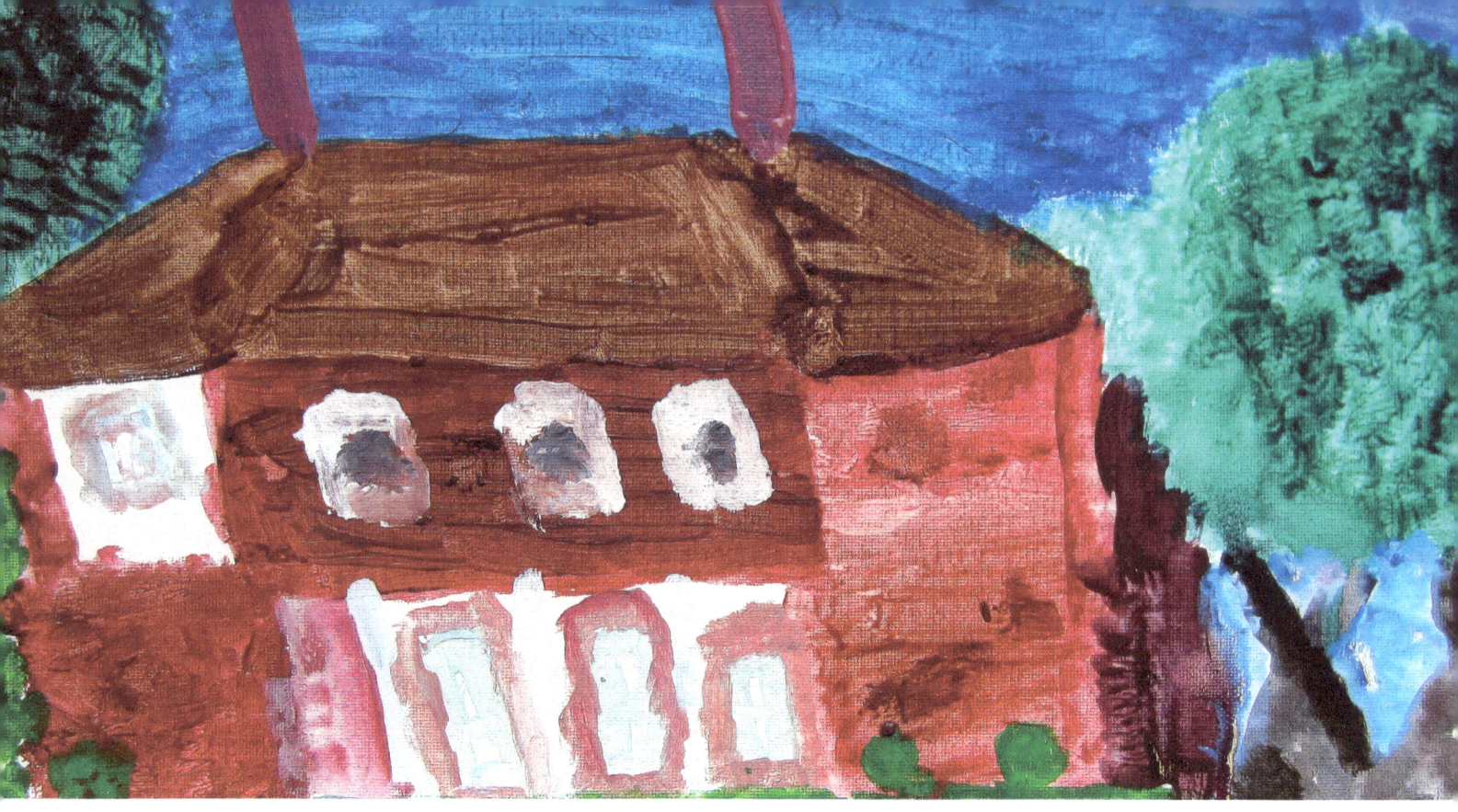

# Timothy

Timothy puts long hours of work into his drawings. He begins with photographs of girls he may know or like to know, and draws in pencil first. He then adds color and a setting. He learns a lot through the process. Sometimes he will work once a week for several months, to make one drawing. He has been making paintings recently as well. In contrast, Timothy often makes a painting in one session, working from a photograph or combining photographs to get the idea he wants. He usually makes his paintings as gifts. He keeps his drawings for himself, as they are more meaningful to him.

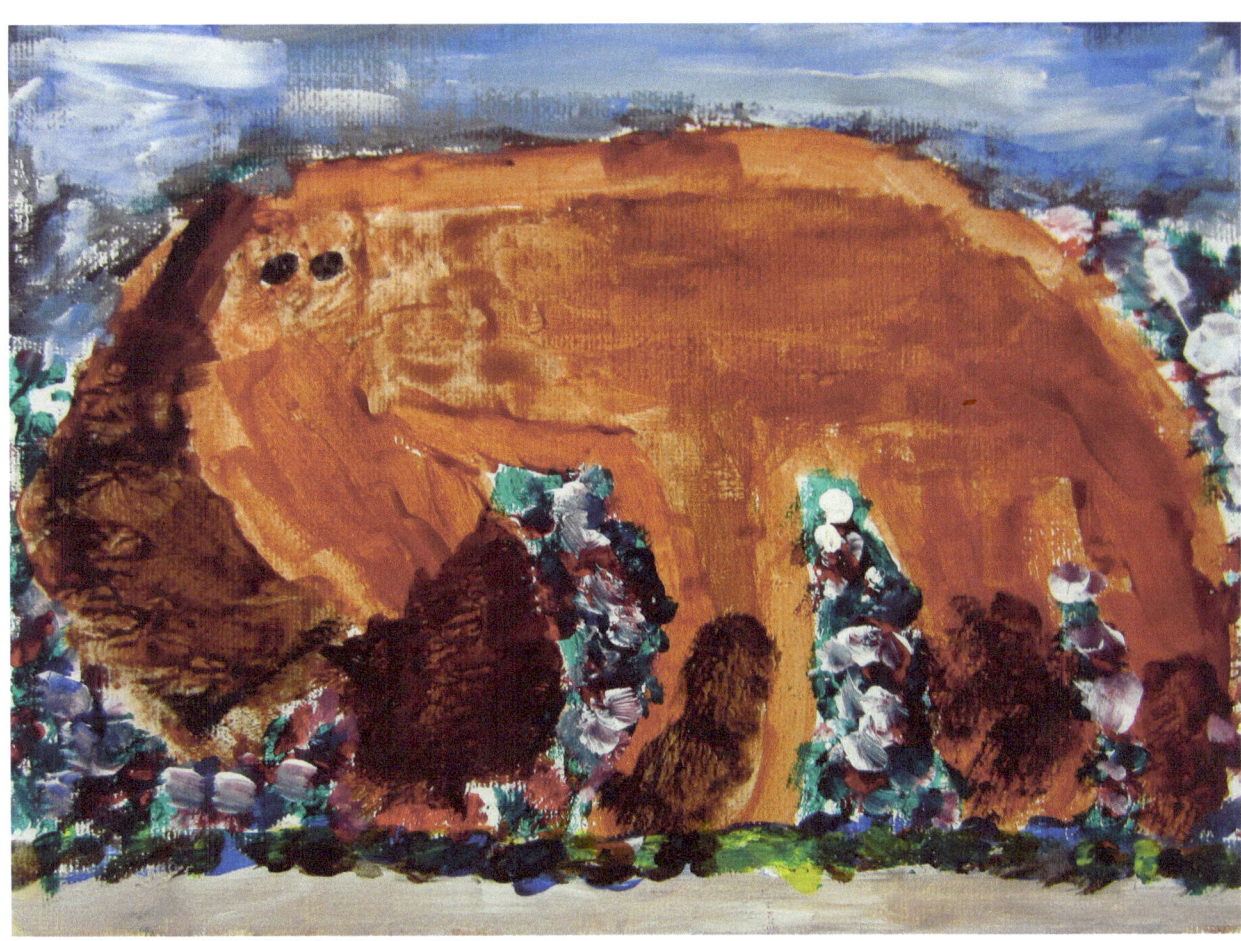

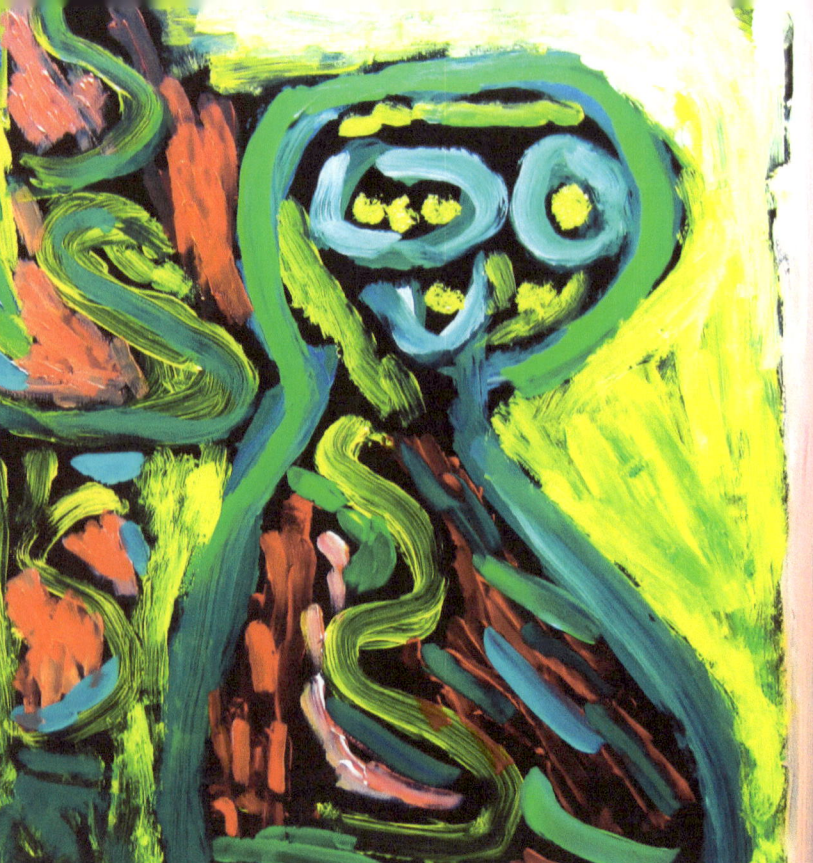
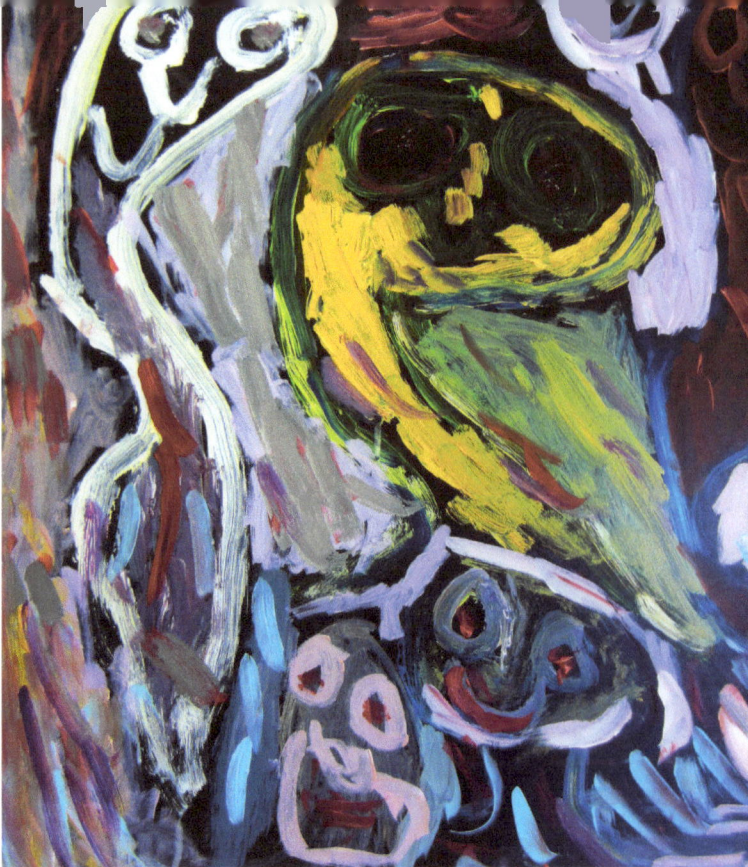

# Wayne

Wayne began by drawing characters from his imagination, producing endless variations of creatures with marks, letters and curves in his many drawings. After a couple of years, he started making paintings and developed his subject matter, compositions and the mark-making and brush strokes, which form the abstract structure of his work. He experiments with color and paint, sometimes mixing his colors on his pallet and sometimes laying down pure strokes of color on the canvas so that colors optically mix. Wayne's images come straight from his imagination. His world is filled with happy monsters, people turning into butterflies, happy bugs, and Chinese soup.

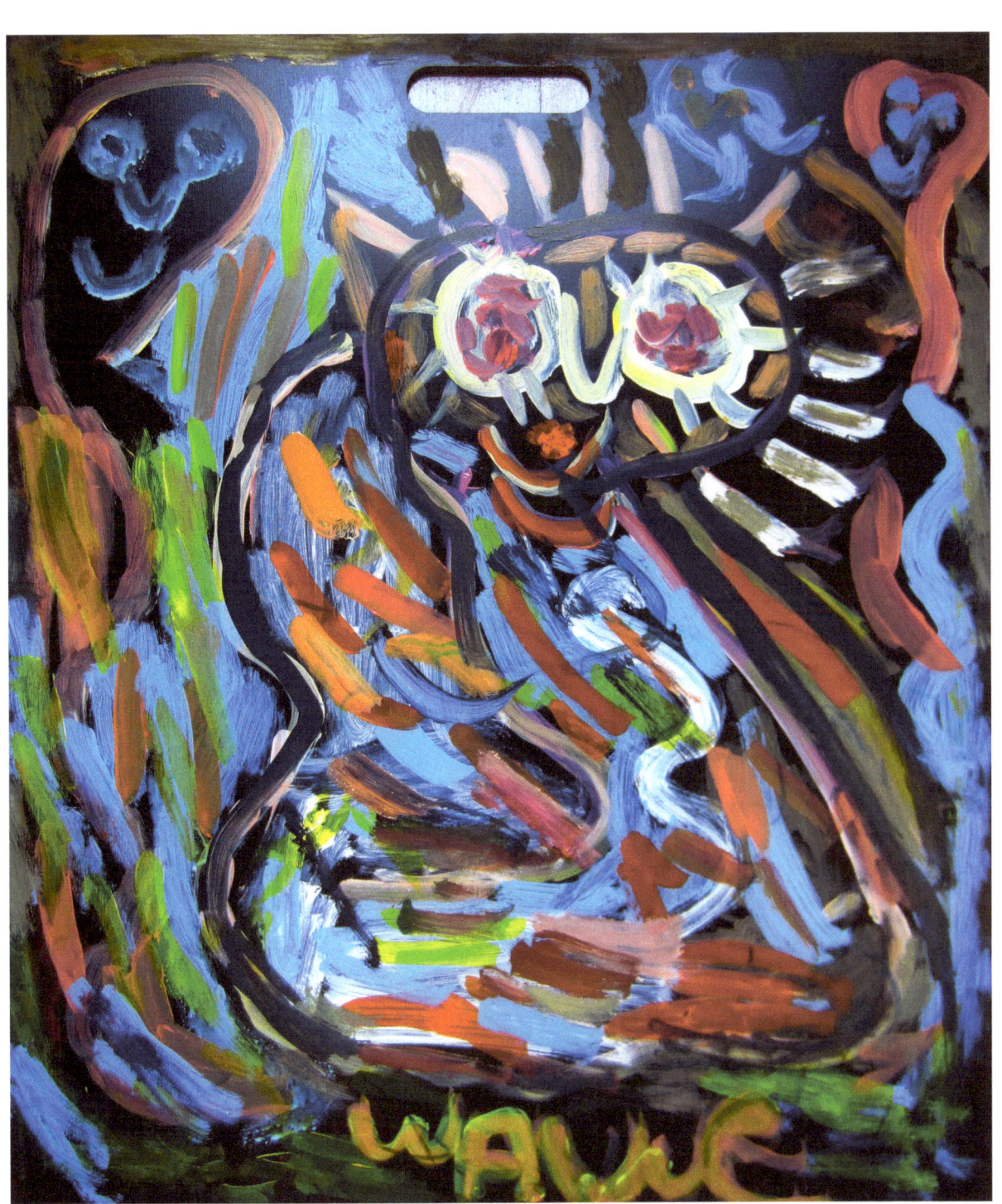

# Wendy

Wendy likes color. She chooses her colors carefully and likes the fluid quality of paint itself. She often works partly with a brush and partly with her fingers to get the movements and marks she wants. Her paintings have a dramatic, energetic contrast of colors and explosive bursts of dark and bright hues. Wendy's paintings are expressive of her strength and determination.

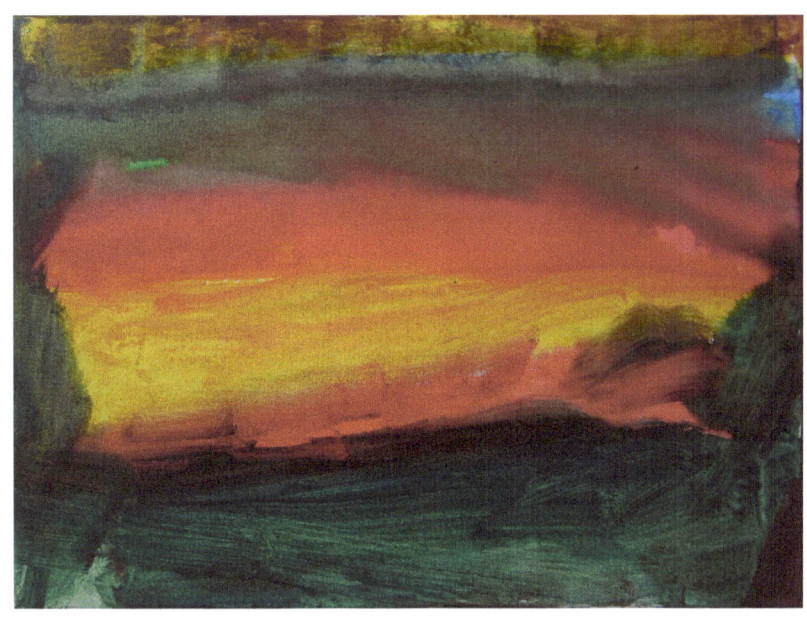

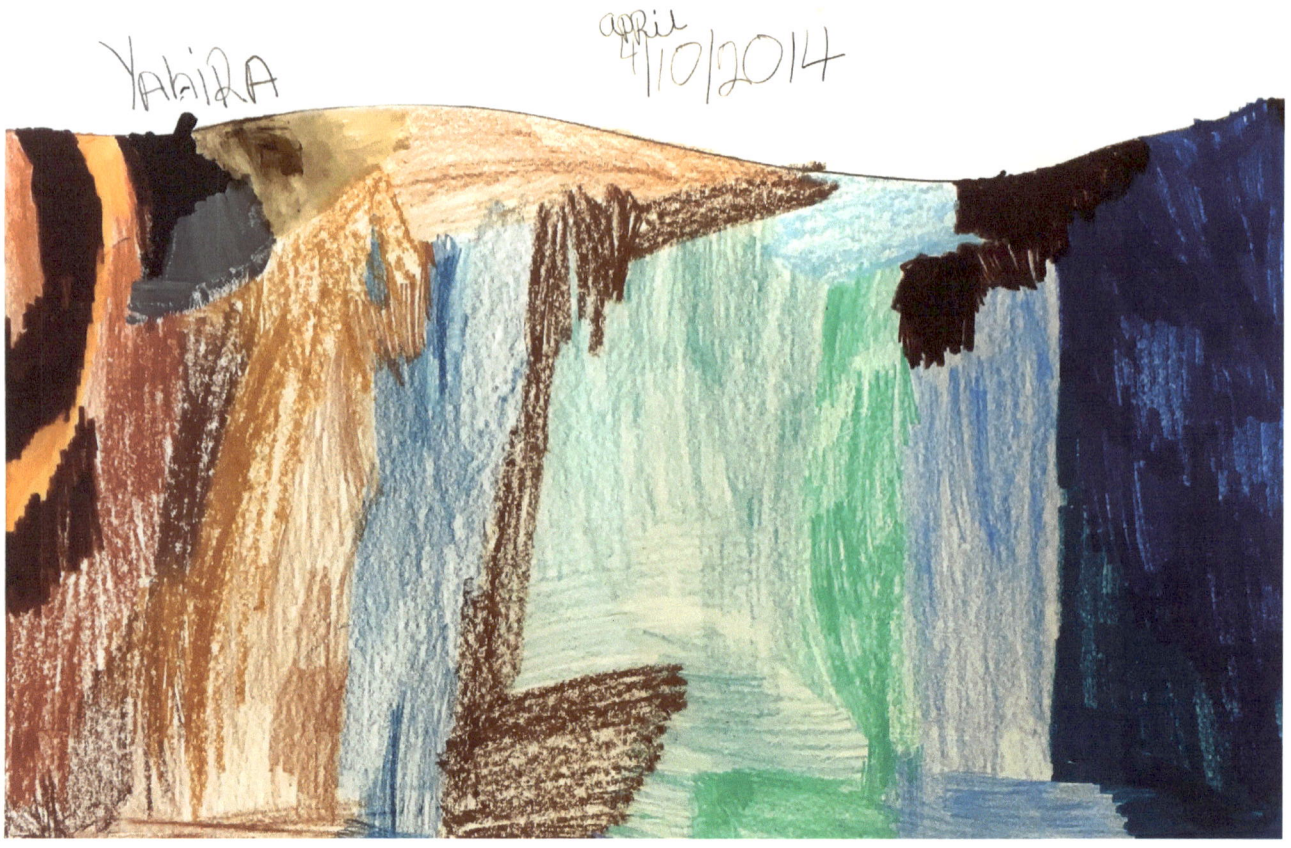

# Yahira

Yahira's landscape pictures are luminous arrangements of tones and textures. She achieves this effect using an assortment of drawing and painting mediums. Colored pencils, markers, watercolor paint, oil pastels and crayons are often employed in the same picture to give it the variety of marks, and build-up of lines and brush strokes, which add depth and variety. She will work from one or two photo-images for each drawing, or will create from her memory. There is almost always a surprise in her drawings in the form of an incongruous element: a multicolored doorway, a traffic cone on the side of a cliff, diamond shapes, hearts, kites floating in the air or precariously balanced on the horizon or inscriptions to loved ones. Dates are not always literal in her drawing.

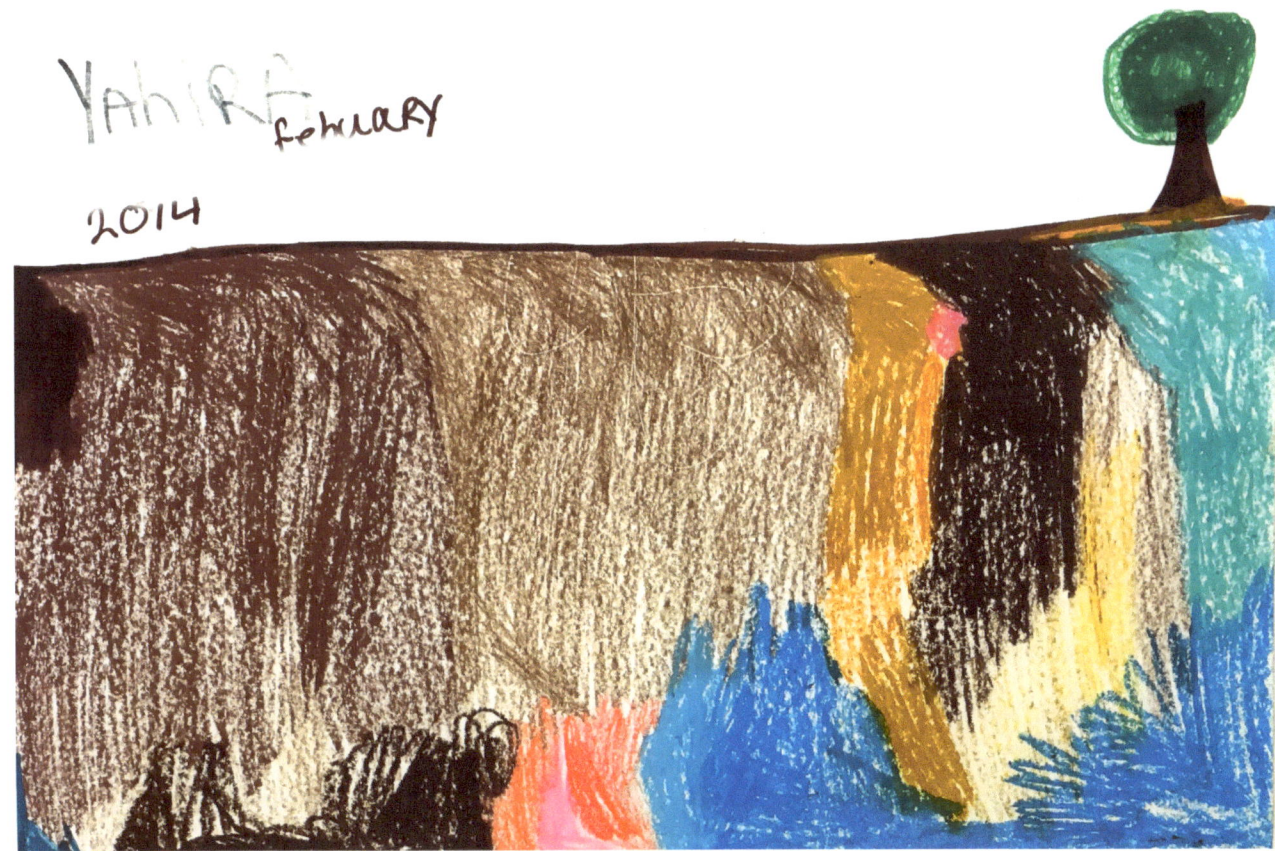

## VICTORY HALL INC. MAJOR SPONSORS AND SUPPORTERS 2016 - 2017
The Geraldine R. Dodge Foundation
Qualcomm
City of Bayonne, CDBG
Hudson County LAP
Kay Cook and Perry Pogany
Mario and Anna Scipione
Patricia Stewart Kerr
Alyce Gottesman

### Donors
Robert Kosinski
Timothy Kerr

## VICTORY HALL INC. STAFF
**Executive Director:** James Pustorino
**Exhibitions Director / Curator:** Anne Trauben:
**Program Manager, Rainbow Thursdays Artists:** Jill Scipione
**Head Teacher, Hand in Hand:** Kimberley Wiseman
**Teaching Artists:** Bruno Nadalin, Ibou Ndoye, Eileen Ferara & Maggie Ens
**Interns:** Alejandro Rubin & Denise Cateron

## BOARD MEMBERS
**President:** Daniel Frohwirth
**Vice President:** Danielle Brooks
**Secretary:** John B. ("Jack") Starr, Jr., Ph.D.
**Treasurer:** Paul Dennison

## COMMITTEE MEMBERS
Maria Ross
Deirdre Kennedy

## VICTORY HALL PRESS
180 Grand St.
Jersey City, NJ 07302
drawingrooms.org

Cover Image: The Can-Man by Wayne
Back Cover Image: Kite Mana by Ed
Title Page Image: Windmill Rainbow Logo by Christopher
Book Layout: Alejandro Rubin

Copyright © Victory Hall Press, May 2016
ISBN-13: 978-1548163365
ISBN-10: 1548163368

This program is made possible in part by funds from the New Jersey State Council on the Arts/Department of State, a partner agency of the National Endowment for the Arts, administered by the Hudson County Office of Cultural and Heritage. Affairs, Thomas A. DeGise, County Executive, and the Board of Chosen Freeholders.

*"Thanks to the families of the participants in the Rainbow Thursdays Artists program for your support"*

SPECIAL THANKS TO:

## J. PATRYCE DESIGN & COMPANY

joan@jpatrycedesign.com | www.jpatrycedesign.com | 201•683•6936

---

## Del Monte Podiatry

150 Warren Street 2nd Floor
Jersey City, NJ 07302
Facebook.com Del Monte Podiatry

### Dr. John Del Monte

Podiatric Medicine and Surgery
201-451-4755/201-451-9459(f)
delmontepodiarty@comcast.net

# Hopkins Group LLC

Developers and Investment Managers

Developers of the award-winning Kennedy Lofts at Jersey City's Journal Square

www.kennedylofts.com

Look out for our Lofts on the Square project coming to Journal Square in 2017!

**(212) 661-8100**
**(201) 798-1818**

## BCB COMMUNITY BANK IS READY TO SERVE YOU!

**BCB** has the **products and services** you find at a major national bank but with the **hometown service and caring** that let's you know **you're important to us!**

We are ready to serve all your **banking needs**, including:
SAVINGS ACCOUNTS ◊ CHECKING ACCOUNTS ◊ CDS
BUSINESS LOANS ◊ RESIDENTIAL MORTGAGES
SBA LOANS ◊ LINES OF CREDIT ◊ AND MORE!

Visit our website or call us for a full list of hours and locations.

www.BCBCommunityBank.com | 1.800.680.6872

*This book is dedicated to
James 'Jimmy' Rokicki
1983 - 2017*

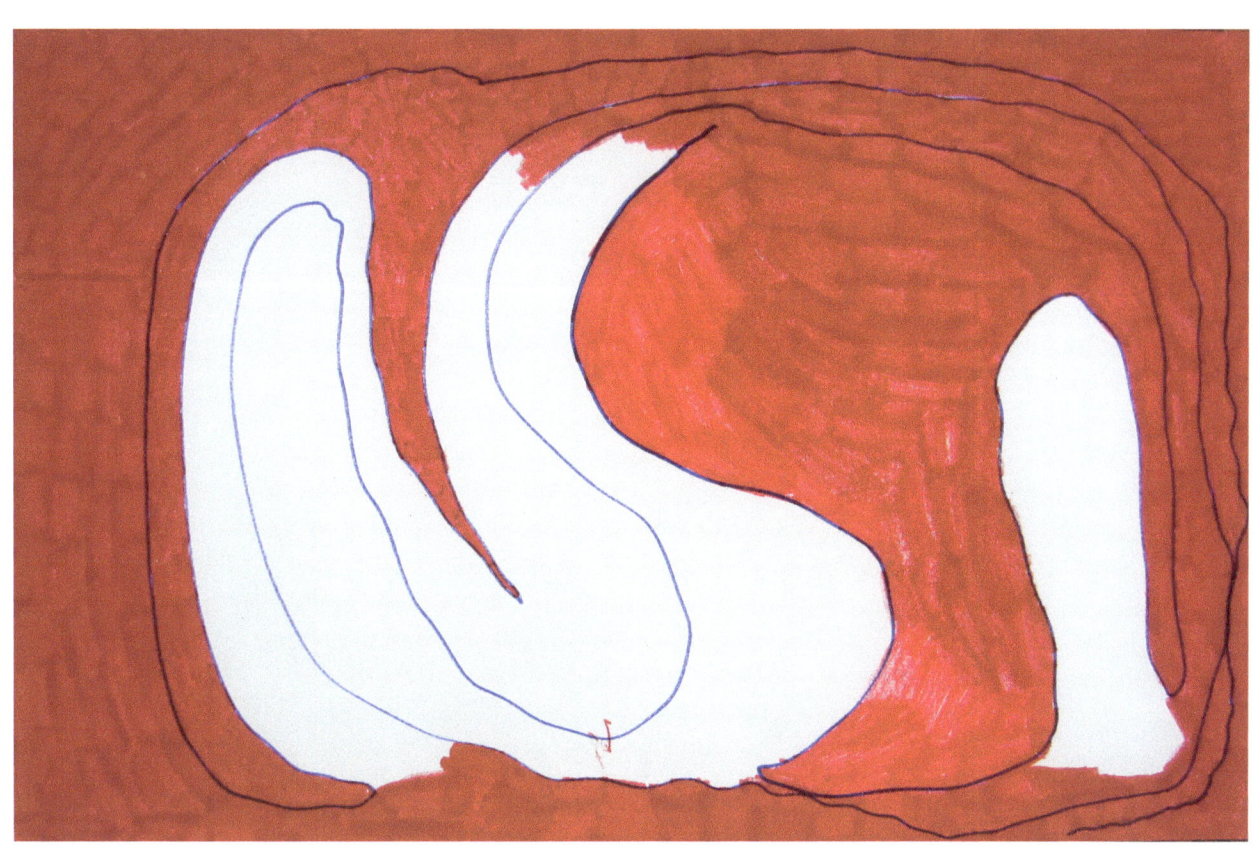
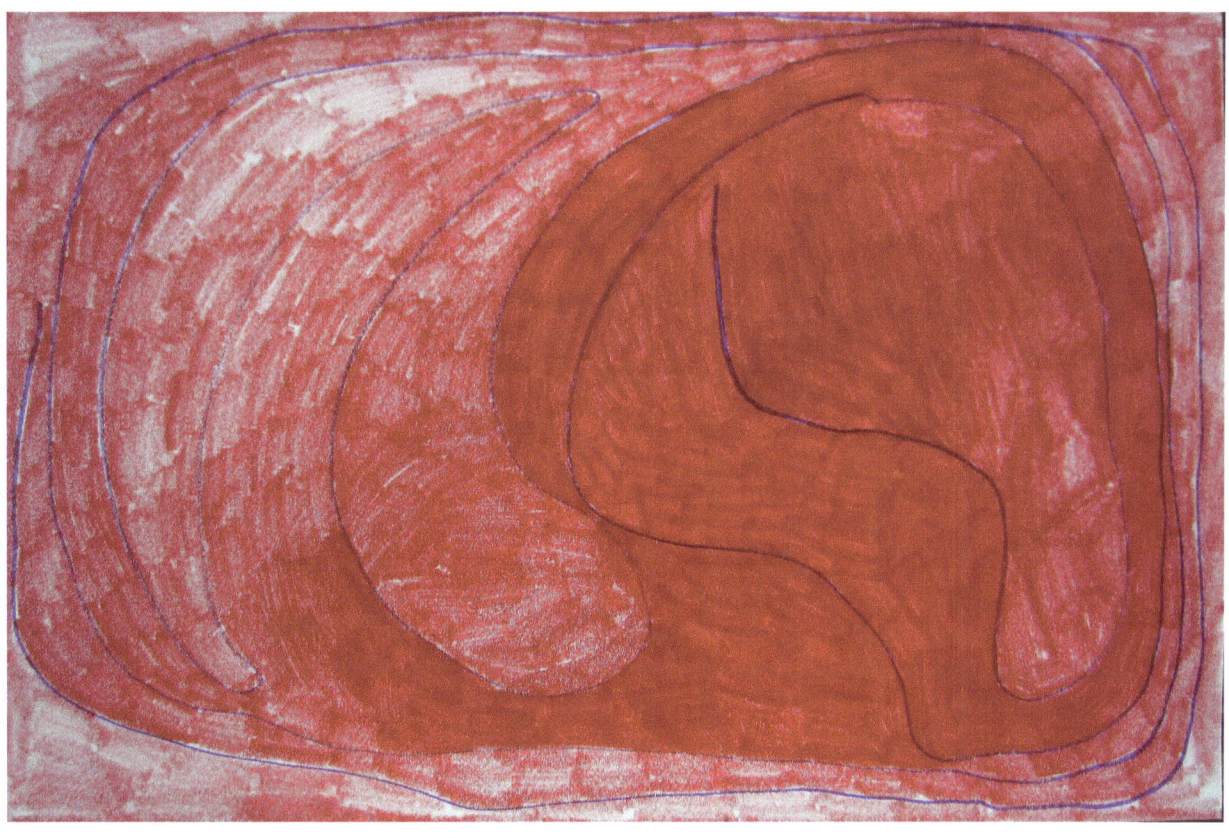

www.ingramcontent.com/pod-product-compliance
Lightning Source LLC
Chambersburg PA
CBHW041314180526
45172CB00004B/1101